REDEEMING

WHEN A WOMAN LIVES LOVED

Live Loved!
Julie Wright

Library of Congress Control Number: 2020950884

TRISTAN Publishing, Inc.
2355 Louisiana Avenue North
Golden Valley, MN 55427

Text copyright © 2022, Julie Wright
ISBN 978-1-939881-22-9
Printed in the USA
First Printing

REDEEMING
EVE

WHEN A WOMAN LIVES LOVED

By Julie Wright

TRISTAN PUBLISHING
MINNEAPOLIS

DEDICATION

To my beloved daughters, Raya, Kelsey, and Nancy—
may you forever live loved.

Table of Contents

Author's Note

Writing *Redeeming Eve* has been an intensely personal journey for me. I first wrote the core study several years ago when I was walking my own healing journey and learning to embrace my God-given identity. I've taught this content many times in many venues, each time gleaning new insights. However, in this writing process, each word, each principle, each emotion has sifted through my heart afresh, reminding me that there's always more truth to learn, more room to grow, and more life to embrace.

When I was first married, we bought an old, dilapidated 11-bedroom mansion in South Minneapolis. (Think the movie *Money Pit*!) The architect and builder of the house on Pleasant Avenue intended it to sit majestically in its original grandeur and glory. A new owner bought it, corrupted the original floor plan, and exploited its grandeur by converting it to a boarding house. Years of neglect took its toll on the once proud home.

We bought that old, dilapidated house and spent the next decade renovating and restoring it. It was a labor of love, and we celebrated each step of renewal. We gutted it, removing all that was old and rotten. We rewired, replumbed, and replastered. We painted walls, polished wood floors, and installed new carpet. Finally, we got to decorate and beautifully furnish each unique room. Slowly but surely, that old house was restored to its intended glory.

Ladies, that house is a picture of our hearts. We were created to reflect the glory of God's love, to be a one-of-a-kind, unique, and majestic showcase of the creative glory of our Creator. But other buyers moved in and took ownership. Sin damaged our hearts' home. We cover up our brokenness with paneling, wallpaper, and paint. The roof leaks and the floors squeak. Our wires are faulty, and the pipes are clogged.

But God is the Master Restorer and Renovator! He designed you intentionally and uniquely, beautifully and purposefully. He has both the power and the desire to heal and restore *you* to *your* intended glory . . . as a reflection of the love of Jesus.

Redeeming Eve is the journey of God's restoration of a woman's heart. We'll look at Eve before the fall of mankind into sin to see God's intended blueprint for her identity, influence, and relationships. In her story, we'll see the calculated assault

of her heart, followed by the corruption of her influence and the heartbreaking relational consequences. We'll be encouraged as we see how God, in His mercy, foretells her redemption. God was and is committed to reversing the curse and redeeming every daughter of Eve, including you and me.

In *Redeeming Eve*, we'll study and unpack the life stories of nine biblical women. Their lives exemplify biblical principles, both directly and indirectly. While the Bible clearly states the facts of their stories, some of the *heart* details, such as motives, thoughts, and emotions are more indirectly revealed. For example, we know from Luke 6:45 (BSB), that "out of the overflow of the heart, the mouth speaks." So, we can extrapolate and understand a woman's heart by what she says (as we'll see in Abigail's story). We also know that deeds are fruit that reveal a root, as Bathsheba's choices reveal.

I've sought to put myself in the shoes of these women, and understand both the cultural and spiritual contexts in which they lived, as well as to imagine the thoughts, emotions, and relational dynamics that likely accompanied their complex circumstances. To this end, I tried to clearly differentiate between taking a principle directly from Scripture and sharing a possible motive or dynamic in their stories.

As we journey through the lives of these precious women, open your heart. Consider with me the facts of their stories that we know, along with the complex emotions and relational realities those facts imply. Allow yourself to look honestly into the lives of the women we'll meet. You'll likely see a little of yourself in each of them. You and I will relate to their strength and their struggle, their beauty and their brokenness. We'll discover that God's grace truly is sufficient. His mercies really are new every morning. His love is forever faithful and true.

He can be wholly trusted with the tender and vulnerable places of your precious heart. He is the lover of your soul. He is not afraid of our brokenness, not fooled by our facade or disgusted with our weakness. He is here. He is engaged. He is all in. May you open your heart, receive His love, and let Him love you to fullness as He redeems the Eve in us all.

God bless you dear friend,

Julie

1

IF ONLY . . .

If only . . . two little words lead to one big trap. If only I were married. If only I were thinner. If only I had children. If only I had a boyfriend. If only I had more money. If only I had a better job. If only I were prettier. If only I had a happy family. If only . . . if only I had something I don't have or were something I am not; *then* I would finally be happy. *Then* I would finally be content. *Then* life would be good.

There's an internal battle in our hearts for contentment, for satisfaction. The search for happiness, love, and fulfillment is real but elusive, always seemingly just out of reach. It begins when we're young. If only I could have this *thing*, this doll or toy or electronic device, *then* my life would magically, miraculously fall into place. Then this longing for life and contentment would be sweetly fulfilled.

My girls were 8 and 10, a marketer's dream. The latest gaming system had just come out as the be-all, end-all of video games, incorporating actual *physical* movement into virtual gaming. It was a parent's dream compromise between *go play outside* and this generation's obsession with technology.

My girls launched a full-on campaign. *We would be healthier if we had this video game . . . we would play it all the time . . . we would never be bored again.* They lobbied with conviction and resolve. *Our family would be happier and more bonded.* Life would just be different, better, and more fulfilling . . . *if only* we had this ultimate gaming technology.

Christmas morning came. The buildup, the anticipation, and finally, the grand unveiling of the marvel toy. Our girls screamed and squealed. Ecstatic and giddy, we raced to get it set up to play. Hours of play ensued. It was a Christmas-day win.

The day after Christmas the girls rushed downstairs to play again. Day one

had formed some preferences, but they continued to explore. Day two formed more. Then came . . . day three. Preferences were set.

I want this.

I want that.

Demands. Arguments. Then, by week's end . . . boredom! All the promises of family bliss from the blessed new game lay silent in a pile of colorful remotes on the basement floor.

Years pass. We grow up and *the thing* changes. A new outfit. A new purse. Shoes. Skin care products. Sports equipment. A beach vacation. A boyfriend. As we mature, a new outfit morphs into a husband, a bigger house, a baby, a promotion. Hoping for kids who get along, a better husband, or any husband at all. *If only* just seems to get more personal, more expensive, and more unattainable.

Comparison has always been a temptation and a destructive trap. Social media has kicked the comparison monster into full force as we desperately wish we felt and lived the lives we portray on social media. As a mother of teen girls in a media-saturated generation, I watched as my girls were bombarded with social media posts showing others experiencing seemingly nonstop fun and happily-ever-after relationships. If we take social media at face value, as the whole of reality, then everyone else is living fairytale lives—permanently on vacation and perpetually falling in love. They are living bliss-filled lives free of conflict, work, disappointment, and pain.

Maybe you're waiting for your Prince Charming—or for your man to become Mr. Right. You may be striving for a promotion or a new position. Perhaps you're desperately wanting to orchestrate the *perfect* family vacation or get-together.

We all dream of our own versions of happily-ever-after. We seek and search; we hunger and hurt, cycling between daring to hope and retreating into defeated cynicism.

As a child of divorce, I desperately wanted a good marriage. Totally understandable. However, unconsciously I turned to my marriage for my identity, wholeness, healing, and fulfillment. I found myself caught in a cycle of pursuing connection, relishing those moments—only to be thirsty, frustrated, and discontent . . . because tomorrow always comes. This cycle was defeating and destructive to me, my husband, and our marriage. However, I didn't know what to do to change it or fix it.

PERPETUALLY THIRSTY

I was praying and asking God to help me, when He led me to the Bible story of the woman in John 4 who is commonly known as the woman at the well. Her story of cyclical thirst leapt off the page, and I looked straight into the mirror of my own heart.

She had been married five times and was on relationship number six when the Bible picks up her story. It was midday. She may have waited until the women of her Samaritan town had already made their daily trip to the well. As a moral and cultural outcast, she may have hoped to avoid any awkward interaction with the other women. Upon arriving at the well, however, she met a stranger. A man named Jesus. Sitting next to the well. He asked her for a drink.

So he [Jesus] came to a town in Samaria. . . . Jacob's well was there, and Jesus, tired as he was from the journey, sat down by the well. It was about noon.

When a Samaritan woman came to draw water, Jesus said to her, "Will you give me a drink?" (His disciples had gone into the town to buy food.)

The Samaritan woman said to him, "You are a Jew and I am a Samaritan woman. How can you ask me for a drink?" (For Jews do not associate with Samaritans.)

Jesus answered her, "If you knew the gift of God and who it is that asks you for a drink, you would have asked him and he would have given you living water."

"Sir," the woman said, "you have nothing to draw with and the well is deep. Where can you get this living water? . . ."

Jesus answered, "Everyone who drinks this water will be thirsty again, but whoever drinks the water I give them will never thirst. Indeed, the water I give them will become in them a spring of water welling up to eternal life."

The woman said to him, "Sir, give me this water so that I won't get thirsty and have to keep coming here to draw water."

He told her, "Go, call your husband and come back."

"I have no husband," she replied.

Jesus said to her, "You are right when you say you have no husband. The fact is, you have had five husbands, and the man you now have is not your husband. What you have just said is quite true. . . ."

The woman said, "I know that Messiah" (called Christ) "is coming. When he comes, he will explain everything to us."

Then Jesus declared, "I, the one speaking to you—I am he."

JOHN 4:5–11, 13–18, 25–26

I tried to imagine her life leading up to this moment. How had she already burned through five marriages? Did her perpetual thirst for love drive her into and out of half a dozen relationships? Did her marriages overlap? Did they begin as affairs? Was it her choice to leave, or theirs?

Five marriages and relationship number six. What was the condition of her heart at this point? Was she hardened and jaded by bitterness and anger? Perhaps her confidence was completely broken, leaving her emotionally bankrupt and empty. Did disappointment leave her demanding and difficult—or desperate and begging? Was she still hopeful—or totally disillusioned?

In this cryptic conversation about drinking water, Jesus summed up her entire existence with a single, insightful sentence in John 4:13: "Everyone who drinks this water will be thirsty again." Was that it?! Was it that simple? Jesus' words exploded and resonated in my own heart! Her *water* was men. Her *thirst*, romantic love. She had drunk deeply of both, and yet here she was, still dabbling with disaster in another bid for a man's attention. Yes, on this day, despite *drinking* the day before, she was *thirsty again.*

> External things cannot fill internal needs. There is only one love that can truly fill and satisfy our thirsty souls.

I found myself identifying with the woman at the well. Up to this point in my life, I had pursued relationships, experiences, and people to fill me. They would fulfill and satisfy for a time, but eventually I found myself *thirsty again.* Jesus told the woman at the well that the issue was *not* her thirst. We are all thirsting for love, for life, for purpose. The issue was the water. What we choose to drink. What we use to water our thirsty souls. That is the issue. External things cannot fill internal needs. There is only one love that can truly fill and satisfy our thirsty souls.

BROKEN CISTERNS AND MAN-MADE WELLS

Soon after, the Lord led me to another Scripture about wells and water. In Jeremiah 2:13, God reveals two possible sources of water to quench our inner thirst. He says, "My people have committed two sins: They have forsaken me, the spring of living water, and have dug their own cisterns, broken cisterns that cannot hold water."

One source for life is God himself and the living spiritual water His love provides. The other source is the *wells,* or *cisterns,* we dig for ourselves, looking for emotional *water.* God says these cisterns are *broken.* They cannot hold water. As Jesus so compassionately shared with our woman at the well, "Everyone who drinks this water will be thirsty again" (John 4:13).

We all glean our identity from something or someone. Some of us look to relationships. Some look to accomplishments. Others look to family and children. Still others look to material possessions. We all search for satisfaction and purpose.

When that search leaves us lacking, we may try to dull the ache with busyness or service. We may look to relationships, food, or alcohol to ease the emptiness. We turn to our escape of choice, a fantasy, or worse. No matter where else we look for life, love, or happiness, we will be thirsty again tomorrow. Tomorrow is always coming!

After my parents' divorce, I resolved to have a good marriage. Marriage became my *well,* the cistern I looked to for my fulfillment. Looking to my marriage as a *source for* my life—instead of a *blessing in* my life—put an enormous amount of pressure on the relationship and my dear, unsuspecting husband. We could have a great date night, an ideal evening of conversation, fun, and connection, but *tomorrow* always came. And I found myself thirsty again.

In Jesus' words to the woman at the well, I heard His offer to my own heart. *Are you thirsty, child? Are you tired and weary? Have you exhausted your options, squeezing every ounce of love out of your relationships, only to be thirsty again when tomorrow comes?*

My throat constricted as I came face-to-face with my own thirst. *Yes. I am. I'm tired, Jesus. And I am thirsty!* Confession broke my emotions free.

Jesus answered, "Everyone who drinks this water will be thirsty again, but whoever drinks the water I give them will never thirst. Indeed, the water I give them will become in them a spring of water welling up to eternal life" (John 4:13–14).

My problem was not my *thirst* . . . my problem was my *source*! I had committed the two sins spoken of in Jeremiah. I had turned away from God as the source for my identity and turned to something else, namely my husband, to fill me—but nothing else can fill us like God can. My marriage was good, but it was a broken cistern! My husband could be a good husband—he could even be a *great* husband—but he would always be a lousy savior. I was looking for him to fill something that only God's love could fill and heal.

I turned away from my broken cistern and turned to the living water of God's love. His love flowed into my thirsty heart, saturating, quenching, and healing it. My heart's desire to be known, loved, and cherished was met in a real love relationship with Jesus. As His love filled me, I experienced a new level of wholeness, security, and contentment. I began to love from this place of wholeness, instead of need. I could live, love, and relate from this place of already being perfectly, completely loved.

What a relief! It's been a journey. When I switched my source from my husband to Jesus, the weight of the world fell off my husband! Our marriage was set free to be enjoyed as a blessing and a gift. Our relationship no longer suffocated under the pressure and demand of being the be-all and end-all as the source of my life, identity, and purpose.

REDEEMING EVE—THE JOURNEY TO LIVE LOVED

Redeeming Eve is the journey toward this wholeness and healing. The destination is to *live loved*. God desires to see each of us *live loved*. He invites us to drink the living water of His unfailing, unending, perfect love. His transforming love will set your heart free and fill you with strength. *Living loved* will restore your hope. *Living loved* will ignite your joy and crown you with beauty.

I'm so excited to journey with you into the incredible lives of these nine biblical women. The Bible is so rich with real-life stories of real-life people: women filled with hopes and dreams, successes and failures, just like you and me. Take a front-row seat to their drama and deliverance. Watch and wonder at their inner battles between courage and corruption, seduction and security, and betrayal and becoming. Cheer them on as we recognize the internal war between passion and purity, sacrifice and scandal. Root for them as they navigate deeds and desires. Applaud their lives as a celebration of the redeeming, restoring love of God that is graciously extended to us all.

Living loved will restore your hope. *Living loved* will ignite your joy and crown you with beauty.

In these women, we will see the power of identity—either broken cisterns or living water—play out for good or bad. We'll explore the sacred influence of women and how to wield that influence in purity, wisdom, and love. Finally, we'll discover how to cultivate the significant relationships we desire and treasure so we can thrive and flourish. We'll see how to nourish our relationships from a position of strength and wholeness. We'll learn that *living loved* replaces

demanding, using, and consuming. We will establish how "perfect love drives out fear" (1 John 4:18) and how God's love secures our identity, which focuses our influence and stabilizes our intimacy.

My heart's prayer is that, at the end of our journey, you will find your freedom, healing, and wholeness in your own encounter with Jesus' perfect love. May His love become your personal well of living water!

Lord Jesus,

I come to you today with an open but thirsty heart. I identify with the woman at the well. I know that the things I use apart from your love don't completely or permanently satisfy. They leave me thirsty again. Lord, I want to get off the perpetually thirsty cycle. If there is living water that will finally fill me, I want it! So, Jesus, right now I invite you to speak to me through your Word, your Spirit, and the lives of the women shared in this book. I ask you to reveal your perfect love to me, remake my identity, renew my mind, and heal my heart.

In Jesus' name, Amen

DISCUSSION QUESTIONS

1. In which areas of life do you experience "perpetual thirst," where you struggle to find contentment and satisfaction?

2. What are the broken cisterns that you use to fill the empty space? What kind of pressure are you putting on those cisterns? What's the result?

3. Are you willing to ask God to fill these places in your heart with His love? What would it look like to let God love you to fullness and wholeness? How might that change these dynamics in your life?

Eve

2

PARADISE BORN, PURE DELIGHT

Why are we so thirsty in the first place? Where did this perpetual thirst and discontent come from? To answer the question posed by the life of the woman at the well, we must go back to the beginning, to the first man and the first woman, to Adam and Eve. To paradise born and paradise lost.

Eve, "the mother of all the living" (Genesis 3:20), the first woman, was the only woman to know life and love without sin, pain, or selfishness. She was the only woman to experience unhindered intimacy and to share perfect love with her husband. She was also the first woman to experience the piercing agony of innocence lost, the crushing blow of betrayal, the searing pain of separation, and the devastation of a broken heart.

> *Then God said, "Let us make mankind in our image, in our likeness, so that they may rule over the fish in the sea and the birds in the sky, over the livestock and all the wild animals, and over all the creatures that move along the ground."*
>
> > *So God created mankind in his own image,*
> > *in the image of God he created them;*
> > *male and female he created them.*
>
> > *God blessed them and said to them, "Be fruitful and increase in number; fill the earth and subdue it. Rule over the fish in the sea and the birds in the sky and over every living creature that moves on the ground." . . .*

The LORD God said, "It is not good for the man to be alone. I will make a helper suitable for him."

Now the LORD God had formed out of the ground all the wild animals and all the birds in the sky. He brought them to the man to see what he would name them; and whatever the man called each living creature, that was its name. So the man gave names to all the livestock, the birds in the sky and all the wild animals.

But for Adam no suitable helper was found. So the LORD God caused the man to fall into a deep sleep; and while he was sleeping, he took one of the man's ribs and then closed up the place with flesh. Then the LORD God made a woman from the rib he had taken out of the man, and he brought her to the man.

The man said,

> *"This is now bone of my bones*
> *and flesh of my flesh;*
> *she shall be called 'woman,'*
> *for she was taken out of man."*

That is why a man leaves his father and mother and is united to his wife, and they become one flesh.

Adam and his wife were both naked, and they felt no shame.

GENESIS 1:26–28; 2:18–25

Everything started out so perfect and beautiful. God created man, along with all the birds of the air and animals of the fields. The moon and stars were set in place. The sun rose and set each day. The oceans swelled and teamed with life. The trees and flowers bloomed. Life burst forth on planet Earth in perfection and glory.

God, who lives in perfect relationship and harmony as the three-in-one God—Father, Son, and Holy Spirit—considered the man He had created in His own image. All creation was good, except for one aspect. Despite the vast spectrum of creation, there was not a mate, a counterpart, a partner, suitable for Adam. In Genesis 2:18, we see God's solution: "It is not good for the man to be alone. I will make a helper suitable for him." God would give Adam a helpmeet. He put the man to sleep, took a rib from his body, and formed woman.

IMAGE BEARERS

God created *both* the man and the woman in *His* image. Both men and women reflect and possess distinct attributes of God. They were created with equal value and equal worth, and they equally carry the glorious image of Creator God.

He distinctly made them male and female. God was not confused about gender. He did not take the ingredients of mankind and throw them into the air with varying degrees of gender combinations. He made two distinct, unique, and glorious genders: male and female, both genders representing different aspects of the awesome image of the Most High God.

While man was created from the dust of the ground, woman was created from the rib of the man, from an essential part of him. Woman was created *from* Adam and *for* unity with him to be a counterpart, a partner, a *helpmeet*, or a *helper suitable* for him. Essentially, within marriage, to be his other half.

To be created *for* him did *not* imply being created to be used by him, in the sense of being for his consumption. I have heard resistance—and at times personally felt defensive—by the implications of what it means that the woman was created as a helper or helpmeet to the man. That is, until I studied the original words for myself.

What is a *helper* or *helpmeet suitable* for the man? First, consider the word *helpmeet*. The word *helper* or *helpmeet* is taken from two root words in the original Hebrew. According to *Strong's Exhaustive Concordance*, it's a combination of the words *ezer* (H5828) and *neged* (H5048). *Ezer* is translated to "help, aide or succour."[1] *Webster's 1913 Dictionary* gives additional insight into this help. Some of the definitions are "to furnish with strength ... deliverance from trouble ... to furnish with relief ... to change for the better, to remedy ... to lend aid or assistance; to contribute strength or means; to avail or be of use."[2]

> Both men and women reflect and possess distinct attributes of God. They were created with equal value and equal worth, and they equally carry the glorious image of Creator God.

This is the same word often used to describe the work of the Holy Spirit in the life of a Christian. Being the helper does not mean you are just *the help*. Being the helper is not defined as being the domestic servant, the glorified babysitter, or the housekeeper with sexual benefits to the man. While there is nothing wrong with traditional roles of responsibility—or nontraditional responsibility roles for that matter—the word *helpmeet* does not imply or prescribe the division of domestic responsibilities. Nor does it install hierarchy or authority.

What it does mean is that man and woman were created for union, partnership, and intimacy—emotionally, physically, and spiritually. The woman as helpmeet would bring the strength of her feminine, image-bearing nature to the relationship to help the man. She would aid, surround, and protect him. She would assist and support in times of hardship and distress. As helper, she would defend and even rescue. She would lend her strength to him.

IN SIGHT FOR THEIR DELIGHT

As for the term *meet*, the definition of the original Hebrew word *neged* is bursting with beautiful imagery. This help would neged, or meet, the man, "in front of . . . in the sight of . . . corresponding to . . . before the eyes of." Literally, she would be placed before him, "as things which are before us, and in the sight of which we delight, are the objects of our care and affections."[3] Eve was literally set before Adam, as the object of his care and affections! God created her as a partner for Adam to love.

In Genesis 2:18, we see that *meet* means to be a helper that is "suitable" or corresponding to him, to be a counterpart, placed in front of him and facing him. Further, *neged* describes two things that "are to be compared" and "are put opposite one another" and which "answer to each other."[4]

Being a helpmeet was not a subservient role. Rather, as helpmeet she would provide this help face-to-face, heart-to-heart, shoulder-to-shoulder. Theirs would be a meeting of the minds, an equal partnership within a vibrant, honest, and trusted friendship. Eve was to reflect back to Adam as a mirror, to provide perspective, and ultimately, to influence and encourage him to godliness.

Woman was created and charged with bringing her strengths and gifts, her wisdom and understanding, her perspective and insight, to bear upon and unite with the man, who—without her—was alone. The original Hebrew word for *alone* is *bad*, Strong's H905, meaning "separated from the root."[5] Further, Webster's defines *alone* as "quite by oneself . . . solitary." It goes on to define it as "isolated from others . . . lacking companions or companionship."[6] Man wasn't meant to be emotionally and relationally disconnected and isolated. God said it was "not good" (Genesis 2:18), meaning it was not a "benefit"; nor was it "promoting or enhancing well-being."[7] For mankind to prosper, to function in God's intended glory, and to flourish, man needed a counterpart. To be the counterpart or helpmeet is a profoundly beautiful and powerful assignment.

UNITY AND EQUALITY

There was no male-female hierarchy in the original, pre-sin order of creation. There was no justified or mandated male domination or rule. Woman was not created as a second-class citizen. Nor was man created to rule woman. Woman was created by God Almighty in His image as the counterpart and partner of the man. She was not meant to be subdued, ruled over, or diminished. In Genesis 1:28, Eve was charged, along with Adam, to rule and reign over creation together.

She was created to be the one Adam cherished and upon whom he lavished his affection, the one upon whom he focused his care and provision. Adam called Eve "bone of my bones and flesh of my flesh" (Genesis 2:23). He was to spend his strength pursuing, protecting, and providing for her! They were created for intense loyalty and devotion toward one another. They were to exist in mutual love and harmony with one another. As they talked face-to-face, receiving and respecting one another's perspectives, they would be able to rule and reign in wisdom, and subdue creation with their combined God-given power and strength.

This holistic and balanced leadership would foster their fruitfulness. They would multiply. Whatever they ruled and nourished together would thrive and flourish, whether it was a family, a business, a dream, or a ministry. The God-given commission to rule, reign, and subdue creation, to be fruitful and multiply, was given to *both* the man *and* the woman. They were to be *one* in this purpose, equally esteemed for their unique perspectives, strengths, and contributions as they ruled and subdued the earth in united, equal partnership.

They were to be an *us* just as the Trinity functions as *us*: "Let us make mankind in our image" (Genesis 1:26), with no competition, dominion, or pride-induced power struggles. The union of man and woman, the intimacy and relationship dynamics between them, were to reflect the unity, equality, and trust of the Trinity. We'll look at this mutual cooperation and submission more closely in a later chapter.

God further solidifies this mutuality and oneness in Genesis 2:24: "That is why a man leaves his father and mother and is united to his wife, and they become one flesh." What reason? When God presented Adam with Eve, Adam fully received Eve as "bone of my bones and flesh of my flesh" (v. 23). She was presented and received, not just as Adam's equal, but as an extension, an essential part of Adam

> They were to be an *us* just as the Trinity functions as *us*: "Let us make mankind in our image" (Genesis 1:26), with no competition, dominion, or pride-induced power struggles.

himself! She was part of him! He was part of her! They were two halves of a whole—one being in two parts. Adam understood that she was literally part of his own body, without division.

Adam was not threatened by Eve's contribution, nor was he dismissive of it. He received her as God-given. There was no insecurity or pride on Adam's part, no male ego that would get in the way of acknowledging a woman's value or corrupt his partnership with her. He did not compare or compete with her. Rather, he received and revered her as a necessary, handcrafted gift from God.

So, for *this* reason, because they were created to be one in essence, spirit, purpose, and even body, men and women were to leave their fathers and mothers and be united to one another, becoming *one*. The concept of being *united* in the original Hebrew, Strong's H1692, means "to be joined together . . . to adhere . . . to be glued . . . to attach oneself."[8] In being united, they were not to be two separate beings of different importance or chemistry. It's like mixing two colors of paint together. They become one new color, a seamless combination of the qualities, textures, and hues of both. Mixed together, they're no longer separate and cannot be divided. They are one new, vibrant expression of the two together. Oneness by definition is holistically equal.

Sexual intimacy is the physical expression of this spiritual and emotional reality. Husband and wife became *one flesh*. Sexual intimacy was created as a glorious, mutual, and exclusive place of wonder, delight, and pleasure between a husband and wife. It's a private celebration of the unity and love between a man and a woman in marriage. There was no fear or shame—no fear of rejection or abandonment, no shame from comparison. They belonged wholly and solely to one another, without rival. Their union was perfect in unfailing fidelity, intimacy and purity.

MATCH MADE IN HEAVEN

Adam and Eve lived in perfect harmony with their creator God. They had unfettered access to God and talked with Him face-to-face! Imagine that—walking and talking physically with God, sharing your thoughts and hearing His. Imagine Adam and Eve learning from Him as He explained how the plants grew and being taught how to care for all of creation. They were completely known and perfectly loved by God and by one another.

There was no sin, no separation from God or from one another! Imagine relationships with friends and family without sin! Who would we be without fear

and insecurity, anger and lust, jealousy and resentment, selfishness and pride? One thing I love about heaven is that we will be totally restored and resurrected to a sinless state of being. We all will be without sin.

Adam and Eve had that. They had a sinless marriage and were perfectly united, without pride or selfishness or fear—they were naked and unashamed. The word *naked* referred to far more than physical nakedness. Yes, they had bodies without age, disease, or decay, handmade by God himself! We could argue that of course they felt no shame in being naked—they had perfect bodies. However, they were also naked emotionally and spiritually. They were completely transparent and known by God and each other with no hiding or covering up. There was no fear of intimacy, exposure, or rejection. There was no shame. There was only complete acceptance and total security. They were both completely fulfilled; emotionally, sexually, and relationally. There was no disappointment, no rejection, and no deprivation. Basically—simply and literally—they had a marriage made in heaven!

In this fullness, Eve's identity was clear and secure. She was a child of God and the beloved, cherished wife of Adam, her other half. She was fulfilled, satisfied, and secure. Their goal was clear; in united partnership with one another and in perfect union with their Creator, they would multiply, rule, and subdue creation. God led them, provided for them, communed with them, and loved them. They honeymooned in paradise, in Eden, the garden of pleasure and delight. Eden summed up their pre-sin existence, until . . .

Lord God,

Thank you for creating me, for making us male and female. As I read of the perfection of the garden, of the unity, acceptance, and love they experienced, there is something inside me that longs for this. Lord, give me a vision for what you meant me to be. Give me a vision for what you meant marriage to be—and even more, what you meant relationship between you and me to be. Lord, redeem the broken places! Heal my fractured heart. Teach me how to walk in the glory, purpose, and identity of a woman created in your image who is completely loved by you!

In Jesus' name, Amen

DISCUSSION QUESTIONS

1. Adam and Eve were both created in God's image. How do men and women each uniquely reflect the image of God?

2. Eve was created in equal partnership with Adam as a helpmeet. Which aspects of being a helpmeet are inspiring to you? Which are challenging? Why?

3. Adam and Eve were totally united—naked and unashamed. What would it look and feel like to have a relationship with no fear of rejection?

3

TROUBLE
IN PARADISE

Adam and Eve's perfect existence didn't last long. With the creation of the tree of the knowledge of good and evil, coupled with God's command not to eat from it, God had provided mankind with a choice. For love to be love, it must be freely given. It cannot be coerced, forced, or mandated. The tree represented the freedom to love and obey God—or to reject and rebel. It wasn't long before an opportunity, a test of their love and trust, presented itself.

Now the Lord God had planted a garden in the east, in Eden; and there he put the man he had formed. The Lord God made all kinds of trees grow out of the ground—trees that were pleasing to the eye and good for food. In the middle of the garden were the tree of life and the tree of the knowledge of good and evil. . . .

The Lord God took the man and put him in the Garden of Eden to work it and take care of it. And the Lord God commanded the man, "You are free to eat from any tree in the garden; but you must not eat from the tree of the knowledge of good and evil, for when you eat from it you will certainly die." . . .

Now the serpent was more crafty than any of the wild animals the Lord God had made. He said to the woman, "Did God really say, 'You must not eat from any tree in the garden'?"

The woman said to the serpent, "We may eat fruit from the trees in the garden, but God did say, 'You must not eat fruit from the tree that is in the middle of the garden, and you must not touch it, or you will die.'"

*"You will not certainly die," the serpent said to the woman. "For God
knows that when you eat from it your eyes will be opened, and you will be
like God, knowing good and evil."*

*When the woman saw that the fruit of the tree was good for food and
pleasing to the eye, and also desirable for gaining wisdom, she took some and
ate it. She also gave some to her husband, who was with her, and he ate it.*

GENESIS 2:8–9, 15–17; 3:1–6

Adam and Eve were not the only beings in the garden. Of course, God was
there. But Satan, the fallen and banished former angel of heaven, also roamed
the earth. Defeated and cast out of heaven by God, powerless to attack God
directly, Satan hated God and sought revenge. The creation of mankind afforded
him an opportunity. If he could entice mankind to sin, to eat from the tree
of the knowledge of good and evil, then God's precious image bearers would
have to die. If he could tempt and trick the children of God to sin, God's own
words and law would condemn them to death. So Satan, the defeated enemy of
God, set out to turn God's children away from Him. He sought to capture their
hearts, lie about their Father's character and love—and destroy them in the
process.

AN "INNOCENT" QUESTION

Posed as a serpent, the Deceiver was casually hanging out near the tree of the
knowledge of good and evil. In Genesis 2:16–17, God had commanded Adam,
"You are free to eat from any tree in the garden; but you must not eat from the
tree of the knowledge of good and evil, for when you eat from it you will cer-
tainly die." Almost on cue, the man and woman strolled toward the murderous
Deceiver. He knew he would fail if he attacked God's love outright. He had to
be subtle. He could not tip his hand and arouse their suspicion that he was
the Enemy. He had to downplay the stakes, understate the obvious, just make
conversation.

In Genesis 3:1, with the supposed innocence of a curious bystander, he casu-
ally, off-handedly . . . seemingly randomly, asked the woman, "Did God really
say, 'You must not eat from any tree in the garden'?" He specifically addressed
the woman, knowing her helpful nature and hoping to exploit it.

Eve naively answered, "We may eat fruit from the trees in the garden, but God did say, 'You must not eat fruit from the tree that is in the middle of the garden, and you must not touch it, or you will die'" (Genesis 3:2–3).

Her answer must have delighted the Evil One. He saw his opportunity! Eve knew the command, yes; but she made two subtle but critical errors in her reasoning. First, she knew the location of the tree—yes, it was in the middle of the garden—but she failed to recall the name. By doing so, she disregarded the *character* of the tree. She knew the rule: Don't eat it; but in forgetting the name of the tree, she dismissed the *reason* for the rule. It was the tree of knowledge of good *and* evil, after all.

Secondly, she had added her own safeguards against violating the rule: "You must not touch it, or you will die" (v. 3). God had not said that. There was no punishment for touching the fruit. Her addition to God's command provided the Serpent with a strategy. All he had to do was get her to touch it and to see that she was still alive. After that, convincing her to eat it would be easy.

Eve's response reveals a simple but careless handling of God's words. We are vulnerable to being attacked and deceived when we don't accurately know God's Word—what it says and what it means. We can know the letter of the law, the rule—but miss the spirit of the law, the reason for the rule.

All God's laws are protective in nature. They all are for our protection and our blessing. They are perfect in their holiness and saturated with His love. Just as a loving parent warns against touching a hot stove—not to deprive but to protect—God's laws lovingly protect us.

> We are vulnerable to being attacked and deceived when we don't accurately know God's Word—what it says and what it means.

USING TRUTH TO LIE

Satan, the Master Deceiver, answers with four statements in Genesis 3:4–5: "You will not certainly die," and then, still directing his conversation to the woman, "For God knows that when you eat from it your eyes will be opened, and you will be like God, knowing good and evil."

The best liars use truth to lie. Satan, the Father of Lies, is the best of the best. Statement one: "You will not certainly die" (v. 4)—is it true, or false? On one hand it is true; she did not drop dead on the spot. On the other hand, it is false. Death entered into human existence, and she would eventually die. Spiritually she did

immediately die, and physically she *began* to die. It was a half-truth, true in one context but false in the other.

The second statement: "For God knows that when you eat from it your eyes will be opened" (v. 5). True or false? It's totally true. Genesis 3:7 tells it clearly: "Then the eyes of both of them were opened." True. True. True.

Statement number three: "and you will be like God" (v. 5). True or false? This is a bit of a trick question. In Genesis 3:22, God said, "The man has now become like one of us." This is true, but in only *one* aspect—the knowing of good and evil. Adam and Eve did not become at all like God in holiness, omniscience, mercy, love, purity, power, or wisdom. It's another partial truth—a lie with an element of truth mixed in, intended to confuse and mislead.

Finally, statement four: "knowing good and evil" (v. 5). Totally true again. So, we have two truths plus two half-truths, which equals one big, fat, lie! Sisters, be aware of how Satan deceives! He uses truth to lie! I like to explain this by using the illustration of my dog. She hated her heartworm medicine but loved peanut butter. She would never eat the medicine alone, but if you slathered enough peanut butter on it, she'd gulp that pill down—no problem!

We, like Eve, would not likely just believe a statement like this: *God is a liar. He hates you and is using you.* But . . . covered in layers of truth and half-truth, Eve swallowed it. She believed the lie and ate the forbidden fruit. Likewise, when Satan is lying to us about our worth, our value, our acceptance, he smears truth upon truth on top of the lie hidden inside.

One of the big lies I once believed was that God had abandoned me—and my family. My parents separated when I was in junior high. They reunited and separated again when I was in high school, eventually divorcing a few years later. I dearly loved my family, and my parents' marriage dissolving was devastating and traumatic for me. As I wrestled with my faith in God's love for me, the lie that God had abandoned me was planted in my heart and covered with the soil of truth. The Deceiver used truth to lie. *Well, you prayed, but your parents still divorced.* True. *Your dad moved out.* True. *This friend and that person left you.* True. *Therefore, God has left you too!* False—but I swallowed the lie. The idea that God had abandoned me was one of several lies I believed. God's truth and love would later heal me and deliver me from those lies.

DIVIDE AND CONQUER

Satan's tactics don't change. His goal is always the same, to attack our relationship with God by questioning what God tells us—"Did God really say . . . ?" (v. 1)—casting doubt on God's love and accusing God's character and motives. Eve *misunderstood* God's words, and therefore, *misapplied* God's words, setting herself up for deception and failure.

Deception always begins with Satan attacking our identity as precious children of God. In Eve's case, he successfully cast doubt on God's love for her. Then, no longer confident and secure in the goodness and faithfulness of God, she experienced an internal shift. Eve transferred her dependency, authority, and submission, from God to her own self. She withdrew her heart from God and placed her trust in her own understanding, reason, and rationale.

> Deception always begins with Satan attacking our identity as precious children of God.

Getting back to Genesis 3, "When the woman saw that the fruit of the tree was good for food and pleasing to the eye, and also desirable for gaining wisdom, she took some and ate it" (v. 6). Eve examined the fruit. It *looked* good (pleasing to the eye). It *appeared* good (for food). It *promised* good (gaining wisdom). So she took some . . . she tentatively reached out and touched it, half expecting to drop dead on the spot—but she didn't die! There appeared to be no immediate consequence . . . the Serpent was right! She was fine. Relieved and disarmed, without further thought or concern, she confidently took a bite. Crunch. Gulp. She ate it.

She thought she was eating fruit for gaining wisdom! But wisdom is not the same thing as the knowledge of good and evil. Wisdom is knowing how to avoid evil and guard against it.

I don't think either Adam or Eve could have imagined what the knowledge of evil even was. They couldn't fathom what they were trading for it. In exchange for their innocence and purity, life would be filled with savage brutality. Satan *never* tells the whole truth. Nor does he reveal the price of our distrust and disobedience. If he did, who would ever knowingly trade life and love for sin and death?

When Eve transferred her confidence from the Lord to herself, her *own* thoughts and feelings became her sacred trust. She relied on her own understanding and obeyed it. She ate. Then, "She also gave some to her husband, who was with her, and he ate it" (v. 6).

It's interesting to consider all the things that *didn't* happen in this critical moment. Eve didn't consult Adam. She didn't even acknowledge his existence in

the discussion or the decision-making process. There was no *What do you think, Adam? Is that correct? Do you think we should try it?* No, she made the decision completely independent of Adam—and God. In doing so, Eve jumped over and above Adam to assume the role of authority in their partnership, replacing God as the leader of her husband and herself.

Adam, however, was not an innocent victim in this fall from grace. He was there the whole time! Remember verse 6: "She also gave some to her husband, who was with her." He stood, watched, and listened. He said and did absolutely *nothing*. What was he thinking?! Why didn't he insert himself when she misquoted the command? *Honey, that's correct about the location of the tree, but don't forget what the tree is—the tree of the knowledge of good and evil.* When she reached out to touch, then eat the fruit, where was his hand pulling hers away, knocking the treacherous fruit out of her hand before it touched her lips? *Don't do it, Eve! I love you! I don't want to lose you!* Where was his exhortation to believe God? *Trust God! He would never lie to us! He is our Father! He is good! Trust Him!*

But Adam did . . . nothing. He said . . . nothing. His inaction seems to suggest his curiosity too. His willingness to let Eve eat first, as the proverbial guinea pig, reveals an intentional negligence. A physical and spiritual abandonment. And a profound exposure to harm. Eve didn't consult Adam, and Adam forsook providing and protecting her. Both of these happened before they even ate.

They listened to a third party other than God for direction. Not all counsel is equal! Not all voices are true! Not all arguments are solid. Be on your guard about whom you let speak into your life, your marriage, and your future. Measure every word against the Word of God. Reject any other counsel that contradicts God's Word or His love. Allow only one voice, the voice of God, to speak into who you are and what you should do.

> Be on your guard about whom you let speak into your life, your marriage, and your future. Measure every word against the Word of God.

Unfortunately, neither of them considered or consulted God. They both left God out of the equation altogether. Eve gave lordship to her own understanding. Adam gave lordship to Eve.

In a moment, their sweet union and perfect, unadulterated partnership was shattered. Togetherness, oneness, and equality were replaced by a woman's dominance and control—and a man's passive neglect. We often talk about male dominance (and that is sinful), but the original sin of breaking equality was Eve dominating and pacifying Adam. In this upset, Eve *jumped* over Adam, reducing him from her

partner to her follower. Eve usurped their union of mutual respect and leapt into the lead. On the other hand, while Adam didn't dominate Eve in that moment, he did expose her, pushing her out in front of himself and hiding behind her instead of protecting her. He risked her well-being for his own potential pleasure. It wasn't a relational shining moment for either of them.

"And he ate it" (v. 6). The universe shifted. Their innocence shattered. Heaven gasped. Satan laughed. Sin entered the world.

Lord Jesus,

I am aware of how easily I doubt you, your goodness, your faithfulness, and your love. I confess that my heart can entertain the subtle accusations of the Enemy against you, accusing your character, motives, and love. I know that I likely believe some lies about you. Please break the power and bondage of lies and deception in my heart and my mind. Lord, I confess that too often I rely on my emotions, opinions, and rationale instead of asking, receiving, and believing what *you* say. Lord, heal this in me. Help me not to bow down and obey my emotions but rather to hear you clearly and trust you wholeheartedly.

In Jesus' name, Amen

DISCUSSION QUESTIONS

1. Satan attacked and undermined God's words, His love, His character and His motives. Which areas does Satan usually attack to tempt you to doubt God?

2. In what areas are you tempted to rely on yourself rather than trust God? Is it your own power and strength? Your own wisdom? Your own control?

3. Are there areas you are tempted to dominate and control? If you're married, how good a partner are you for your husband? Where are you tempted to dominate or control? In what other relationships are you tempted to function with control?

4

PARADISE
LOST

One fateful bite. One forbidden fruit. One act of rebellion. Mankind forfeited their sinless, idyllic existence and unity with God. They exchanged their holy God for corrupted self. Self would rule relationships: self-centered, self-conscious, self-protective, self-serving, self-interested, self-absorbed, self-ISH!

> *Then the eyes of both of them were opened, and they realized they were naked; so they sewed fig leaves together and made coverings for themselves.*
>
> *Then the man and his wife heard the sound of the Lord God as he was walking in the garden in the cool of the day, and they hid from the Lord God among the trees of the garden. But the Lord God called to the man, "Where are you?"*
>
> *He answered, "I heard you in the garden, and I was afraid because I was naked; so I hid."*
>
> *And he said, "Who told you that you were naked? Have you eaten from the tree that I commanded you not to eat from?"*
>
> *The man said, "The woman you put here with me—she gave me some fruit from the tree, and I ate it."*
>
> *Then the Lord God said to the woman, "What is this you have done?"*
>
> *The woman said, "The serpent deceived me, and I ate."*
>
> *So the Lord God said to the serpent, "Because you have done this,*

> "Cursed are you above all livestock
> and all wild animals!
> You will crawl on your belly
> and you will eat dust
> all the days of your life.
> And I will put enmity
> between you and the woman,
> and between your offspring and hers;
> he will crush your head,
> and you will strike his heel."

To the woman he said,

> "I will make your pains in childbearing very severe;
> with painful labor you will give birth to children.
> Your desire will be for your husband,
> and he will rule over you."

To Adam he said, "Because you listened to your wife and ate fruit from the tree about which I commanded you, 'You must not eat from it,'

> "Cursed is the ground because of you;
> through painful toil you will eat food from it
> all the days of your life.
> It will produce thorns and thistles for you,
> and you will eat the plants of the field.
> By the sweat of your brow
> you will eat your food
> until you return to the ground,
> since from it you were taken;
> for dust you are
> and to dust you will return."

Adam named his wife Eve, because she would become the mother of all the living.

The LORD God made garments of skin for Adam and his wife and clothed them. And the LORD God said, "The man has now become like one of us, knowing good and evil. He must not be allowed to reach out his hand and

take also from the tree of life and eat, and live forever." So the LORD God banished him from the Garden of Eden to work the ground from which he had been taken. After he drove the man out, he placed on the east side of the Garden of Eden cherubim and a flaming sword flashing back and forth to guard the way to the tree of life.

GENESIS 3:7–24

With the reassuring words of the Serpent from Genesis 3:4 still ringing in their ears, "You will not certainly die," their eyes opened. Their perspective changed. The peaceful, beautiful world they once enjoyed altered as the lens of sin skewed their view. Eyes that previously saw only purity and wonder were clouded over with fear and shame.

Bewildered and afraid, Eve looked at Adam, just as Adam looked at her. A wave of insecurity crashed over them simultaneously. They were exposed! They were naked! And suddenly, they were excruciatingly uncomfortable and vulnerable. Without pausing to analyze the shift, panicking, they scrambled to find a way to cover up. Large leaves would have to do for the moment.

Invisibly but palpably, Adam retreated from Eve. He didn't want to see her, and he didn't want her to see him. A piercing, sharp wedge severed the unity they'd shared, leaving them as two halves sliced apart with their inner sides exposed. Their comfortable, confident trust was immediately replaced by suspicious, tentative hiding. A new sensation flooded over both of them: fear.

YOU CAN RUN, BUT YOU CAN'T HIDE

Dismayed, they heard the Lord God approaching in the garden. Normally they would have joyfully run to greet Him. But with fear pulsating through their veins, they hid—desperately hoping the Lord would not see them. The Lord called out to Adam, "Where are you?" (Genesis 3:9). Of course, God being God, He knew exactly where they were and what they had done. But the question wasn't for God's sake, it was for theirs.

Discovered. Called out. With nowhere to run and hide, Adam answered, "I heard you in the garden, and I was afraid because I was naked; so I hid" (v. 10). Honest, in part. "Who told you that you were naked?" God questioned. "Have you eaten from the tree that I commanded you not to eat from?" (v. 11). And just

like that, like an arrow hitting the bull's-eye, the Lord's question pierced through the cloak of fear and the ploy of hiding—and hit the heart of the matter. *Have you done what I commanded you not to do? Have you disobeyed me? Have you rebelled and taken the one thing I warned you not to take? Son, have you forsaken me?*

SHAME AND BLAME

The truth of their treachery against their Maker stared them straight in the face. Sin's roots of pride and shame sprang forth in a burst of blame and accusation. To Eve's astonishment and horror, Adam stepped away from her, turning on her with the desperation of a cornered animal. It was as if he pointed a long, accusing finger at her and another accusing finger at God, protesting violently, "The woman you put here with me—she gave me some fruit from the tree, and I ate it" (v. 12). Adam apparently looked at her not as bone of his bones, flesh of his flesh, but as a treacherous and despised traitor. He placed blame on God for making the cursed woman in the first place and telling him to trust her! He claimed it was *the woman's* fault he had even considered eating the fruit in the first place. Without *her*, he would not have sinned! Without *her*, all would be well. Without *her* . . . Adam was willing to sever himself completely and totally from Eve to save himself.

I cannot imagine the shock of abandonment in that moment. If you have ever experienced betrayal, abandonment, or rejection, you have tasted a *drop* of the pain that pierced Eve's heart. She went from *perfect* unity and intimacy to *total* betrayal and condemnation—before God himself—by the person who was supposed to love and protect her. As her heart shattered and her security evaporated, she frantically grasped for her own excuse. "What is this you have done?" (v. 13). God asked sincerely and directly. I imagine that Eve, still reeling from Adam's accusation, pointed her own finger at the Serpent. "The serpent deceived me, and I ate" (v. 13).

WHEN IDOLS FAIL

To make their decision to eat the forbidden fruit, both Adam and Eve relied on and gave authority to something other than God. Whatever we turn to for our value and identity, our security and authority, apart from God, is an idol. *Idolatry* is when you make something or someone else your god—instead of the real God.

For Eve, she made her own logic and understanding into her god. And it failed her. She was deceived. For Adam, he made Eve his authority, looking to

her instead of God for his direction. And she failed him. Both chose to follow something or someone other than God; and when it failed, they blamed the very thing they'd idolized. Rather than repenting of their own idolatry, they just blamed their broken idols.

> Whatever we turn to for our value and identity, our security and authority, apart from God, is an idol.

THE BLAME GAME

God was not moved by their blame shifting, and He wasn't duped by their excuses. In response to Adam's blaming, God did not say, *Oh, I see. Now I understand. You're right. It's all the woman's fault. And really, I take responsibility for this whole mess—for making both you and her in the first place.* Nor, in response to Eve's, *Poor me, I was tricked* excuse, did God say, *Yes, you're right. Serpents can be so tricky these days. How were you to know whom to listen to or whom to trust? It's okay.*

God held both players in the drama responsible for *their own* actions and choices. Then God announced the consequences of each one's sin. The Serpent is cursed to slither on the ground, perhaps removing some form of arms, legs, or wings. Additionally, God placed enmity between the Serpent and the woman, prophesying that her offspring would strike his head and he would strike His heel.

There is a unique hatred that the Serpent, Satan, has for women—and a unique threat that women pose for Satan. If and when a woman learns of and stands up in her identity as a child of God, she is a hated threat to the kingdom of darkness. Because of this, Satan still targets women today, to oppress, steal, kill, and destroy them and the image of God that they bear.

EVE'S CURSE: PERPETUAL THIRST

For Eve's sin, God explained, "I will make your pains in childbearing very severe; with painful labor you will give birth to children. Your desire will be for your husband, and he will rule over you" (Genesis 3:16). Sin brought a curse to both Adam and Eve. Of course, there are two sides to every story. There is Eve's, and there is Adam's. For our purposes, we'll focus on Eve, on women, and on what our role and our redemption look like. This doesn't excuse Adam or exalt or diminish him; it just means we'll save *Redeeming Adam* for another book.

As a result of Eve's sin, of usurping partnership and jumping over Adam to assume control, there would be a consequence in the intimacy and trust of their relationship. Eve would *desire* her husband. At first glance, that doesn't sound like

a bad thing, certainly not a curse! Why shouldn't a woman desire her husband? However, when you look at the root word, it sheds some light on the meaning. According to Strong's H8669, the Hebrew word for *desire* in this context means to "wish for, hope for, an intense longing, craving, as in 'a beast to devour.'"[9] It didn't seem too bad until the beast part!

This longing, this deep wish, implies it is an *unfulfilled* wish. A deferred hope. An insatiable craving. A longing that is never quite satisfied. A perpetual thirst for love. Note that it doesn't say she will long *for* a husband, as in a single woman longing to have a husband. Rather, this longing will be for *her* husband, the man she is already married to. What does it mean, then, that she would wish for, long for, desire, the husband she already has? What, then, is she wishing and longing *for*?

CONSUMING HUNGER

The answer is the essence of the curse. The consequence of sin affects her intimacy with man. Eve was given a sacred influence in Adam's life, a sacred trust. That trust was violated when she jumped over him and assumed the lead. The curse altered her influence with Adam. Thereafter she would long for that lost trust and yearn for the deep connection and intimacy with Adam for which she was created. Essentially, Eve—and all women after her—will long for more closeness, oneness, and relationship with their husbands than they will likely receive.

In this void of intimacy, a deep yearning, a *thirst* for love, created a need-based dynamic in Eve's heart. It skewed the balance of emotional equality in the relationship between man and woman. Eve's need for love gave Adam leverage to rule over her. His love or rejection, his devotion or disregard, his approval or criticism, would rule her life.

According to Strong's H4910, the Hebrew word for *rule* here means to "have dominion . . . to exercise dominion" over.[10] Keep in mind that this rule described the curse. A husband's *rule* was not prescriptive, nor was it God's design or intention for relationship between a man and a woman. Rather, this *curse-induced* rule expresses and exposes the *result of sin* in the dynamics of male-female relating.

> As a result of sin, mankind's identity would be rooted in pride and shame, selfishness, and insecurity.

"He will rule over you" (Genesis 3:16). As a result of sin, mankind's identity would be rooted in pride and shame, selfishness and insecurity. This fallen nature would wreak havoc on the intimacy between a man and a woman, driving

husbands to rule over their wives and driving wives to desire their husbands in perpetual discontent.

Women's capacity for intimate relationship is one of their greatest and most beautiful strengths. But corrupted by sin, and targeted toward fallen men, a woman's drive for intimacy can morph from a mutually giving and receiving relationship into a consuming hunger—a desire that always demands more relationship than is given. Never satisfied, it devours relational bites like a ravenous beast. This hunger can also manifest in being willing to tolerate almost anything, including abuse, for a morsel of love. This dissatisfaction, this lack, is part of the curse and the consequence of sin. It is what God desires to redeem, heal, and restore in every woman.

I have taught and conversed with women all over the world on this subject. It doesn't matter their culture, economic status, or religion. When I ask them if they are consistently content with the emotional and spiritual intimacy in their marriages, they either laugh knowingly . . . or they cry. When I share this definition—that women will always wish for more relationship than they have, even struggle with discontentment at times—the huge majority nod in sisterly agreement.

NEED AND GREED

This new cycle of need and fear, power and withholding, created new relational goals for men and women. They would be motivated by self-protection, avoiding shame and exposure, and a fundamental commitment to *I* instead of *we*. "Self" became god, and selfishness would rule relationships. No longer *one*, but two opposite, opposing, selfish people in relationship.

Competition and control replaced completion and oneness. Being naked and unashamed evaporated in the intensity of guilt and shame. Adam withdrew from Eve and hid from God. Need and greed replaced intimacy. It was still not good for man to be alone. Driven by fear and self-protection, fallen men may respond by ruling and dominating women instead of nourishing and trusting them.

Eve's desire produced a goal to quench her thirst for love and intimacy from relationship with Adam, reducing him and his love into something to consume. To the extent that we need someone, we cannot love that person. To the extent that we need someone, we *use* that person to meet our own needs. The most devastating result of sin between Adam and Eve was that they would *use* and *consume* one another instead of *love, nourish,* and *help* one another.

THE CURSE PLAYS OUT

A profound result of sin was that sin not only entered individuals, but entered every relationship, including families. This explains why there is no perfect family—because there are no perfect people.

Obviously, Eve's labor and child birthing was painful, but the pain wouldn't stop there. In fact, Strong's word H3205 includes "bring up" in the definition that refers largely to birthing.[11] Women, created to bear, nurture, and raise children, would experience the heartache and toil of children born with and living with inherent sin.

It didn't take long for the curse of sin to show itself in the first family. Driven by rebellion and jealousy, Eve's elder son Cain killed her younger son, Abel. Then Cain was driven away by God (Genesis 4). Mothering children in a fallen world was indeed excruciatingly painful for Eve, as she lost both sons to Cain's sin.

DAUGHTERS OF EVE: TARGETS OF ENMITY

"And I will put enmity between you [the Serpent Satan] and the woman, and between your offspring and hers; he [Jesus] will crush your head, and you will strike his heel" (Genesis 3:15).

What began in the garden as the curse between the Serpent and the woman continues to grow insidiously and entangle women today. Satan "The Great Serpent" has a unique hatred and dread for the daughters of Eve.

Women in every culture, in every century, and in every economic station wrestle with some level of discrimination, victimization, or oppression. Some worldviews actively denounce a women's equal value and legitimize oppression. Others celebrate a consumer culture, objectifying women as sexual objects to exploit. More subtly, many sub-cultures foster attitudes that ignore, belittle, or dismiss a woman's contribution. In all, women fight to be seen, heard, and valued as equal to men.

On a relational level, women often contend with families, marriages, and even ministries that express subtly or outright that the boys are more important and more worthy of investment, while the girls are *nice* but somehow *less*. This is *not* God's design, nor His heart! Beautiful and inspiring is the family where women are treated with honor, where they are esteemed as equally valuable to the men, lovingly protected and highly cherished.

Attitudes that disrespect, disregard, devalue, or objectify women are rooted in demonic enmity. According to Strong's H342, the Hebrew word for *enmity* also

means "hatred."[12] Webster's further defines *enmity* as "a state of opposition; hostility . . . a state of deep-seated ill-will."[13] Webster's goes on to define *hatred* as "a feeling of dislike so strong that it demands action."[14] It is a focused animosity, hostility, and malice. It is with this venomous hate that Satan seeks to devour women.

Satan, who exists to "steal and kill and destroy" (John 10:10), attacks a woman in a systematic, targeted, and intentional way. He strategically forges weapons to cause emotional distress intended to wound and disable her spirit. He aspires to reduce a woman's perceived value and diminish her influence. He labors to undermine her confidence. He schemes to sabotage her identity and neutralize her godly, image-bearing nature. At its worst, in its profound disregard for a woman's value, enmity will manifest to physically abuse, objectify, and sexually exploit a woman.

Satan has a purpose in this targeted hate. He has an objective. If he can ruin and devastate Eve, he can cripple and neutralize her influence. His ultimate goal is to obliterate and stamp out the image of God's nature she bears and could reveal to the world. What is the root of this hatred and dread? Why are women such a threat to Satan?

MOTHER OF ALL THE LIVING

"Adam named his wife Eve, because she would become the mother of all the living" (Genesis 3:20). *Eve* was more than just a name. It was an assignment, a call, and a commission. Naming held great weight. Names represented natures. They set expectations, defined responsibilities, and established authority. In the order of creation, when Adam "named his wife Eve," he was installing and esteeming her as "the mother of all the living" (v. 20).

The name *Eve* literally means *life giver*. It's this inherent power to bring forth life that Satan most viciously opposes in women. In the very definition of *mother*, the daughters of Eve carry the power to nurture things to life. A woman can nurture a person, a cause, or a family. Likewise, she can nurture fear, resentment, or offense. Whatever a woman nurtures realtionally will grow, so be careful what you sow. Eve, as mother of the living, was meant to be a conduit, an emotional and spiritual watering can of life-giving resources from God to mankind. One of the Hebrew definitions for *living*, Strong's H2416, is "flowing, fresh when describing water . . . opposed to that which is stagnant and putrescent, which is called . . . dead water."[15] Her truest nature as mother of the living would have life-flowing waters running through her.

In war, a key strategy to defeat the opponent is to cut off their supply of food and provisions. No army can fight effectively or indefinitely without replenishment. If Satan can deeply hurt and wound a woman, her emotions become stunted and shut down. When this happens, he has effectively blocked the flow of life-giving emotional strength, wisdom, and provision flowing through her. Cutting off the flow of life through her weakens all those around her. Therefore, destroying women emotionally is one of his greatest tactics of war against mankind.

I am a woman who grew up in the wake of the sexual revolution, legalized abortion, and a generation of rampant divorce and single parenting. I'm profoundly aware of biases both in me and around me that dismiss the value of our *mother nature* as women. On the surface, traditional roles of literal motherhood are mocked in some circles, viewed as a role of subjugation that underutilizes or even *wastes* a woman's gifts and talents. Worse, motherhood is touted as a necessary evil or something to be avoided at all costs.

This profound attack, which dismisses motherhood, results in despising children. Demonically fueled, this belittling and undermining of Eve as mother of all the living seeks to transform Eve from a bearer and protector of life into an enemy of life, even to the lives of her own children. Satan has lied to us, claiming that children are *not* a gift, but a burden. Make no mistake, Satan hates *life*. He hates women and despises children. He plots and schemes to see lives, peoples, and cultures eliminated and destroyed.

When women root their identities in God's love and in their value to Him, their influence is released in life-loving, transforming power, fostering health and healing in their relationships.

The battle between the Serpent and the daughters of Eve has raged on since the garden to present day. Satan attacks women at the core of their identities. His goal is to halt, hinder, or hijack their influence and destroy their intimacy. And while our Enemy is crafty, he's not undefeated. When women root their identities in God's love and in their value to Him, their influence is released in life-loving, transforming power, fostering health and healing in their relationships.

At her core, Eve's nurture-nature was created to literally shout, *Hail life!* Her influence was pointing to the Lord God for life! She would nurture exuberant vitality. People and things would literally burst into life around her and *because of* God's life and love flowing through her. A confident and healthy, generous and gracious woman can invade a life or a situation to revive, replenish, and restore it!

REDEMPTION FORETOLD

Sin has caused us so much pain. Because God loves us, He hates sin. Love protects. God desires to protect us from the pain sin causes. He longs to redeem us, our relationships, and our families from the destruction of sin. Thankfully, sin and pain are not the end of our story.

"The LORD God made garments of skin for Adam and his wife and clothed them" (Genesis 3:21).

God showed His mercy and care for His beloved children, Adam and Eve. Before He removed them from the Garden, He made provision to cover their sin. He killed an animal. The first death, the first sacrifice for sin, to make garments *of skin* for Adam and Eve. God himself fashioned their clothing and *covered* their nakedness as a sign of His promise to totally cover their sin with Jesus and *reverse the curse.*

Let's turn now to watch as this battle for the heart and soul of a woman and her glorious, life-bringing influence unfolds in the lives of seven more women of the Bible. My prayer is that you will, as I have, see yourself in the women's stories lived out in these pages. As we face our strengths and weaknesses, our brokenness and our potential, our disappointments and our dreams, may hope burst forth in your heart. May we embrace God's love, redeeming the Eve in all of us.

Lord Jesus,

I see the devastation of sin all around me: in my heart, in my family, and in our world. I see the division, distrust, and lack of authentic love in so many relationships. And if I am being honest, I often respond with my own walls of self-protection. I've also felt the attacks of the Enemy against my heart, knocking me down and attacking my value. Lord, please come and heal! Redeem me! Restore me to the strength and glory for which you created me! Reverse the curse in me, in my family, in my relationships, and in my world. You are mighty, Lord Jesus! I trust your redeeming love!

In Jesus' name, Amen

DISCUSSION QUESTIONS

1. Eve's desire was corrupted. The curse said she would desire more relationship with Adam than she would receive, that this relational discontent would rule her life. How have you seen the curse at work in your relationships?

2. How has your desire for intimate relationship with a man become unbalanced and negatively affected your life or hurt your relationships?

3. What would healthy desire for relationship look like for you?

Notes

Daughters of Eve

5

LEAH AND RACHEL: LACK AND LABELS

The tale of two sisters is a tragic story of rivalry, comparison, competition, and perpetual discontent. From the deceptive beginnings of a stolen marriage, two sisters entered a lifelong struggle for value, identity, and the love of the man they both called *husband*. Childbearing became their battlefield. Roots of rivalry were born. Striving stole their joy. Resentment replaced gratitude. Ultimately, their rivalry was perpetuated into the next generation, as their children were tools in their triangular tug of war.

> *Now Laban had two daughters; the name of the older was Leah, and the name of the younger was Rachel. Leah had weak eyes, but Rachel had a lovely figure and was beautiful. Jacob was in love with Rachel and said, "I'll work for you seven years in return for your younger daughter Rachel."*
>
> *Laban said, "It's better that I give her to you than to some other man. Stay here with me." So Jacob served seven years to get Rachel, but they seemed like only a few days to him because of his love for her.*
>
> *Then Jacob said to Laban, "Give me my wife. My time is completed, and I want to make love to her."*
>
> *So Laban brought together all the people of the place and gave a feast. But when evening came, he took his daughter Leah and brought her to Jacob, and Jacob made love to her. And Laban gave his servant Zilpah to his daughter as her attendant.*

When morning came, there was Leah! So Jacob said to Laban, "What is this you have done to me? I served you for Rachel, didn't I? Why have you deceived me?"

Laban replied, "It is not our custom here to give the younger daughter in marriage before the older one. Finish this daughter's bridal week; then we will give you the younger one also, in return for another seven years of work."

And Jacob did so. He finished the week with Leah, and then Laban gave him his daughter Rachel to be his wife. Laban gave his servant Bilhah to his daughter Rachel as her attendant. Jacob made love to Rachel also, and his love for Rachel was greater than his love for Leah. And he worked for Laban another seven years.

When the LORD saw that Leah was not loved, he enabled her to conceive, but Rachel remained childless. Leah became pregnant and gave birth to a son. She named him Reuben, for she said, "It is because the LORD has seen my misery. Surely my husband will love me now."

She conceived again, and when she gave birth to a son she said, "Because the LORD heard that I am not loved, he gave me this one too." So she named him Simeon.

Again she conceived, and when she gave birth to a son she said, "Now at last my husband will become attached to me, because I have borne him three sons." So he was named Levi.

She conceived again, and when she gave birth to a son she said, "This time I will praise the LORD." So she named him Judah. Then she stopped having children.

When Rachel saw that she was not bearing Jacob any children, she became jealous of her sister. So she said to Jacob, "Give me children, or I'll die!"

Jacob became angry with her and said, "Am I in the place of God, who has kept you from having children?"

Then she said, "Here is Bilhah, my servant. Sleep with her so that she can bear children for me and I too can build a family through her."

So she gave him her servant Bilhah as a wife. Jacob slept with her, and she became pregnant and bore him a son. Then Rachel said, "God has vindicated me; he has listened to my plea and given me a son." Because of this she named him Dan.

Rachel's servant Bilhah conceived again and bore Jacob a second son. Then Rachel said, "I have had a great struggle with my sister, and I have won." So she named him Naphtali.

When Leah saw that she had stopped having children, she took her servant Zilpah and gave her to Jacob as a wife. Leah's servant Zilpah bore Jacob a son. Then Leah said, "What good fortune!" So she named him Gad.

Leah's servant Zilpah bore Jacob a second son. Then Leah said, "How happy I am! The women will call me happy." So she named him Asher.

During wheat harvest, Reuben went out into the fields and found some mandrake plants, which he brought to his mother Leah. Rachel said to Leah, "Please give me some of your son's mandrakes."

But she said to her, "Wasn't it enough that you took away my husband? Will you take my son's mandrakes too?"

"Very well," Rachel said, "he can sleep with you tonight in return for your son's mandrakes."

So when Jacob came in from the fields that evening, Leah went out to meet him. "You must sleep with me," she said. "I have hired you with my son's mandrakes." So he slept with her that night.

God listened to Leah, and she became pregnant and bore Jacob a fifth son. Then Leah said, "God has rewarded me for giving my servant to my husband." So she named him Issachar.

Leah conceived again and bore Jacob a sixth son. Then Leah said, "God has presented me with a precious gift. This time my husband will treat me with honor, because I have borne him six sons." So she named him Zebulun.

Some time later she gave birth to a daughter and named her Dinah.

Then God remembered Rachel; he listened to her and enabled her to conceive. She became pregnant and gave birth to a son and said, "God has taken away my disgrace." She named him Joseph, and said, "May the LORD add to me another son."

GENESIS 29:16–30:24

Later, on the journey to Jacob's homeland when Rachel was pregnant with her second son,

Rachel began to give birth and had great difficulty. And as she was having great difficulty in childbirth, the midwife said to her, "Don't despair, for you

have another son." As she breathed her last—for she was dying—she named
her son Ben-Oni [son of my sorrow or trouble]. But his father named him
Benjamin [son of my right hand].

<div align="center">GENESIS 35:16–18, AMPLIFIED BY THE AUTHOR</div>

Rivalry is not new, nor is it limited to these two sisters long ago. The temptation
to compare and compete, especially in women, is intense. Comparison wreaks
havoc on our identity and assaults our sense of security and value. Nothing steals
joy and destroys contentment faster than comparison.

LEAH

LIVING FROM LABELS

Leah. The older, unmarried daughter with "weak eyes" (Genesis 29:17). Weak eyes
could have been a physical defect. She may have been partially blind, had a lazy
eye, or simply had a face that was "weak" on the eyes. In any case, Leah was not the
beauty of the family.

> Comparison wreaks havoc on our
> identity and assaults our sense of
> security and value. Nothing steals
> joy and destroys contentment faster
> than comparison.

By contrast, the younger Rachel "had a
lovely figure and was beautiful" (v. 17). Leah
grew up being outshone by her younger
sister. Labels are powerful in forming iden-
tity. If we aren't careful, we can attach our worth and our identity to the labels that
others give us. We can spend our lives trying to live up to our labels, disprove our
labels, or maintain our labels. Is there a label you wear that defines your worth,
beauty, or identity?

LIVING FROM LACK

Leah went from being the unattractive, unmarried sister to being the unwanted
and unloved wife of her sister's husband. At her core, she based her adult identity
on what she *was not*; she *was not* loved. As we will see, this state of being unloved
by her husband ruled her life, drove every decision, and clouded every blessing.

Is there something you are *not* that plagues your contentment? Perhaps you
are not married, or not athletic. Not thin enough or curvy enough. Not rich or

not educated. What are the things you think you are *supposed* to be that accuse you of being *not*?

When we focus on what we are not, discontentment spreads like an out-of-control weed choking out joy, strangling our gratitude, and overrunning our confidence. Left unchecked and unresolved, basing our identities on what we are *not* creates an obsession for our motives and goals. Our goal will be to get that thing which we believe we are not.

DREAMING AND SCHEMING

In Leah's case, her life goal was to *get love*. Not just any love, but specifically, Jacob's love. She was willing to do whatever it took to get the love she so desperately desired. With no man pursuing her, she resorted to participating in an elaborate plan to *steal* the love that belonged to someone else. In this case, to steal her sister's husband-to-be.

Imagine the scene: It's her sister's wedding day. The guests are arriving. The place is decorated. The ceremony proceeds. Jacob pronounces his love for Rachel. We don't know for sure if Leah's charade of being Rachel started in the ceremony under cover of a veil or if her father swapped her with Rachel before entering the bridal chamber. What we do know is that Jacob clearly believed he was marrying Rachel. Leah is not a victim in this. True, she may have been emotionally manipulated and persuaded by her father, but she still had a choice and a voice in the intimate moments with Jacob.

There is no moment of reveal in the bridal chamber before Jacob makes love to her. As Jacob eagerly approaches his bride, she does not pause and whisper, *Jacob, before we do this, there is something you must know. I don't want to deceive you. I am not Rachel.* There is no concern for the hurt to Rachel or Jacob. Perhaps there is just an irrational hope that, just maybe, if she gets Jacob into bed, he will bond to her instead and divert his love from Rachel to her.

Somewhere in Leah's heart, she must have come to accept and believe that this was her best bet—or only option—to find love. Sometime, before the wedding night, Leah must have given up on the dream of being pursued for who she was, of being wanted as herself and loved as Leah. This belief led her to willingly compromise her integrity and self-respect and to sexually manipulate a man, trying to steal his love from someone else.

Unfortunately, Leah's father reinforced—and maybe even instilled—this belief. It was her own father, after all, who somehow convinced her that this was what

she must do. The Bible doesn't reveal what Laban said to convince Leah to go along with the deception. We only know that, whatever he said, it worked. It was enough to motivate Leah to covet, deceive, and steal her sister's wedding night. Whatever his rationale, by encouraging his daughter to have sexual intimacy under false pretenses, to deceive and steal the love meant for someone else, her own father demeaned her beauty, belittled her worth, and diminished her value.

A father has such a powerful voice in the life of his daughter—for good or for evil. If your value was dismissed, disregarded, or destroyed by the lack of affirmation from your earthly father, know that his opinion of you is not the final or true judgment of your value as a woman. God, *the Father*, who hand-crafted every aspect of you, deeply loves you. He passionately treasures you. He enthusiastically upholds you as *His* one-of-a-kind, beautiful, amazing daughter.

RULED BY REJECTION

Sisters, we must not let the lack of love or the pride and arrogance of other people curse our value or rule our lives. Other people, no matter who they are, do not determine our value! What is true about you is what *God* says about you. His voice speaks over and nullifies all other voices. His opinion and judgment are the *final* judgment. And *He* pronounces us *loved*!

As we see in Leah's case, this intense desire for love, for an intimate relationship with a man, can result in a woman's unrelenting pursuit of a man, even a man who doesn't love her or want her. When a woman does the pursuing, a foundation of emotional apathy, irresponsibility, and even neglect can be established on the man's part. She likely will continue being the one pursuing, trying, and leading relationally. Don't rob yourself. Don't settle for someone you have to try to persuade to love you.

> Other people, no matter who they are, do not determine our value! What is true about you is what *God* says about you.

At its darkest, this desire for relationship can cause some women to do almost anything, to endure almost anything, in a desperate grasping at some scrap of love. My dear friend, you are worth more than that. You are not a beggar. You are loved and cherished by the God who created and designed you. You are His precious daughter, His precious jewel, and His beloved bride. Let His love secure your heart and your worth.

Living from our labels and faulty identity always leads to deficiency and compromise. Of course, stealing love doesn't work. Rather than endearing Leah

to Jacob, the ruse shocked and angered him. He had been deceived by Laban and Leah, leaving him justified to resent or even reject her.

Through scheming and entrapment, Leah found herself married to a man who didn't love her. She resorted to a new course of action to get love. This time she set out to *earn* love, to perform well enough to *make* Jacob love her. In a society that highly esteemed the birth of sons, Leah excelled. In the culture of the time, naming children revealed their purpose, calling, and intent.

Leah had her first son, naming him Reuben, meaning *behold a son*. Stating, "It is because the LORD has seen my misery. Surely my husband will love me now" (Genesis 29:32). She had a second son, naming him Simeon, meaning *God listens*, saying, "Because the LORD heard that I am not loved, he gave me this one too" (v. 33). Leah tried again with a third son, Levi, which means *attached*, pronouncing, "Now at last my husband will become attached to me, because I have borne him three sons" (v. 34). The hoped-for love and attachment from Jacob still eluded her, despite the birth of sons.

FREEDOM FOUND

Leah had a fourth son and named him Judah, meaning *praise*. She declared, "'This time I will praise the LORD.' Then she stopped having children" (v. 35). With son number four, Leah experienced freedom from the spirit of competition with her sister and freedom from striving for her husband's affection. Judah's birth represented a season of freedom for Leah, a season of contentment and rest. This time, she received her son with gratitude as a blessing from God, and she praised the Lord.

Leah lived from the label *not loved*. True, she was not loved by Jacob. She may not have been loved by her sister, and arguably was not loved well by her father. But she was *never* unloved by God. Despite her mistakes and deception, God, in His compassion, was still caring for Leah and blessing her with children. Freedom for Leah came in turning toward the God who did love her, completely and unfailingly. Freedom for you and me can come only when we turn away from others as our source—and turn instead to God, letting His love fill us.

If only she had held on to the truth she understood when Judah was born, she might have resisted being re-ensnared in rivalry with her sister. Leah's season of freedom with Judah is a good reminder to us that, when we are set free, we have to guard our freedom! When we rise above a mindset that has plagued us, we have to guard our hearts and minds from sinking back into those pits.

A verse from the book of Romans sums this up perfectly: "Do not conform to the pattern of this world [a pattern of negative thinking and untruth], but be transformed [changed, set free] by the renewing of your mind [guarding your mind, focusing on what is true about you according to *God*]. Then you will be able to test and approve [recognize and know] what God's will is—his good, pleasing and perfect will [see your life from God's perspective, His love for you and His truth]" (Romans 12:2, amplified by the author).

FREEDOM FORFEITED

All this time Leah's sister, Rachel, was childless. In a common practice of the day, Rachel, desperate for children herself, gave her maidservant, Bilhah, to Jacob, hoping she would bear children for her. Rachel's servant bore two sons. Rachel's attitude was competitive and provoking in naming the children from her surrogate. Rachel's first surrogate-born son she named Dan and said, "God has vindicated me; he has listened to my plea and given me a son" (Genesis 30:6). Rachel ratcheted up the competitive atmosphere with the second surrogate-born son, naming him Naphtali or *my struggle*, announcing at his birth, "I have had a great struggle with my sister, and I have won" (v. 8).

Leah, who had found a moment of rest and gratitude in Judah, took the rivalry bait and engaged her maidservant, Zilpah, in the baby race. She matched her sister's two surrogate-born sons with two of her own, triumphantly announcing with baby Gad, "What good fortune!" (v. 11), and with Asher, "How happy I am! The women will call me happy" (v. 13).

At some point Leah resigned herself to the fact that she would never have Jacob's heart. At this point she demanded her rights as a wife. One day, her oldest son found the highly coveted mandrake plants, which were believed to make a woman more fertile and help her to conceive. Rachel, desperate for children of her own, begged for the prolific plant. Seizing the opportunity, Leah negotiated for a night with Jacob, literally *buying* him from Rachel with the plants. When Jacob arrived from the field, Leah informed him, "You must sleep with me [tonight]. I have hired you with my son's mandrakes" (v. 16). In her quest to *get love*, Leah gave up longing for love and was willing to settle for buying and demanding the benefits and duties of love.

Wherever we place our identity, our goal will be to *get* that thing for identity. In Leah's case, her goal was to *get Jacob's love*. Her life question could be summarized, *What must I do to make you love me?* When she was seeking his love

as the source of her identity, she forfeited her personal power to live well for the love or rejection of a single person. She gave Jacob the power to determine her worth and well-being. Her entire identity rested on the whims and responses of one fallible, human, and conflicted man. She embodied the curse, "Your desire will be for your husband, and he will rule over you" (Genesis 3:16). Jacob's lack of love ruled her life.

Is there someone whose approval or rejection you value too much? Have you given that person the power to determine your value, your self-esteem, or contentment? Does your joy or peace ride on the response or opinion of another person? A spouse, parent, child, friend, boss, co-worker, or leader? If so, you are giving that person the power to decide your identity, your worth, and even your destiny.

APPLES AND ORANGES

In my own life, I experienced intense comparison and rejection from a woman whose approval and acceptance I'd sincerely hoped for. Over and over, I heard feedback of this person's criticism and disapproval. The criticism was not about actual bad behavior or something I had done morally wrong, in which case I could and should have changed and made it right. Rather, it was based on comparison—and not being enough like her or her ideal of what a woman should be.

As I thought and prayed about this, God's Spirit rose up in me, and a picture of truth set me free. I thought about the example of apples and oranges. They are both fruit, but very different. If you bite into an orange—even the most delicious orange—but are expecting an apple, you'll be disappointed.

Comparison with other women is always like that—comparing apples to oranges. In this case, I saw that we were both women, but made very differently. She was an apple; I was an orange. And I was an amazing orange! It was deceptive and damaging to my identity and value to be compared to an apple. This illustration opened my eyes to the nature of the rejection I was experiencing. It set me free from coming under that person's opinion or giving her authority to speak into my identity. I refused to receive and live under the labels of what I was *not*.

IT'S NOT MY FAULT

What if Leah had made a similar choice and refused to spend her life seeking love from Jacob? I can't help but wonder what might have happened if Leah had owned up to her deception, apologized, and released Jacob to love Rachel? What if she had allowed herself to be convicted and humbled when she saw that Jacob didn't

love her? She could have gone to him in truth and repentance, acknowledging her personal responsibility in the deception.

Imagine Leah saying, *Jacob, I owe you and Rachel a huge apology. There are no words to express my sorrow at stealing your wedding night from you, tricking you into marrying me, and hijacking your relationship with my sister. I cannot undo what has been done. But I can ask you to forgive me. I release you from any further obligation to me. I bless you and my sister and your marriage.* Perhaps, with such a humble confession and release, Jacob would have grown to love her—or at least begin to trust her.

But that didn't happen. At the point of the mandrake negotiations, and eight children into the baby race, Leah still held to her illegitimate claim as Jacob's first wife and accused Rachel, "Wasn't it enough that you took away my husband? Will you take my son's mandrakes too?" (Genesis 30:15). What?! *Who* stole *whose* husband?!

> When we adopt a victim mentality, we don't see our situation, our contribution, or our responsibility clearly or truthfully.

When we live under a faulty identity long enough, our perspective on reality becomes warped and skewed to justify the compromises we make along the way. When we adopt a victim mentality, we don't see our situation, our contribution, or our responsibility clearly or truthfully.

RELATIONAL RUIN

The damage of competition and rivalry to our relationships and intimacy is profound. Instead of honoring and respecting Jacob as a man, Leah saw him as something to consume and possess. As such, she was willing to deceive and use him to meet her need for identity.

A woman will never win a man's heart and affections through manipulation, demand, and control. Nor is seduction and sexual entrapment a guarantee of love. Both these methods reveal a profound disregard for a man's heart and a disrespect of his sexuality. Rather than fostering love, they forge a foundation of resentment and distrust.

As their relationship played out, Leah settled for less and less in defeat. In the early days of their marriage charade, Leah hoped for love. By son number three, she was willing to settle for attachment. Later, after the season of the maids' children, Leah bore another two sons, Issachar and Zebulun. With the latter she

concluded, "God has presented me with a precious gift. This time my husband will treat me with honor, because I have borne him six sons" (Genesis 30:20). The dream of connection with Jacob gave way to settling for some honor as the mother of many sons.

The effect of rivalry on Leah's relationship with her sister was disastrous! Rachel became her enemy and rival. They both forfeited the friendship they might have enjoyed had they chosen mutual love and respect. Instead of sisterhood, comparison and competition trapped them in a vicious cycle of jealousy, striving, and resentment that was never relinquished or resolved.

In fact, their rivalry passed on to the next generation. After Leah had her six sons and a daughter, Rachel finally gave birth to a biological son, Joseph. As the natural-born son of Rachel—the wife Jacob truly loved—Joseph was his favorite. Just as Leah resented Rachel as the wife who was loved most, Leah's sons resented Joseph as the son who was loved most. Later, when the sons were young men, Leah's sons plotted to kill Rachel's son. They faked his death and sold Joseph as a slave to Egypt. The sins of the fathers, or in this case, the sins of the mothers, were passed on to the next generation.

THIS TIME I WILL PRAISE THE LORD

The sons were currency in a competition between two sisters. Only one of the thirteen children was received as a blessing with no strings attached. Judah was the only child either sister received with gratitude, praise, and thanksgiving. Judah was the only son not used as a tool in the power struggle between the sisters.

These twelve sons became the fathers of the twelve tribes of Israel. But the tribe of Judah was chosen to be the line of King David, which became the line of Jesus. Gratitude matters to God. Cultivating gratitude is our single greatest weapon to battle comparison and to nurture contentment.

In whatever situations we find ourselves, whatever messes we may have made through our own sin, dysfunction, and brokenness, we can know that God is not standing by to condemn us. Rather, He is eager to enter in with His compassionate care, healing love, and restoring hope.

We can choose to stop striving. Let go of competition and control. Stop complaining about what we don't have and instead, count the blessings we *do* have. Look up at the God who loves us. Choose freedom. *Live loved.* Declare it with overwhelming conviction: *This time, today, I will say thank you . . . today, this time, I will praise the Lord!*

RACHEL

BLESSED AND DISTRESSED

Rivalry, by definition, requires a rival. Leah was Rachel's rival. Rachel, the beautiful, pursued, and sought-after younger sister, possessed the unwavering love and devotion of Jacob. Rachel did not have to strive and scheme for Jacob's love. She already had it. Jacob was so totally smitten with her that he was willing to work for not only the original seven years, but also an additional seven years for the privilege of marrying her. Rachel was pursued, wanted, and loved by Jacob.

So far so good—until she was betrayed by her father and sister in their scheme to get Leah married before Rachel. This scheme propelled Rachel into a family scenario she could never have imagined. Rachel didn't choose to be one of two wives in a marriage. This dysfunctional family dynamic was thrust upon her and Jacob because of others' sin, deception, and choices.

We cannot always choose our family dynamics. We can't control or choose the actions and attitudes of other family members. However, we *can* choose our responses. We can choose who we will be and how we will function and respond.

Rachel married Jacob, but under her father's condition that Jacob also keep her sister Leah as his wife. A justifiable offense lodged in Rachel's heart. A seed of resentment was planted and grew into a bitter root toward her sister. This root of resentment grew into a stronghold of rivalry.

Despite legally having two wives, Jacob's heart was true to Rachel. His love was not divided. Rachel did not have to share his heart with another. Rather than secure her identity in that love and seek to keep her heart free, she embraced rivalry with her sister. Rachel had everything her sister wanted: love, marriage, beauty, wealth. But for Rachel that wasn't enough to bring her joy or contentment. Instead of receiving the gift of love that God gave her, Rachel focused her identity on the *one* thing she did *not have*. Rachel did not have children.

LIVING FROM LACK

When Rachel saw that Leah was having sons, a fierce jealousy rose up in her. Instead of seeing her life through the lens of gratitude, she based her identity on comparison to her sister. When we place our identify in something, we will seek to *get* that something in order to fulfill our identity. In Rachel's case, with her identity based on what she did not have in comparison with her sister, her life goal was to beat her sister and rival, to *win* in the comparison game.

And Rachel did win, in every arena but one: in having children. Comparison leads to pride or shame. When we compare, if we see ourselves as better, a haughty arrogance results. You might call it *comparrogance*. By contrast, if we compare and don't feel that we measure up, a desperate shame and crippling insecurity roar to life. Rachel knew she was prettier. Rachel knew she was more loved. Rachel knew she was chosen. And Rachel knew Leah was having children—and she wasn't. And that envy-laced knowledge ate away at her joy and eroded her contentment.

DISSATISFIED AND DEMANDING

Eventually her obsession with competing and comparing caused Rachel to lash out at her husband and blame him. In an impassioned, but irrational plea, she demanded from him, "Give me children, or I'll die!" (Genesis 30:1). Based on the anger in Jacob's response, this was no small side comment like, *I need a coffee or I'm going to die.* It was an indictment on him and his provision. It expressed her deep dissatisfaction, possibly even revealing a veiled threat: *If I can't have children, I don't even want to live!* Her pronouncement of discontent, of the deficiency and insufficiency of their lives and his love, grieved and provoked Jacob. "Am I in the place of God, who has kept you from having children?" (v. 2). He gave her everything he had to give, but it wasn't enough.

When we focus on what we don't have, instead of receiving what we do have with gratitude, we become entitled, spoiled, ungrateful, and selfish—not what most of us aspire to be! Those are strong descriptions, and we can quickly brush them off, convinced we are better than that. But think about how you would complete this sentence: *Of course I am grateful for what I have. I just want _____.* Whatever the thing is that completes this sentence may be something that has grown from a desire to a demand. From a prayer to an idol. From a gift and a blessing to something that you think God, life, your husband, or your children *owe* you. Gifts, by definition, are not owed. They are not payment that is earned. They are simply gifts, expressions of love and care.

> Ironically, the more we focus on self-gratification and demand satisfaction, the less content we are!

Ironically, the more we focus on self-gratification and demand satisfaction, the less content we are! Being a taker fosters discontentment, cultivates disappointment, and eventually reaps disillusionment. Rachel fell into this trap. Her focus on her lack left her selfish and demanding.

COMPETE AND DEFEAT

After Leah gave birth to four sons, Rachel was so desperate to find a way to beat her sister that she gave Jacob her maidservant, Bilhah. She demanded that he father a child with her, a child whom Rachel could claim and raise as her own. We have no indication how the servant girl felt about this. In their culture, servants were owned and had few rights. This practice of birthing children for your master was not uncommon. Regardless of how culturally prevalent it was, being common or cultural did not make it right—or less painful for the person being used.

Rachel's attitude about the birth of the maidservant's two sons showed little gratitude to God. Rather, it was laced with arrogance and spite toward her rival. She names them "God has vindicated me" (Genesis 30:6) and "I have had a great struggle with my sister, and I have won" (v. 8). Of course, these sons neither satiated Rachel's discontent nor cured her rivalry. She was still longing to *win* at any cost. Later she even resorted to *renting out* her husband for a shot at Leah's mandrake plants to help her get pregnant. Seriously, imagine that! Rachel so longs for the one blessing she doesn't have that she is willing to trade the blessing of her husband, who she does have, to get it!

To be fair, Rachel did have a serious offense against her sister. Leah *had* deceived Rachel. She had hijacked and derailed Rachel's *happily-ever-after* dream. Life *will* disappoint. People *will* fail, and they *will* sin against us. Unforeseen hardship and tragedy may befall us. We have no power over other people's sin. But we do have power over our own choices and responses.

A terribly unfair and uninvited event unleashed a devastating dynamic into Rachel's life. It wasn't Rachel or Jacob's fault that Leah was also Jacob's wife. But it *was* Rachel's choice to enter into lifelong resentment, hostility, and rivalry. Rachel was offended. That offense morphed into bitterness; it was a prison from which Rachel never broke free.

We all experience painful, disappointing, legitimate offenses in life. If we're not careful, we can get stuck there. The hurt can lodge in our hearts, fester, poison our present, and rob our future of happiness, contentment, and joy. You cannot undo what has been done. But you can choose your response. You can choose to forgive and release both the justice and your future protection to God. Forgiveness does not release the offender from justice. It releases *you* from the offense! And it puts the offender into the hands of the one true righteous and fair judge, God Almighty. He will deal with the offense. This releases you to go on with your life, free of the burden of righting the wrong.

Justice is not a burden that God intends for us to carry. We have a Father in heaven who is more than able to take care of it. When I was a little girl, a neighbor boy stole my toy. Rather than trying to make him give it back to me, I ran home to my father. My dad would make it right! My strong and wise dad listened to my angst and assured me, *I'll take care of it. You don't need to worry. I'll deal with this.* I had complete trust in my father's ability and his resolve to remedy the situation. My dad had it. It was as good as done. My heart was free. Without another thought or care, I ran back outside to play and enjoy the day.

In the same way, we can run to our Heavenly Father, pour out our turmoil to Him, then entrust Him with the responsibility of justice. Once we hand it to Him, we are free, released to go on and enjoy our lives. He's a good Father. He's got it!

In Rachel's story, sometime later God remembered her and eventually enabled her to have a son. Rachel received her son as a sign of God's removing the disgrace of being barren. After years of waiting and yearning, Rachel finally had a son of her own. Of all the sons born to the sisters, you would think this son would be named with thanksgiving, with a name like *Thank the Lord* or *My prayer is finally answered* or *What a precious gift!* Unfortunately, her discontent and desire to *win* overrode the opportunity for gratitude. She named her son Joseph—which means *Add to me another!* Instead of saying thank you, she received her son, basically demanding, *Give me more.* I doubt Rachel would have been satisfied even with another son . . . or another. Her primary desire was to outdo her sister, not necessarily to have children. This desire likely would have driven her to demand more sons until she won.

RULED AND ROBBED

Rachel lived a blessed life of extreme wealth and unusual beauty, receiving the unwavering love and loyalty of a devoted husband. It's sad to see that, in spite of these abundant blessings, there's little evidence of joy, gratitude, or contentment. Living from selfishness and rivalry robbed her of the joy from the blessings she *did* have. As with Eve, the curse of discontentment manifested and ruled over her so that what she had wasn't enough.

Her desire for more had profound relational consequences with her husband, sister, and children. Her discontent caused her to blame and resent her loyal husband. She exploited him in her unrelenting quest to have children by *hiring* him out to her sister. She saw Jacob as owing her happiness instead of seeking to be a

source of happiness to him. Not once do we see her acknowledge Jacob's heart, needs, or feelings. Her life revolved around her rivalry and her desire to win.

Rivalry or other conflict can steal from us and consume us if we let it. Guard against reactionary living. Don't let others' conflict, drama, and dysfunction suck you in, sap your energy, and become your focus. Diligently protect your peace and contentment. Foster gratitude. Establish and maintain healthy boundaries.

With Rachel, this rivalry cost her the potential friendship of her sister. Rachel likely knew her father's role in setting up this conflicted situation and his attitude toward Leah's chances of getting married. Rachel may have observed Leah's pain and belief that she was *unlovable* and lacking value. What if Rachel had chosen mercy or compassion? What if she had opened her heart and home to enfold her sister as a friend and ally instead of an enemy and rival? Might there have been a way to honor Jacob's desire to be married to Rachel and enfold Leah as a sister—and not a second wife? But both women chose to compete and strive instead.

Rachel's children were tools in her competition. She, along with Jacob, passed on her superior and exclusive spirit to Joseph, who was exalted from a young age above his older brothers, the sons of Leah. Joseph paid dearly for the favoritism; being resented by his brothers, he was eventually sold as a slave.

Finally, identity rooted in rivalry affected Rachel's relationship with God. We see little evidence of her worshiping Him or relating to Him. When she does acknowledge God, it is shallow and in the context of what she can get from Him. Perhaps she saw God as a force who could have helped her but hadn't. Rachel felt she was entitled to have children. That God had so far withheld this blessing may have embittered her toward Him. Unlike Leah, who acknowledged and sought God for help, believing God was listening to her, Rachel acknowledged only her own strength and her right to keep score. When Rachel finally did acknowledge God, it was with *Finally you show up to help me! It's about time! Now that you are finally helping me, give me another son!*

Perhaps God waited to give Rachel children in an attempt to humble her, to give her time to say thank you for the abundant blessings He had *already* given her . . . to break the spirit of entitlement off her life. He had not forgotten Rachel; He had just waited.

And then God honored her request for another son. Rachel conceived again.

A time came when Jacob decided to leave her father's house and travel back to his own family. Rachel stole her father's idols before leaving on their journey.

Sadly, she placed more hope and faith in idols of stone and wood than in the God who had opened her womb after years of barrenness. Rachel was willing to use God to take what she could get from Him. But she was unwilling to trust Him wholeheartedly, to serve or even really love Him.

On the journey, she went into painful labor and was dying. Her stolen idols didn't help. Even at death's doorstep, in dire need, she did not cry out to the living God who loved her and could save her. As her son was being born, she named him Ben-Oni, meaning *son of my sorrow*. She gave birth to a precious second son but didn't live to enjoy him—or to boast. Rachel's last act, the naming of her son, revealed her spirit of defeat and her striving with Leah coming to a bitter end. Had she forsaken rivalry, her final act on earth could have been to bless her son, naming him something like *son of hope* or *son of the future*.

And that's it. Rachel tragically died in her discontentment. Hers was a blessed life robbed of joy. Satisfaction and peace were stifled by comparison and competition.

Let's pause.

Let's take a moment to look in the mirror and check our own attitudes. Are we content? Are we grateful? Are we givers of appreciation and blessing to those who bless us? Or are we takers—demanding, critical, and never satisfied? What would our spouses, friends, co-workers, and children say?

Jacob watched the birth and received the gift of another son from his beloved Rachel. After her death, he changed the baby's name from *son of my sorrow* to Benjamin, *son of my right hand*. Friends, it is not too late to change the names of your circumstances from defeat to hope, to wash your perspective from bitter dissatisfaction to healing gratitude and grace. There's still time to humbly say, *Thank you, Lord, for all you have given me. Thank you, too, for all you have withheld from me in your wisdom. I trust you. I will reach up from my sorrow and disappointment to forsake resentment, express gratitude, and take your right hand.*

Lord Jesus,

I am sorry for striving, comparing, and competing. I repent of looking to other things and people to determine my worth and value. While it may be true that others have rejected me or not loved me, I have always been loved by you. You love me. Fully. Wholly and perfectly. I do not need to live from the lack—from what I am not or what I don't have. So today I choose gratitude. Thank you for loving me. Thank

you for forgiving me. Thank you for choosing me, for wanting me, for keeping me. You are faithful and true! And you will never let me go! I will *live loved*!

In Jesus' name, Amen

DISCUSSION QUESTIONS

1. From what limitations or labels, either positive or negative, are you tempted to live? What are the labels that say, "You are not"? How can you "reject rejection" and break off the curse of labeling from your life?

2. What is something you don't have that you desperately desire—something you believe will fulfill you and make you happy? Why do you think possessing this will do that? Will it?

3. Are there areas in which you're tempted to compare and compete with other women? What is the root of this spirit of rivalry for you?

4. Have you ever experienced a season of freedom as Leah did with Judah? What led to your freedom? Did it last? How can we guard and protect our freedom and healing to avoid becoming enslaved and entangled all over again?

6

ESTHER:
ROBED IN RESPECT

Esther was an ordinary young girl with an extraordinary destiny. She didn't come from privilege—just the opposite. Esther was an orphan. She lost her parents at a young age and was adopted by her uncle. They were a minority family in an oppressive, prejudiced culture. As Esther grew, a radiant beauty bloomed inside her—one that was rooted in something deeper than her physical appearance. Indeed, it would be this special radiance, an inner resolve reflected on her face and revealed in her courageous acts, that would change her life and the course of two nations.

In the land of Persia, following the banishment of Queen Vashti for publicly disobeying and dishonoring King Xerxes, the king was looking for a new queen.

Then the king's personal attendants proposed, "Let a search be made for beautiful young virgins for the king. Let the king appoint commissioners in every province of his realm to bring all these beautiful young women into the harem at the citadel of Susa. Let them be placed under the care of Hegai, the king's eunuch, who is in charge of the women; and let beauty treatments be given to them. Then let the young woman who pleases the king be queen instead of Vashti." This advice appealed to the king, and he followed it.

Now there was in the citadel of Susa a Jew of the tribe of Benjamin, named Mordecai son of Jair, the son of Shimei, the son of Kish, who had been carried into exile from Jerusalem by Nebuchadnezzar king of Babylon, among those taken captive with Jehoiachin king of Judah. Mordecai had a cousin named Hadassah, whom he had brought up because she had neither father nor mother. This young woman, who was also known as Esther, had a lovely figure and

was beautiful. Mordecai had taken her as his own daughter when her father and mother died.

When the king's order and edict had been proclaimed, many young women were brought to the citadel of Susa and put under the care of Hegai. Esther also was taken to the king's palace and entrusted to Hegai, who had charge of the harem. She pleased him and won his favor. Immediately he provided her with her beauty treatments and special food. He assigned to her seven female attendants selected from the king's palace and moved her and her attendants into the best place in the harem.

Esther had not revealed her nationality and family background, because Mordecai had forbidden her to do so. Every day he walked back and forth near the courtyard of the harem to find out how Esther was and what was happening to her.

Before a young woman's turn came to go into King Xerxes, she had to complete twelve months of beauty treatments prescribed for the women, six months with oil of myrrh and six with perfumes and cosmetics. And this is how she would go to the king: Anything she wanted was given her to take with her from the harem to the king's palace. In the evening she would go there and in the morning return to another part of the harem to the care of Shaashgaz, the king's eunuch who was in charge of the concubines. She would not return to the king unless he was pleased with her and summoned her by name.

When the turn came for Esther (the young woman Mordecai had adopted, the daughter of his uncle Abihail) to go to the king, she asked for nothing other than what Hegai, the king's eunuch who was in charge of the harem, suggested. And Esther won the favor of everyone who saw her. She was taken to King Xerxes in the royal residence in the tenth month, the month of Tebeth, in the seventh year of his reign.

Now the king was attracted to Esther more than to any of the other women, and she won his favor and approval more than any of the other virgins. So he set a royal crown on her head and made her queen instead of Vashti. And the king gave a great banquet, Esther's banquet, for all his nobles and officials. He proclaimed a holiday throughout the provinces and distributed gifts with royal liberality.

. . . But Esther had kept secret her family background and nationality just as Mordecai had told her to do, for she continued to follow Mordecai's instructions as she had done when he was bringing her up.

ESTHER 2:2–18, 20

Sometime later . . .

> King Xerxes honored Haman son of Hammedatha, the Agagite, elevating
> him and giving him a seat of honor higher than that of all the other nobles.
> All the royal officials at the king's gate knelt down and paid honor to Haman,
> for the king had commanded this concerning him. But Mordecai would not
> kneel down or pay him honor.
>
> ESTHER 3:1–2

This action angered Haman to the point of scheming not only to kill Mordecai,
but to annihilate *all* Jews living in Persia. Using flattery, slander, and extortion,
Haman acquired the signature of the king on a royal decree to destroy every Jew,
young and old, in the land.

> Dispatches were sent by couriers to all the king's provinces with the order to
> destroy, kill and annihilate all the Jews—young and old, women and chil-
> dren—on a single day, the thirteenth day of the twelfth month, the month
> of Adar, and to plunder their goods. . . .
>
> When Mordecai learned of all that had been done, he tore his clothes,
> put on sackcloth and ashes, and went out into the city, wailing loudly and
> bitterly. But he went only as far as the king's gate, because no one clothed
> in sackcloth was allowed to enter it. In every province to which the edict
> and order of the king came, there was great mourning among the Jews, with
> fasting, weeping and wailing. Many lay in sackcloth and ashes.
>
> When Esther's eunuchs and female attendants came and told her about
> Mordecai, she was in great distress. She sent clothes for him to put on instead
> of his sackcloth, but he would not accept them. Then Esther summoned
> Hathak, one of the king's eunuchs assigned to attend her, and ordered him
> to find out what was troubling Mordecai and why.
>
> So Hathak went out to Mordecai in the open square of the city in front
> of the king's gate. Mordecai told him everything that had happened to him,
> including the exact amount of money Haman had promised to pay into
> the royal treasury for the destruction of the Jews. He also gave him a copy
> of the text of the edict for their annihilation, which had been published in
> Susa, to show to Esther and explain it to her, and he told him to instruct
> her to go into the king's presence to beg for mercy and plead with him for
> her people.

Hathak went back and reported to Esther what Mordecai had said. Then she instructed him to say to Mordecai, "All the king's officials and the people of the royal provinces know that for any man or woman who approaches the king in the inner court without being summoned the king has but one law: that they be put to death unless the king extends the gold scepter to them and spares their lives. But thirty days have passed since I was called to go to the king."

When Esther's words were reported to Mordecai, he sent back this answer: "Do not think that because you are in the king's house you alone of all the Jews will escape. For if you remain silent at this time, relief and deliverance for the Jews will arise from another place, but you and your father's family will perish. And who knows but that you have come to your royal position for such a time as this?"

Then Esther sent this reply to Mordecai: "Go, gather together all the Jews who are in Susa, and fast for me. Do not eat or drink for three days, night or day. I and my attendants will fast as you do. When this is done, I will go to the king, even though it is against the law. And if I perish, I perish."

So Mordecai went away and carried out all of Esther's instructions.

On the third day Esther put on her royal robes and stood in the inner court of the palace, in front of the king's hall. The king was sitting on his royal throne in the hall, facing the entrance. When he saw Queen Esther standing in the court, he was pleased with her and held out to her the gold scepter that was in his hand. So Esther approached and touched the tip of the scepter.

Then the king asked, "What is it, Queen Esther? What is your request? Even up to half the kingdom, it will be given you."

"If it pleases the king," replied Esther, "let the king, together with Haman, come today to a banquet I have prepared for him."

"Bring Haman at once," the king said, "so that we may do what Esther asks."

So the king and Haman went to the banquet Esther had prepared. As they were drinking wine, the king again asked Esther, "Now what is your petition? It will be given you. And what is your request? Even up to half the kingdom, it will be granted."

Esther replied, "My petition and my request is this: If the king regards me with favor and if it pleases the king to grant my petition and fulfill my request, let the king and Haman come tomorrow to the banquet I will prepare for them. Then I will answer the king's question."

Esther 3:13; 4:1–5:8

After leaving the banquet, Haman saw Mordecai at the king's gate. Again, Mordecai showed him no honor. Haman complained to his wife and friends. Depending on which version of the Bible you are reading, his wife recommended building either gallows to hang Mordecai or a pole to impale him. The time came for the next evening's banquet.

So the king and Haman went to Queen Esther's banquet, and as they were drinking wine on the second day, the king again asked, "Queen Esther, what is your petition? It will be given you. What is your request? Even up to half the kingdom, it will be granted."

Then Queen Esther answered, "If I have found favor with you, Your Majesty, and if it pleases you, grant me my life—this is my petition. And spare my people—this is my request. For I and my people have been sold to be destroyed, killed and annihilated. If we had merely been sold as male and female slaves, I would have kept quiet, because no such distress would justify disturbing the king."

King Xerxes asked Queen Esther, "Who is he? Where is he—the man who has dared to do such a thing?"

Esther said, "An adversary and enemy! This vile Haman!"

Then Haman was terrified before the king and queen. The king got up in a rage, left his wine and went out into the palace garden. But Haman, realizing that the king had already decided his fate, stayed behind to beg Queen Esther for his life.

Just as the king returned from the palace garden to the banquet hall, Haman was falling on the couch where Esther was reclining.

The king exclaimed, "Will he even molest the queen while she is with me in the house?"

As soon as the word left the king's mouth, they covered Haman's face.

ESTHER 7:1–8

Haman was put to death on the gallows he had prepared for Mordecai. Mordecai was given his home, his royal position, and the signet ring of the king. Queen Esther was given authority along with Mordecai over the kingdom. The Jews were not only spared, but they were able to rid the kingdom of those who intended them harm.

Like Rachel and Leah, Esther lived with some powerful labels. She was an orphan. She was a minority, a Jew living in Gentile Persia. She was adopted. She was beautiful. Positive or negative labels, depending on perspective. Labels that could have defined her. Labels that could have limited her. Labels that could have ruled her. The labels were all *true*. However, Esther did not embrace them as the basis for her identity. She chose neither to live out of, nor live from, her labels.

Also like Rachel and Leah, Esther lived without. There were several significant things Esther did not have. She did not have parents. She did not have a country. She did not have freedom to choose her circumstances—and she would have less and less freedom as her story unfolded. She did not have many personal rights; and the few she did possess before her inauguration as queen vanished when she received the royal crown.

Esther's destiny collided with her reality after the edict of King Xerxes. A search was made of the land of Persia for the most beautiful young maidens to present to the king as candidates to be the new queen. In a single day, Esther was forcibly taken from her home by the king's soldiers and taken to the palace with many other scared and bewildered young women. In a moment, her freedom was gone. Her dreams and ambitions for her own life vanished. In an instant, she became totally subject to the will of the king and the king's men. Any authority she thought to exercise over her future evaporated in an instant.

If Rachel and Leah thought they had lived with rivalry, Esther's situation was the Rivalry Olympics! She was moved into the king's harem—the holding house of women, at the king's pleasure and disposal—with no more rights than a purchased horse in the stables. A harem is potentially the most hostile, catty, competitive environment any woman could experience. Rivalry for the king's attention and for position among the women was rampant in such a place. To put fuel on the competitive fire, Esther was actually part of a public contest for the king's affections. This was no subtle competition for the attention of a man. It was the world premiere, the ultimate reality show of *The Bachelor King* with a nation watching.

And yet, we don't see Esther cringe or rage or despair. We do not see cunning rivalry or bitter disappointment. On one hand, she lost everything she had known and everything she may have wanted, along with the power to choose to pursue her own desires. But on the other hand, she was somehow still okay, still safe, still secure. How? Because Esther did not place *any* of her identity in external things. Stripped of everything and everyone she had ever known, she still had her heart,

her core identity, and her God—an identity that no one could steal, damage, or destroy—no matter the circumstances.

LIVING LOVED

Esther based her identity on *who* and *whose* she was. She was a Jew, which meant less about her nationality than it did about her allegiance to God. In this foundational relationship, she was a child of the Most High God. She knew what she believed and whom she believed in. Her faith was not just in a creed or a set of doctrines or rules. Rather, it was in a living, engaging, and personal God. One who is responsive and powerful. One who is full of perfect wisdom and unfailing love.

At her core, Esther's heart trusted God. Her adoption by Mordecai, her uncle, formed in Esther a strong bond of trust, loyalty, and obedience that carried over to her trust and obedience of her heavenly Father. Esther was surrendered to God and committed to the people God gave her. She trusted God's authority to provide for her, to guide her, and to protect her.

Trust is rooted in having full confidence in the character and nature of the one trusted. To be trustworthy literally means to be *worthy of trust*. In my own journey to grow my trust in God, I realized that my trust boiled down to firmly believing three core characteristics of God: His sovereignty, His wisdom, and His love.

Trusting in His sovereignty is trusting that God is powerful. Actually, *all* powerful. *Nothing* is too hard for Him to do. He is *able* to do what He promises to do. He is strong enough, big enough, powerful enough. Nothing can stop Him or stand against Him.

Trusting His wisdom is knowing God cannot be fooled, mocked, or deceived. He knows *all* and He knows the best way. We don't have to stress, overanalyze, or worry. Nor do we need to figure things out. God *fully* knows and *fully* understands every aspect of every detail of our lives. He sees the implications, the possibilities and the realities of every situation and challenge in which we find ourselves. Not only does He fully perceive all, but He knows the wisest and best way *through* all. He has perfect wisdom for anything and everything we face.

Finally, trusting in His love is not referring to a sentimental, warm-feeling kind of love. Rather, it's His personal, powerful, and perfect love *for you*. It's the faithful, never-ending, never-dying, casting-out-all-fear-of-rejection kind of love. His is a love that is forgiving and sacrificial, a love that is pure. His is a love that fully and completely has *your* best interest at heart.

When we believe in and receive God's perfect, unfailing love for us, we can trust the motive of God's guidance. We can trust Him and the wisdom of His instructions enough to follow them because we're convinced they're true and right. Being fully convinced that these directions are backed by the power, wisdom, and faithfulness of Almighty God, we can trust and obey.

> When we believe in and receive God's perfect, unfailing love for us, we can trust the motive of God's guidance. We can trust Him and the wisdom of His instructions enough to follow them because we're convinced they're true and right.

Esther's identity was rooted in this kind of trust. Esther *trusted* the *love* of God! She lived internally loved. She did not live from an orphan spirit. You don't have to be a literal orphan to have an orphan spirit. To have an orphan spirit is to believe at your core that you are alone, unloved, and unprotected. You can have parents, siblings, a spouse, and children and still be plagued with feeling unloved at the core of your identity. It is this orphan spirit that Jesus longs to heal and redeem in every man and woman.

Although Esther was literally orphaned, she fully accepted her adoption by both her uncle Mordecai and by her heavenly Father, God himself. She received and believed the truth that she was chosen, wanted, and loved. She literally *lived loved*. She stood on the truth that she was eternally, unfailingly, and perfectly loved. This foundational belief enabled her to walk in profound security. She could build her life on solid ground. *Living loved* provided an unshakable foundation. No matter what happened, she was safe and sound, held securely in the unfailing love of God. Love dispelled all fear and insecurity, for "there is no fear in love. But perfect love drives out fear" (1 John 4:18).

How did *living loved* affect her life, channeling her energy and focus? Identity determines our influence and what we pursue. Our goals are derived from our identity. Esther's identity was based on a trusting, loving relationship with God. Therefore, her goal was simply this: to *trust* and *obey*. Her goal in each circumstance was to do what was right according to God. Confident trust enabled her to fully submit to God's direction. She believed God was who He said He was. She surrendered to His purposes. Her goal was to *be* faithful and reflect the nature and character of her True King.

RESPECT: CLOTHED IN STRENGTH AND DIGNITY

Living loved empowered Esther to live securely. Living securely empowered her to live confidently and respectfully. Respect is a beautiful thing. Respect is becoming a rare thing. Respectful people conduct themselves with dignity and treat others with value. They are magnificent showcases of integrity and honor. Respectful people are strong enough to restrain themselves from extreme anger or self-pity. They are courageous enough to boldly and graciously speak the truth. They are secure and unthreatened by others' disapproval. Finally, because respectful people's words are guarded by integrity, they can relate and communicate confidently without fear of reprisal.

> Respectful people conduct themselves with dignity and treat others with value. They are magnificent showcases of integrity and honor. Respectful people are strong enough to restrain themselves from extreme anger or self-pity.

Esther was clothed in the regal garments of respect, trust, and submission. She deeply respected the God-given authorities in her life. She sincerely honored them and wholeheartedly submitted to them. Looking at the actual definitions of *respect, trust,* and *submit* provides significant, descriptive insight into what living from a foundation of security looks like.

To respect someone is "to regard as worthy of special consideration . . . to consider worthy of esteem . . . an attitude of admiration . . . courteous regard for people's feelings."[16] A secure woman who *lives loved* does not compete and compare herself with others. Secure in herself, she can esteem and value other people. She can celebrate others' joys. She can generously care for others because she doesn't need to receive value from them.

A woman who *lives loved* can also trust. When we trust someone, we "place confidence in . . . rely on, [believe] in the honesty and reliability of others . . . without fear."[17] To the extent that we trust, we can obey or follow. In other words, if we trust we can submit.

When I used to hear the word *submit*, like many women, I heard, *unconditional compliance and mindless, unquestioned obedience*—a definition more akin to slavery than love! But that is not the definition of *submit*. To submit is "to acquiesce . . . to yield without murmuring."[18] It is to accommodate, "to bring into agreement or harmony . . . to adapt oneself . . . be agreeable . . . make compatible with."[19] Essentially, it's having a helpful, conscientious awareness and regard for another's needs. Submission is the result of having a deep care and concern for

another person. It is a commitment to be attentive and considerate of another's feelings, perspective, and well-being. This true definition of submission is not about control, dominance, or authority, but rather unselfishly loving another with respect, consideration, and honor.

Respect and submission were core elements of Esther's character. They governed how she approached her relationships. We see her respect, trust, and submit to Mordecai throughout her life. When she first arrived at the harem, and later prepared to go before the king,

> Secure in herself, she can esteem and value other people. She can celebrate others' joys. She can generously care for others because she doesn't need to receive value from them.

Esther respected Hagai, her authority in the harem. She trusted and submitted to his recommendation of what to take before the king. Finally, throughout her marriage to the king, we see her treat her husband with this winsome respect, sincere esteem, and authentic honor.

GOD-SERVING VS. SELF-SERVING

This leads to one of several great exchanges we need to make to live as a redeemed Eve. Esther sought to serve the king's interests instead of competing with them. We don't see Esther demanding or vying for her own self-interest. Through her respect and submission, she was committed to serving *God's* interests in her husband's life. A few more definitions are helpful. For example, the definition of *serve* is absolutely beautiful, challenging, and motivating. *Serve* is defined as "to labor on behalf of; to exert oneself . . . for the benefit of."[20] To *benefit* "promotes prosperity."[21] *Prosper* means "to grow, to increase."[22] Looking a bit deeper, *to grow* means to "develop and reach maturity . . . to thrive; to flourish."[23]

What wife wouldn't want to *serve* her husband if it meant being a *benefit* to him, helping him mature, grow, and reach his full stature as a man?! This wife would be a gift and a blessing to the man she marries because she helps him thrive, flourish, and prosper. And from the man's point of view, what kind of noble love, provision, and protection might such a wife inspire him to give?

Another king decreed in Proverbs 31:10–12, "A wife of noble character who can find? She is worth far more than rubies. Her husband has full confidence in her and lacks nothing of value. She brings him good, not harm, all the days of her life."

Such a noble woman, a secure, *live-loved*, full-of-gracious-respect-toward-her-husband kind of woman, is a rare and precious treasure to the man who

marries her. Such a woman can be trusted with the vulnerable and sometimes fragile heart and ego of a man. With this woman, he is safe. With this woman, he can be himself. He *fully* trusts her not to do him harm or demean him. He can share his weakness and need, confident in her respect and her commitment to *help* him—not judge him—through it.

Esther showed us what honor and respect look like in how she approached the king during the crisis of the edict to annihilate the Jews. Sometimes what someone *doesn't* do is as powerful an example as what they actually *do*. Consider some of the ways Esther could have approached the king—but didn't.

She could have barged into the king's court, demanding an audience. Imagine her blasting through the door in a rage, publicly or privately, accusing and condemning him. *What were you thinking? Do you have any idea what you've done? How could you do something so reckless, cold-hearted, and stupid?! Do you realize you have ordered my execution?! What kind of a man—what kind of a husband—are you?*

Or she could have approached him need-first, as an emotional basket case—sobbing, inconsolable, and broken. Or she could have challenged and threatened him, using whatever leverage or power she had based on her knowledge of his heart or his weaknesses. A modern day *I'll take your children away from you* or *I'll shame you publicly if you don't do . . . XYZ!*

Even in a national crisis, which was also a family crisis and a very personal crisis, Esther remained respectful and honoring. She stayed rooted in her identity as a child of God. She stood in her faith and trusted in God's sovereign, loving purposes over her life. Her call to fasting and prayer reveal her goal in this crisis: to *serve God's purpose*. With her goal set, her identity secure, Esther submitted to the Lord in obeying Mordecai to approach and appeal to the king. She was trusting and completely surrendered to the Lord's purposes, willing to risk all, resolving, "If I perish, I perish" (Esther 4:16).

Look at the wisdom and grace with which Esther did approach the king. She was robed in majesty, regal with honor and respect. She took great care *not* to dishonor or embarrass him in any way. She approached him respectfully. She wisely protected his public honor by *not* making her appeal publicly. Rather, by inviting him to a banquet, she publicly honored him in the area where the former queen had dishonored him. This pleased him. This blessed him. The king was not angry or upset that she approached him uninvited. She publicly honored him. In response, he was more than willing to grant her request.

In one courageous act of obedience, Esther modeled a redeemed Eve. Unlike Rachel and Leah who demanded life *from* others, Esther gave and risked her life *for* others. Esther committed her life, her needs, and the *outcome* to God. She did not trust in her own control, strength, manipulation, or cunning. She instructed Mordecai and the Jews to fast and pray along with her for three days. She sought God's confirmation, empowerment, and intervention. Spiritually and emotionally prepared and surrendered, Esther obeyed.

From this foundation of identity, based in being securely loved in an authentic relationship with God, Esther risked her life to serve God's purposes in the lives of a nation. She sought to trust and obey with honor and respect. The results of her actions, especially with her husband and king, were glorious and profound.

THE FAVOR OF ALL

Esther won the favor of all who knew her; especially those in authority. She had a pleasing, winsome, regard for others and gained favor by deliberate effort through honor and respect. She was helpful and conscientiously aware of others' needs. The result? She won the king's favor, not by her mere physical beauty or sexuality, but by her attitude of honor and uncompromising character.

We all know physically beautiful women who have sour or arrogant attitudes. Their anger, bitterness, or pride disfigures their otherwise beautiful features. Their hurtful and vindictive character repulses rather than attracts. Likewise, we know women who radiate joy. Love and laughter light up their eyes. A contagious smile beams warmth to all those around. They may or may not have magazine-model physical beauty, but they radiate a peaceful beauty that doesn't fade with time or age. That was Esther's beauty—she was beautiful from the inside out.

Her husband trusted her. He extended his scepter, the symbol of his acceptance and favor, because he knew her character, loyalty, and motives. He knew her purity. He was confident she would not dishonor him in any way. He had full assurance of her respect. As a result, his heart and strength were inclined to her needs and requests. He was motivated to provide for and protect her. He was not threatened by her or afraid he would be diminished by her in any way. Rather, he trusted her as his helpmeet, the woman who did him good, not evil, all the days of his life. He trusted her to the point of sharing authority over the kingdom *with* her. Not just this once. After Haman's plot was exposed, he installed Mordecai *and* Queen Esther with the authority to rule, alongside him, the largest kingdom in the world.

Ladies, does your husband trust you to esteem him when you talk about him? Is he confident you will speak to him and about him with honor and respect? Does he have no fear of harm—no fear of being criticized, put down, mocked, shamed, or belittled? Proverbs 18:21 says, "The tongue has the power of life and death." How you speak *to* and how you speak *about* your husband has the power to bring life or death to your relationship, to establish or sabotage his emotional trust. Guard your tongue! Guard your heart! "For out of the overflow of the heart, the mouth speaks" (Luke 6:45, BSB). Guard love, model honor, uphold respect—in your heart first, and in your words.

This is also true in other relationships. Do our parents, children, and co-workers trust us to treat them with respect? Along with how we speak to and about our husbands, how we speak to and about our children is our greatest influence for life or death. We are responsible to *speak life* into our children, to treat them with honor and respect as gifts from the Lord. We are accountable to God for how we raise, treat, and love them. God is ready and willing to help us tame the tongue. Ask Him for help! Speak life. "Speak the truth in love" (Ephesians 4:15, NLT).

Commit to serving God's interests and God's purposes in the lives of those around you. This frees you to live in *His* love, *His* pleasure, and *His* favor as His love flows through you. You are free to give to others instead of looking to them to give to you. You are filled up from Him—the living water is flowing in and through you in an outward direction!

Esther served other's interests instead of using others for her own interests. Above all, she served God's interests. She trusted and obeyed Him even in the face of great personal loss, intense rivalry and hostility, and life-threatening danger. Esther's courageous trust and profound obedience to the purposes of God saved one nation from annihilation and brought justice and blessing to the most powerful nation on earth at the time. One little orphan girl, who chose to believe *who* and *whose* she was—one life lived in trust and submission to God's purposes—not only won the heart of the king of Persia but won the trust of the King of Kings. She became the most powerful woman in the world, ruling the most powerful kingdom of the world. She *lived loved* and changed the world.

Lord Jesus,

Thank you that you have a plan and a purpose for every situation and every challenge I find myself in. You work all things together for my good as I trust and obey you. Lord, help me to submit and surrender my

dreams, goals, and desires to you, to your sovereign good and perfect plan. Help me not to fight for my "rights" but rather to entrust my life to you. You are good! You are faithful! Because your plans will prevail at the end of the day, I can stand secure. I can boldly and courageously engage. Use me for your kingdom purposes. I entrust myself to you. I will *live loved*.

In Jesus' name, Amen

DISCUSSION QUESTIONS

1. Esther focused her identity on who and whose she was. If you build your identity on being a child of God, how will that grow security and change your current perspective on life?

2. Esther served her husband's best interests instead of competing with them. She honored, esteemed, and respected him. Do you need to change any behaviors or patterns of relating to others? How is God challenging you to cultivate more honor and respect?

3. Esther trusted and obeyed God in the crisis instead of scheming and manipulating. Is there an area where God is calling you to trust and obey Him more, to stop trying to fix or change it on your own? What will trusting and obeying God in that situation look like?

7

SARAH:
TRIAL OF TRUST

Sarah was a woman, like you and me, with dreams and goals for her life. She dreamt of getting married, building a family with her husband, and living happily ever after. Dreams can inspire and motivate, but they can also frustrate and tempt when they go unfulfilled or are delayed in coming. God's ways often conflict with our ways, and His timing conflicts with our timing. And sometimes we just get tired of the waiting and the trusting—and decide to take matters into our own hands. It was at the conclusion of that time of waiting that God renamed Sarai and her husband Abram, calling them Sarah and Abraham.

> *The name of Abram's wife was Sarai. . . . Now Sarai was childless because she was not able to conceive. . . .*
>
> *The LORD had said to Abram, "Go from your country, your people and your father's household to the land I will show you.*
>
> > *"I will make you into a great nation,*
> > *and I will bless you;*
> > *I will make your name great,*
> > *and you will be a blessing.*
> > *I will bless those who bless you,*
> > *and whoever curses you I will curse;*

and all peoples on earth
will be blessed through you."

So Abram went, as the LORD had told him. . . . Abram was seventy-five years old when he set out from Harran. . . .

The LORD appeared to Abram and said, "To your offspring I will give this land."

GENESIS 11:29–30; 12:1–4, 7

Some years passed.

The LORD said to Abram after Lot had parted from him, "Look around from where you are, to the north and south, to the east and west. All the land that you see I will give to you and your offspring forever. I will make your offspring like the dust of the earth, so that if anyone could count the dust, then your offspring could be counted. Go, walk through the length and breadth of the land, for I am giving it to you."

GENESIS 13:14–17

More years passed, and God reaffirmed His promise to Abraham.

"After this, the word of the LORD came to Abram in a vision:

> *"Do not be afraid, Abram.*
> *I am your shield,*
> *your very great reward."*

But Abram said, "Sovereign LORD, what can you give me since I remain childless and the one who will inherit my estate is Eliezer of Damascus?" And Abram said, "You have given me no children; so a servant in my household will be my heir."

Then the word of the LORD came to him: "This man will not be your heir, but a son who is your own flesh and blood will be your heir." He took him outside and said, "Look up at the sky and count the stars—if indeed you can count them." Then he said to him, "So shall your offspring be."

Abram believed the LORD, and he credited it to him as righteousness. . . .

Now Sarai, Abram's wife, had borne him no children. But she had an Egyptian slave named Hagar; so she said to Abram, "The LORD has kept me from having children. Go, sleep with my slave; perhaps I can build a family through her."

Abram agreed to what Sarai said. So after Abram had been living in Canaan ten years, Sarai his wife took her Egyptian slave Hagar and gave her to her husband to be his wife. He slept with Hagar, and she conceived.

When she knew she was pregnant, she began to despise her mistress. Then Sarai said to Abram, "You are responsible for the wrong I am suffering. I put my slave in your arms, and now that she knows she is pregnant, she despises me. May the LORD *judge between you and me."*

"Your slave is in your hands," Abram said. "Do with her whatever you think best." Then Sarai mistreated Hagar; so she fled from her....

Abram was eighty-six years old when Hagar bore him Ishmael.

When Abram was ninety-nine years old, the LORD *appeared to him and said, "I am God Almighty; walk before me faithfully and be blameless. Then I will make my covenant between me and you and will greatly increase your numbers."*

Abram fell facedown, and God said to him, "As for me, this is my covenant with you: You will be the father of many nations. No longer will you be called Abram; your name will be Abraham, for I have made you a father of many nations. I will make you very fruitful; I will make nations of you, and kings will come from you. I will establish my covenant as an everlasting covenant between me and you and your descendants after you for the generations to come, to be your God and the God of your descendants after you. The whole land of Canaan, where you now reside as a foreigner, I will give as an everlasting possession to you and your descendants after you; and I will be their God."...

God also said to Abraham, "As for Sarai your wife, you are no longer to call her Sarai; her name will be Sarah. I will bless her and will surely give you a son by her. I will bless her so that she will be the mother of nations; kings of peoples will come from her."

Abraham fell facedown; he laughed and said to himself, "Will a son be born to a man a hundred years old? Will Sarah bear a child at the age of ninety?" And Abraham said to God, "If only Ishmael might live under your blessing!"

Then God said, "Yes, but your wife Sarah will bear you a son, and you will call him Isaac. I will establish my covenant with him as an everlasting covenant for his descendants after him. And as for Ishmael, I have heard you: I will surely bless him; I will make him fruitful and will greatly increase his numbers. He will be the father of twelve rulers, and I will make him into a

great nation. But my covenant I will establish with Isaac, whom Sarah will
bear to you by this time next year." . . .

The LORD appeared to Abraham near the great trees of Mamre while he
was sitting at the entrance to his tent in the heat of the day. Abraham looked
up and saw three men standing nearby. When he saw them, he hurried from
the entrance of his tent to meet them and bowed low to the ground. . . .

"Where is your wife Sarah?" they asked him.

"There, in the tent," he said.

Then one of them said, "I will surely return to you about this time next
year, and Sarah your wife will have a son."

Now Sarah was listening at the entrance to the tent, which was behind
him. Abraham and Sarah were already very old, and Sarah was past the
age of childbearing. So Sarah laughed to herself as she thought, "After I am
worn out and my lord is old, will I now have this pleasure?"

Then the LORD said to Abraham, "Why did Sarah laugh and say, 'Will I
really have a child, now that I am old?' Is anything too hard for the LORD? I
will return to you at the appointed time next year, and Sarah will have a son."

Sarah was afraid, so she lied and said, "I did not laugh."

But he said, "Yes, you did laugh." . . .

Now the LORD was gracious to Sarah as he had said, and the LORD did
for Sarah what he had promised. Sarah became pregnant and bore a son to
Abraham in his old age, at the very time God had promised him. Abraham
gave the name Isaac to the son Sarah bore him. When his son Isaac was eight
days old, Abraham circumcised him, as God commanded him. Abraham
was a hundred years old when his son Isaac was born to him.

Sarah said, "God has brought me laughter, and everyone who hears about
this will laugh with me." And she added, "Who would have said to Abraham
that Sarah would nurse children? Yet I have borne him a son in his old age."

The child grew and was weaned, and on the day Isaac was weaned
Abraham held a great feast. But Sarah saw that the son whom Hagar the
Egyptian had borne to Abraham was mocking, and she said to Abraham,
"Get rid of that slave woman and her son, for that woman's son will never
share in the inheritance with my son Isaac."

The matter distressed Abraham greatly because it concerned his son.
But God said to him, "Do not be so distressed about the boy and your slave
woman. Listen to whatever Sarah tells you, because it is through Isaac that

*your offspring will be reckoned. I will make the son of the slave into a nation
also, because he is your offspring."*

*Early the next morning Abraham took some food and a skin of water
and gave them to Hagar. He set them on her shoulders and then sent her off
with the boy. She went on her way and wandered in the Desert of Beersheba.*

GENESIS 15:1–6; 16:1–6, 16; 17:1–8, 15–21; 18:1–2, 9–15; 21:1–14

For simplicity's sake, going forward, we will refer to Sarah and Abraham only
by their God-given new names. Beautiful Sarah and her husband of faith,
Abraham, received a call and a covenant from God. Calling them to leave their
homeland and go to the land He would give them, God made a guaranteed,
binding promise to Abraham. God promised to make Abraham into a great
nation with descendants more numerous than the stars in the sky or the sands
on the shore. Sarah was the one-flesh wife of the covenant. She courageously
and faithfully left the comfort and familiarity of home and family to follow
God's call into this new land.

Abraham and Sarah grew older. The realities of age crept in. When tempted
to doubt or disbelieve the promise, Abraham brought his questions to the Lord.
Each time, God reassured, reaffirmed, and re-clarified His promise: "A son who
is your own flesh and blood will be your heir" (Genesis 15:4). Sarah shared the
hope of the promise with Abraham. And waited. And waited. And waited. She
was dearly loved by Abraham. They prospered and flourished everywhere they
went. They became extremely wealthy in this new land, just as God had promised.
But they remained childless.

STRUGGLE TO SURRENDER

Sarah was aging out of child-bearing years. Abraham, who was ten years older
than Sarah, was getting old. Again, God reaffirmed His promise of a son to
Abraham. Somewhere in the inner workings of Sarah's heart, she wrestled with
the friction between the promise and their reality, between passively waiting
and actively pursuing, between surrendering and scheming. What was once a
beautiful dream and hope-filled promise, had become a source of consternation
and turmoil. The promise morphed into pressure. How were they going to have
a child? God had promised. God couldn't and wouldn't lie. How was God going

to fulfill His promise to us . . . to Abraham? *That's it!* Suddenly an idea sprang into a feasible plan in Sarah's mind.

As we saw with Rachel and Leah, it was a custom of the peoples around them that, when a woman could not bear children of her own, a servant could bear a child for her. Voluntarily or not, slaves had few rights and little or no recourse. In some ways, a slave bearing a child for the master could even secure or raise her standing in the home, elevating her to be a wife instead of a slave.

We don't know which motive drove Sarah's next move. Perhaps it was sheer impatience—that she just got tired of waiting. After all, it had been decades! Or perhaps her desire for a family, coupled with the years progressing, created a sense of urgency bordering on desperation to get the promise fulfilled while they still had time to be parents. Or in all her longing, pondering, and wondering, Sarah concluded that it was up to her to do her part, to help build their family, to find a way, to do whatever was in her power to do, to make sure that Abraham had an heir. In her angst over the unfulfilled promise rapidly becoming the *impossible* promise, Sarah devised a plan.

She approached her husband. Using her sacred influence, she suggested a solution: "The Lord has kept me from having children. Go, sleep with my slave; perhaps I can build a family through her" (Genesis 16:2). As you can imagine, asking your husband to sleep with another woman—assuming the woman will happily just have a baby for you and not interfere with your marriage or expect anything in return—does not go so well!

She gave her slave Hagar to Abraham. Once pregnant, Hagar became arrogant and entitled, and disrespectful to Sarah. Sarah blamed Abraham for Hagar's attitude, insinuating something like, *Now that she sees she is the mother of your child, she thinks she is the queen bee around here and doesn't need to listen to me! She thinks she is better than I am, and she's disrespecting me! You have treated her too well.*

Abraham promptly retreated and let go of Hagar, telling Sarah to do whatever she felt was necessary to rectify the situation. "Your slave is in your hands" (v. 6). He was implying that she should do what she had to do so Hagar clearly knew she was *just a slave* and *not* the mistress of the house.

Sarah mistreated Hagar. When we study the word *mistreated*, we see from Strong's H6031 that in the original Hebrew, the word *ana* means "to afflict, oppress, humble . . . to mishandle . . . through the idea of looking down or browbeating."[24] Essentially, Sarah mistreated Hagar to put her in her place. In pain, Hagar ran away and had an encounter with God, as we see in Genesis 16:7–13. Then she

returned home to submit to Sarah. Hagar bore a son, Ishmael, for Abraham. For the next 14 years, Sarah, Abraham, Hagar, and Ishmael lived with the tension and confusion of one father and two mothers sharing one son.

CONSEQUENCE OF COMPROMISE

I wonder how many days it took—as Sarah watched Abraham nurture and love *his* son—for her to regret her scheme? Did she silently lament, *What have I done?* The son bonded with his mother Hagar, engaged his father, and likely left Sarah watching as the proverbial third wheel. Did an emotional consequence work its way through Sarah's heart, creating a longing to get untangled from the web she'd woven? I am sure she tried to make it work. She had gotten them into this situation and was invested in trying to make it turn out well. As the saying goes, *Sometimes we have so much invested in a bad decision that we think investing more will make it better.* Was this really the fulfillment of the promise God had given them? I can't help but think that these years were tainted with regret and tarnished with the feeling of being trapped in a mess of her own making.

Surely, in God's promise of a great nation coming from Abraham, God also had the power and the means to fulfill His promise without the compromise, control, and abuse used in producing an heir. Would a holy and good God really expect unholy means to fulfill His promise?

In Sarah's great compromise, she showed a lack of understanding the character and ways of God. This exemplifies a key point: An inadequate understanding of God will always lead to an insufficient trust in Him. Had Sarah understood God's principles of unity and oneness in marriage, she would have understood that a promise of a child from Abraham's body was a one-flesh promise for a child from *her* body as well.

If we don't understand God's sovereign power, we'll ultimately rely on our own power and resources. If we don't believe His infinite wisdom, we will lean on our own understanding and reasoning. If we don't trust in His unfailing love, we will self-direct in self-reliance. It's impossible to wait on God, trust Him, or follow Him when we don't know and understand His character and promises. This lack of knowing

> An inadequate understanding of God will always lead to an insufficient trust in Him.

God hinders our ability to trust and obey Him. This leads us to take things into our own hands and devise our own schemes to meet our own needs or fulfill our own dreams. Ultimately, this leads to compromise—with long-lasting consequences.

Proverbs 3:5–7 wisely summarizes, "Trust in the LORD with all your heart and lean not on your own understanding [logic, scheming, wisdom]; in all your ways submit to him [trust and obey God's promises and instructions], and he will make your paths straight [clear the way for a straight way forward]." Further, "Do not be wise in your own eyes [don't rely on your own logic and wisdom]; fear the LORD [submit, trust, and surrender to God's authority and direction] and shun evil [avoid all evil at all costs]" (amplified by the author).

IS ANYTHING TOO HARD FOR THE LORD?

The core question of Sarah's life was later called out by the Lord. After Ishmael was 14 years old, the Lord visited them in angelic form, proclaiming that a child from *both* Abraham and Sarah would be born within a year. In response to their shock and disbelief, the Lord exposed the root of Sarah's distrust: "Is *anything* too hard for the LORD?" (Genesis 18:14, emphasis added). All her years of waiting, her struggle to trust and submit to God's way and His timing, all boiled down to her answer to that single question. Regrettably, 14 years earlier her answer was yes, having a child in old age was, according to Sarah, too hard for the Lord. She'd concluded it was just a little beyond His scope of authority or ability. The result? She, Sarah, believed she needed to help God do what He didn't seem able to do without her assistance.

Saying it like this sounds a little ridiculous, but it also reveals how we sometimes think. If God is really God, if He really is all-powerful, all-wise, and all-loving, why do we doubt? Why do we struggle with trusting Him? Why do we think that we know better? We hear God say XYZ, but we think ABC is a better strategy. At the root, our hearts ask the same question: "Is anything too hard for the LORD?" (v. 14).

Writing *Redeeming Eve* has been an extremely personal and soul-searching process for me. I've taught this material many times; and every time I've gleaned new insights into the life dynamics of these women. In writing this book, each truth has sifted my heart, my mindset, and my motives. This has prompted repentance and the resetting of some very deep places in my heart.

To be honest, I'd always held some judgment toward Sarah for taking matters into her own hands with such an obviously foolish scheme for building her family. What was she thinking?! During the season of my girls leaving the nest, I felt challenged to let them go and entrust them into God's hands. I saw some of my own fear surfacing. I stared at the temptation to *help* God *make sure* they went the right way and made the right decisions. But *right* according to whom?

Me?! I liked to think God shared my views and opinions. As I continued to labor to release, entrust, and surrender my children to God's guidance and authority, I empathized more with Sarah's struggle. My family isn't *mine* to build; it's God's to build. My job is to seek Him, to trust and obey and express my faith in love.

In repenting of my own tendencies to pressure, control, or fix, I've been convicted of having pride in thinking that I can make things and people better. As God has allowed challenges to get bigger than my ability to deal or heal, I have surrendered! I've called out to Him as the only one *big enough*. I'm not big enough to heal broken hearts. I'm not big enough to mend relationships. I'm not big enough to instill faith, ignite hope, or restore joy. Praise God, He is! He is big enough to heal *any* hurt. He is big enough to rescue, strong enough to save, and merciful enough to forgive. Relief and grace flooded my soul when I surrendered my needs and dreams for my family to His mighty, capable, and faithful care. My heart was released. And my peace restored.

GOALS AND DESIRES

Sarah—and I, if I am being honest—confused goals with desires. One of the wisest words of counsel on this I have ever heard is from Dr. Larry Crabb's book, *The Marriage Builder*. In it, he shares the concept that a goal must be something you can achieve without the help or cooperation of another person. A desire is something that requires the cooperation of another person.[25] Within that definition, you *work toward* your goals and *pray* for your desires.

Marriage provides a good example of what confusing goals and desires looks like, as well as what true goals and desires can be. If I make it my goal to have a good marriage, well, that requires the cooperation of my husband. I cannot achieve that goal alone. So, by definition, having a good marriage cannot be a goal.

When our goals require something of someone else, in our attempt to meet those goals, we can easily begin to pressure, control, or manipulate—whatever is needed to get others to meet *our* goals. Not many people appreciate our attempts to control them!

To properly align my marriage goals and desires, my goal can be to be a godly wife, to trust and obey God's Word and ways. I can do that with or without my husband or anyone else. My desire is that by living and relating in this way, my husband will also desire to relate in a godly manner—and as a result, our marriage will flourish. I can do *that* goal and pray for my desire.

Confusing goals and desires will lead to control and manipulation. Sarah's goal was to *get* Abraham a son, an heir. This was not something she could accomplish without the cooperation of another person—including God! And when God didn't cooperate with her goal, she moved on to plan B. She pressured her husband, then used and abused Hagar to accomplish her goal.

Sarah's goal could have and should have been to trust God, to actively seek Him with her questions. She needed to press into His character when her faith faltered and her heart hurt. She needed to remain in a place of worship and expectant wonder over how her faithful God was going to accomplish the seemingly impossible. If her goal had been to actively trust, her desire would have been kept in check. She could have submitted to God's sovereign timing and faithfulness.

CONTROL: ASSUMING GOD'S ROLE

Sarah assumed control and responsibility to make it happen. When we assume control, we falsely assume *responsibility* for making *others* into something we desire; and we will *always* overstep healthy boundaries. We'll find ourselves pressuring those we love and using them to meet our needs and self-serving goals instead of serving and loving them. This can be rooted in a well-meaning desire to do things right, to have a good marriage or build a good family. However, when *our* sense of responsibility to do things right morphs into feeling responsible for making sure *others* do things right, we move from love into the dangerous and violating waters of manipulation and control.

Control is not love. Control is not godly authority. Control is my exerting my own will, by personal power, onto someone else. Control violates love. It violates respect and dishonors the one we seek to control. Control is rooted in pride and fear: fear of failing, fear of loss, fear of abandonment—and pride in assuming we know better or are better able to direct others' lives than they are themselves. To the extent that we do not rest in a trusting love relationship with the Lord, we will lean on our own attempts to control to bring security, love, and success.

Control and trust are opposite. To the extent that we trust God, we will relinquish our attempts to control. Conversely, where we struggle with trusting God, we will trust our own personal power, opinions, and strength to exert control.

In truth, we don't really have control over anyone or anything besides ourselves. You can control only yourself—your thoughts, actions, attitudes, and responses. Taking personal responsibility for our own selves is more than enough to keep us busy!

Sarah's confused goals and desires led her to lean on her own understanding and devise her own plan. When Abraham doubted God's promise as the years progressed, he actively sought God and asked Him if he understood Him correctly. Each time Abraham inquired, God graciously and generously answered and reassured him.

CORRUPTED INFLUENCE

Sarah didn't inquire of the Lord. She did not seek Him for herself; neither did she take her doubt and confusion to the Lord. She didn't even take her question to Abraham. Rather, she wrestled with her own thoughts, in her own mind, with her own jumbled and conflicting emotions. When we stay isolated and silent, not seeking godly input or sharing our struggles, we can easily think ourselves into a hole and find ourselves drowning in a well of distorted unbelief.

While *not* consulting God, Sarah still *used* God in her persuasive argument for plan B. "The LORD has kept me from having children" (Genesis 16:2). Basically, she was persuading Abraham with the argument that, since God had kept her from having children, *obviously* He had a different plan in mind for providing Abraham with an heir. In this moment, she usurped God's authority, replacing it with her own. Yet she still tried to justify her plan by *borrowing* God's authority. She implied that she'd heard from the Lord by bringing Him into the conversation. Her confused goals led to manipulation and spiritualizing an unspiritual argument. Beware of wielding God's Word to manipulate! Don't use God's name with a spirit of control. Don't speak for God when you have not heard from Him!

> When we stay isolated and silent, not seeking godly input or sharing our struggles, we can easily think ourselves into a hole and find ourselves drowning in a well of distorted unbelief.

Unfortunately, Abraham listened to her. Sarah encouraged her husband to listen to her instead of seeking the Lord and listening to Him. She indirectly implied her plan was from the Lord. Sarah, like Eve, had a sacred influence in her husband's life, but she misused it, influencing Abraham to dilute the promise of God, to compromise the integrity of their marriage, and ultimately, to sin.

Ladies, we have influence, for better or for worse. We can use this powerful trust and influence to move our loved ones toward trusting and obeying God . . . or into unbelief, self-reliance, and sin. Our influence can be driven by pride, fear, or selfishness. Or it can be fueled by purity, trust, and honor. Wield your influence wisely.

Whatever the internal motivations, Sarah's influence was corrupted. Abraham and Hagar conceived, and she bore a son. Predictably, it all started to fall apart before the child was even born. The consequences of Sarah's lack of trust manifested by upsetting the order, balance, and peace in their home. Rather than acknowledging any personal responsibility, Sarah blamed Abraham and punished Hagar.

As with Leah, what might have happened if failure had been followed by genuine humility and repentance? When the fruit of their decision began to sprout its poison, imagine if Sarah had bowed to the conviction and repented: *Abraham, I was wrong. I gave into fear and doubt, and I pushed you into compromise. I am so sorry! This is not what God said or promised. I don't know what to do now, but we need to seek the Lord for help.*

Or, in supernatural humility, what if she had gone to Hagar? *Hagar, you have served us faithfully and respectfully. It was wrong of me—of us—to expect such a sacrifice from you and to make such a life-altering decision for you, without consulting you. I am truly sorry. And while we cannot undo what has been done, we can tell you that we will support you and give you your freedom. This child is your child. I will not forcibly take your baby from you. This whole thing was wrong. Please forgive me.*

But pride won. Pride causes us to justify bad decisions instead of admitting them. Pride traps us into staying with bad decisions just to prove ourselves right. Pride prevents us from acknowledging failure and sin—and breaking free. Sometimes we have so much invested in our bad decisions that we just keep on investing more, throwing good money after bad.

Eventually we will be humbled. "God cannot be mocked. A man reaps what he sows" (Galatians 6:7). It may have taken years of living with the consequences of her self-directed plan for Sarah to move toward humility and repentance, and away from her pride and insistence that this was all someone else's fault.

THE PROMISE GIVER IS A PROMISE KEEPER

When Ishmael was 14, the Angel of the Lord visited Abraham announcing, "I will surely return to you about this time next year, and Sarah your wife will have a son" (Genesis 18:10). And Sarah indeed had a son. They obeyed God and named him Isaac, which means *laughter*. In keeping with His promise, it was at this time that God changed their names. Abram, *exalted father*, became Abraham, *father of a multitude*. Also, Sarai, meaning *princess*, was changed to Sarah, *mother of nations*.

As the new parents relished the joy and wonder of young Isaac, savoring precious moments with their child of a promise fulfilled, the dethroned and displaced Ishmael began mocking his brother. Ishmael understandably resented Isaac, the little intruder who had stolen the attention of his father and completely consumed the love of his other mother. Abraham and Sarah finally had what they had been believing, hoping, and praying for all these years! *This* son truly was the child of the promise! Resentment toward Isaac, possibly bordering on a dangerous loathing, grew in Ishmael's heart.

DISENTANGLED

Sarah saw that Ishmael was mocking Isaac. According to Strong's H6711, *ṣāḥaq* means, *mocking*: "to laugh outright . . . scorn, by implication, to . . . make sport."[26] As a mother, Sarah likely was discerning the undercurrents of resentment in the teasing. This wasn't playful childhood banter. Mocking implies a more menacing, contempt-filled toying with a younger brother. In response, Sarah told Abraham, "Get rid of that slave woman and her son, for that woman's son will never share in the inheritance with my son Isaac" (Genesis 21:10). Her lack of attachment to Ishmael and the lack of any grief in sending him away is glaring evidence that her plan to "build a family" (Genesis 16:2) through Hagar had completely backfired. There was no family. Ishmael clearly was not her son. And with the arrival of the promised son Isaac, Sarah was done with the charade and entanglement caused by her compromise.

Deeply distressed, Abraham, to his credit, did not simply take Sarah's advice. This time, before blindly following the lead of his wife, Abraham took the matter to the Lord. God confirmed the wisdom of Sarah's instruction. He comforted and reassured Abraham that God himself would also be faithful to Ishmael, while simultaneously making it clear that Isaac was the child through whom God's promise to bless all nations would be fulfilled.

I cannot begin to comprehend the emotions each person experienced as they disentangled and detached from one another. Abraham clearly grieved for his son. Sarah might have finally seen a light at the end of the tunnel, a new day, a fresh start, and freedom from her prison of regret and dysfunction. Was Hagar grieved at the loss of her home—or relieved to finally gain her freedom? Did she feel rage at being used and then discarded, or rejoice at finally being released?

And Ishmael . . . how could this teenage boy reconcile the drama and trauma of his life? His father was his father—but wouldn't be anymore. His mother was

sort of his mother—but his other mother was his *real* mother. He was no longer the heir of his father's kingdom and estate after the little prince was born. No wonder he became "a wild donkey of a man" whose hand was "against everyone and everyone's hand against him." Predictably, he lived "in hostility toward all his brothers" (Genesis 16:12).

Who could have imagined the result of one misguided idea, one self-directed plan on the lives and relationships of so many? Ladies, we each have influence in our own homes, families, and communities. Leadership is influence. You don't have to hold the position of leadership to have powerful, undeniable influence for good or for evil. We must pause and consider our goals. What are we pursuing with our influence? There is a cost. We reap what we sow. Steward your influence wisely.

FAMILY FALLOUT

Consider the cost to Sarah's relationships. Her plan B caused her beloved husband great pain. True, Abraham was not an innocent bystander or a helpless victim in this scheme. Regardless of his role and responsibility, Sarah still used her influence to mislead him. Tension, disunity, and eventually great loss were the results. In the end, Abraham released his first-born son, potentially never to see him again.

In her relationship with Hagar, Sarah's influence was purely self-seeking and self-absorbed. Sarah showed no empathy or care for Hagar. She willingly used and abused her. After that, when she no longer needed Hagar, Hagar became disposable to her.

Perhaps even worse was Sarah's inconsistency in relationship with Ishmael. She was initially committed to him as long as he served her goals and needs. We don't know if a mother-son dynamic between them was ever really established. It may have been undermined from the beginning. Or perhaps Sarah's initial intentions and bond slowly disintegrated in the complexity of a two-mother household. Regardless of how, if, and when the mother-son bond developed, it totally evaporated when Isaac arrived. Because she no longer benefited from Ishmael, Sarah's commitment and engagement declined. Eventually she completely abandoned and renounced him as her son.

Sarah's sin against Hagar and Ishmael is still wreaking havoc on the world today. For from Isaac came the Jewish nation. From Ishmael came the Arab nations. And as God foretold, these two half-brothers would live in hostility. Wars have been fought and will continue to be fought. All from the fruit of Abraham's compromise and Sarah's moment of faltering faith, self-reliance, and corrupted influence.

What were the consequences in Sarah's relationship with God? When she heard the promise of a son from *her own* body, she laughed. First, I imagine she thought in astonishment, *Seriously?!* Now, *after all this time*, now *I am to have a child?!* Her first reaction was likely followed by a nervous laugh, as in *Uh-oh, this is going to get complicated.* It may have been a half-hearted *Ha ha* while inside her mind accused her: *What about the* other *son you already schemed to get?!* A guarded chuckle may have hidden the uncomfortable fact that they *already* had a son.

When God asked why she laughed, Sarah was afraid—afraid to face God with the truth of her circumstances. Rather than confess her angst behind her laugh, she lied and claimed, "I did not laugh" (Genesis 18:15). Like Adam and Eve before her, Sarah's natural response to sin was fear and hiding from God. She tried to hide the truth, perhaps hoping to avoid the entire uncomfortable conversation. In the same verse, God graciously and simply called her out, "Yes, you did laugh." He let her know He had seen. He had heard. He was fully aware. There was no hiding from Him!

MESS MEETS MERCY

Then God did something astonishing. God knew she was guilty. He was completely aware of the royal mess she'd made. But look at God's response: He did not confront her with what she had done. He did not rebuke or scold her. He did not chastise or punish her. God waited, allowing reality and the consequences of her disobedience and unbelief to play themselves out, until Sarah herself saw the folly of her own actions. Then He met her with *mercy*.

My friend, we all mess up. We all fall short. We all make mistakes and deal with the pain and fallout of them. God is fully aware. Those mistakes are not hidden. That fact alone is slightly terrifying if it were not for God's incredible love and mercy. While God is clearly aware of our sin and shortcomings, His *desire* is not for our punishment and condemnation, but for our freedom, healing, and restoration.

> While God is clearly aware of our sin and shortcomings, His *desire* is not for our punishment and condemnation, but for our freedom, healing, and restoration.

God responded to Abraham and Sarah's predicament with *faithfulness* and *grace*. Grace is the free and unmerited favor of God. It is receiving blessings we haven't earned and don't deserve. It is being forgiven by God because He paid the price for our sin, cancelling the debt we owed. Grace is unconditional love

that can't be earned or lost. Grace is love rooted in the character and nature of the giver. It is not dependent upon or determined by the character or behavior of the receiver.

If you've ever been forgiven, truly forgiven for something awful, knowing that you could never change it, earn it, or fix it, you've experienced a taste of grace. God loved Sarah. He understood her life struggle. He forgave her doubt and her misused influence. In His grace and mercy, He still blessed her with a son. He fulfilled His promise because of *His* character, not because of *hers*. In doing so, He answered in a profound and powerful way, the question of Sarah's heart: "Is anything too hard for the LORD?" (Genesis 18:14).

In His infinite wisdom and love, God waited until Sarah and Abraham were well past the age to bear children, until it was impossible. God waited until they had exhausted all their other resources and self-reliant attempts to make it happen. God waited until they were fully aware that it would take a miracle. Then, finally . . . "the LORD was gracious to Sarah as he had said, and the LORD did for Sarah what he had promised" (Genesis 21:1).

Isaac, the long-awaited promised son, was born. Sarah laughed again—this time in joyful response to the awesome mercy and faithfulness of God. She laughed in awe and wonder. Her dormant dream and hijacked hope sprang back to life in one incredible moment of grace. Sarah laughed. Abraham laughed. God laughed. Celebrating this wonder of grace and obeying God's command, Abraham pronounced their son's name to be Isaac, meaning *laughter*.

Filled with overwhelming joy, Sarah announced with glee, "God has brought me laughter, and everyone who hears about this will laugh with me" (v. 6). Smiling ear to ear, a deep laugh bubbling up from inside, she laughed again, "Who would have said to Abraham that Sarah would nurse children? Yet I have borne him a son in his old age" (v. 7).

In His great faithfulness and unfathomable mercy, God forgave. Then He blessed and fulfilled His promise to Abraham and Sarah. God's faithfulness to His Word is not dependent on our performance. We do not have the power to thwart the hand of God. We don't derail His plans and purposes with our disobedience or unbelief. God is able to do all He says He will do. We and our sin, or others' sins against us, are not big enough to block the purposes of God. The story isn't over until it's over.

However, our sin will still have consequences. God promises that we also reap what we sow. Abraham and Sarah reaped the consequence of living nearly two

decades in the dysfunctional family environment that their faithless decisions had created. God not only showed His grace and mercy in giving them a son, He also helped them untangle themselves from the mess they'd made.

No matter what kind of mess you find yourself in, what kind of snare you have become entangled in, God is able to provide you with a way out. He can disentangle you and set your feet back on the path of His purpose. Like Abraham and Sarah's, that process may involve pain and loss. It may require letting go of the things you have held on to for identity or releasing your grip on relationships you cling to for security. You may need to renounce patterns of behaving and relating that are contrary to God's way and His Word. But the pain will be worth the freedom. There is always a road home. No matter the mess, God is big enough to redeem, merciful enough to forgive, gracious enough to heal. Come clean! Receive His powerful restoration in your broken places. Dare to dream again. There is hope! There is healing! Your heart will laugh. For truly, nothing is too hard for the Lord!

Lord Jesus,

You are the one who plans our days. You are sovereign and in control. Lord, help me to trust you as I wait on you. Help me to believe in your goodness and your faithfulness to me, even when I don't see it. Lord Jesus, I forsake my own efforts to make things happen in my timetable. I repent of my attempts to fix or control people and circumstances. Please give me the wisdom to discern godly goals and desires. Heal my relationships from my control, pressure, and manipulation. I release others to you and your faithful work in their lives. I trust you. Truly, nothing is too hard for you!

In Jesus' name, Amen

DISCUSSION QUESTIONS

1. Sarah struggled with trusting God in some areas of her life. This lack of trust led her to try to control in that area. Is there an area of your life for which it's difficult to believe and trust God? Has this led to controlling behavior? If so, how?

2. Control is always destructive to others. How has your need to control hurt yourself, your relationships, and other people?

3. Goals are what we can do without others' cooperation. If something requires others to participate, it's a desire. You can only do you. In your area of struggle, choose a goal that only you can do. What is the desire you'll pray for?

8

ABIGAIL: A VOICE
AND A CHOICE

Abigail is famous for one of the most courageous acts of wisdom and diplomatic intervention in the Bible. The intelligent and beautiful wife of an obnoxious drunk, she found herself caught in the crossfire of a belligerent husband, an insulted and justifiably enraged king, and impending disaster for her entire household. She masterfully disarmed the offense and neutralized the threat. Her wise and bold intervention is a profound lesson in diplomacy, courageous honor, and respectful submission without subjugation.

> *A certain man in Maon, who had property there at Carmel, was very wealthy. He had a thousand goats and three thousand sheep, which he was shearing in Carmel. His name was Nabal and his wife's name was Abigail. She was an intelligent and beautiful woman, but her husband was surly and mean in his dealings—he was a Calebite.*
>
> *While David was in the wilderness, he heard that Nabal was shearing sheep. So he sent ten young men and said to them, "Go up to Nabal at Carmel and greet him in my name. Say to him: 'Long life to you! Good health to you and your household! And good health to all that is yours!*
>
> *"'Now I hear that it is sheep-shearing time. When your shepherds were with us, we did not mistreat them, and the whole time they were at Carmel nothing of theirs was missing. Ask your own servants and they will tell you. Therefore be favorable toward my men, since we come at a festive time. Please give your servants and your son David whatever you can find for them.'"*

When David's men arrived, they gave Nabal this message in David's name. Then they waited.

Nabal answered David's servants, "Who is this David? Who is this son of Jesse? Many servants are breaking away from their masters these days. Why should I take my bread and water, and the meat I have slaughtered for my shearers, and give it to men coming from who knows where?"

David's men turned around and went back. When they arrived, they reported every word. David said to his men, "Each of you strap on your sword!" So they did, and David strapped his on as well. About four hundred men went up with David, while two hundred stayed with the supplies.

One of the servants told Abigail, Nabal's wife, "David sent messengers from the wilderness to give our master his greetings, but he hurled insults at them. Yet these men were very good to us. They did not mistreat us, and the whole time we were out in the fields near them nothing was missing. Night and day they were a wall around us the whole time we were herding our sheep near them. Now think it over and see what you can do, because disaster is hanging over our master and his whole household. He is such a wicked man that no one can talk to him."

Abigail acted quickly. She took two hundred loaves of bread, two skins of wine, five dressed sheep, five seahs of roasted grain, a hundred cakes of raisins and two hundred cakes of pressed figs, and loaded them on donkeys. Then she told her servants, "Go on ahead; I'll follow you." But she did not tell her husband Nabal.

As she came riding her donkey into a mountain ravine, there were David and his men descending toward her, and she met them. David had just said, "It's been useless—all my watching over this fellow's property in the wilderness so that nothing of his was missing. He has paid me back evil for good. May God deal with David, be it ever so severely, if by morning I leave alive one male of all who belong to him!"

When Abigail saw David, she quickly got off her donkey and bowed down before David with her face to the ground. She fell at his feet and said: "Pardon your servant, my lord, and let me speak to you; hear what your servant has to say. Please pay no attention, my lord, to that wicked man Nabal. He is just like his name—his name means Fool, and folly goes with him. And as for me, your servant, I did not see the men my lord sent. And now, my lord, as surely as the LORD your God lives and as you live, since the

LORD has kept you from bloodshed and from avenging yourself with your own hands, may your enemies and all who are intent on harming my lord be like Nabal. And let this gift, which your servant has brought to my lord, be given to the men who follow you.

"Please forgive your servant's presumption. The LORD your God will certainly make a lasting dynasty for my lord, because you fight the LORD's battles, and no wrongdoing will be found in you as long as you live. Even though someone is pursuing you to take your life, the life of my lord will be bound securely in the bundle of the living by the LORD your God, but the lives of your enemies he will hurl away as from the pocket of a sling. When the LORD has fulfilled for my lord every good thing he promised concerning him and has appointed him ruler over Israel, my lord will not have on his conscience the staggering burden of needless bloodshed or of having avenged himself. And when the LORD your God has brought my lord success, remember your servant."

David said to Abigail, "Praise be to the LORD, the God of Israel, who has sent you today to meet me. May you be blessed for your good judgment and for keeping me from bloodshed this day and from avenging myself with my own hands. Otherwise, as surely as the LORD, the God of Israel, lives, who has kept me from harming you, if you had not come quickly to meet me, not one male belonging to Nabal would have been left alive by daybreak."

Then David accepted from her hand what she had brought him and said, "Go home in peace. I have heard your words and granted your request."

When Abigail went to Nabal, he was in the house holding a banquet like that of a king. He was in high spirits and very drunk. So she told him nothing at all until daybreak. Then in the morning, when Nabal was sober, his wife told him all these things, and his heart failed him and he became like a stone. About ten days later, the LORD struck Nabal and he died.

When David heard that Nabal was dead, he said, "Praise be to the LORD, who has upheld my cause against Nabal for treating me with contempt. He has kept his servant from doing wrong and has brought Nabal's wrongdoing down on his own head."

Then David sent word to Abigail, asking her to become his wife. His servants went to Carmel and said to Abigail, "David has sent us to you to take you to become his wife."

She bowed down with her face to the ground and said, "I am your servant
and am ready to serve you and wash the feet of my lord's servants." Abigail
quickly got on a donkey and, attended by her five female servants, went with
David's messengers and became his wife.

1 SAMUEL 25:2–42

Abigail is my hero. She was a woman who knew who she was and what she was about. She was fiercely strong in her convictions and incredibly tender in her heart. She was bold and she was submissive. She was righteous and she was merciful. She was noble and she was humble. She was loyal and she was independent. She was truthful and she was gracious. She was wise and she was winsome. Basically, she was simply amazing!

Like the other women we've met so far, Abigail had advantages and disadvantages. She possessed gifts and endured some very real challenges; yet unlike Rachel and Leah, she did not define herself by them. She was a beautiful, intelligent woman who found herself married to a difficult man whose mean, combative, and arrogant nature was only exacerbated when he was drunk. Like Rachel, Abigail could have focused on what she didn't have. She did not have a respectable husband or the marriage she desired and was capable of having. She did not have the security, friends, and community that an honest man brings to the table.

Nor did she, like Leah, base her identity on what she was not. She was not living in a household where people were treated with honor or respect. She was likely not treated kindly or tenderly. Her husband was surly and mean. In Strong's, the Hebrew root word *surly* means "hard, cruel, severe, obstinate . . . difficult . . . stubborn."[27] Similarly, *mean* is defined as "bad, evil . . . disagreeable . . . unpleasant,"[28] a far cry from any woman's dream man.

WE HAVE A CHOICE

Living in an unsatisfying marriage to a disrespectful and foolish man, Abigail had a choice. When women are faced with dysfunctional, codependent, or addictive spouses, they often make one of two choices. They give up and give in to the sin of their husbands, resigning themselves to live with it. Or they attempt to balance or manage their husbands' sin, trying to hide and justify reality. Resignation

leads to unholy subjugation and fosters a victim mentality. Controlling leads to manipulation and their own dysfunction and codependency.

Abigail did neither. Faced with Nabal's sin, Abigail did not just take it, believing she was a powerless victim. She stood on a powerful truth: *You always have a choice.* No matter which challenges you face, you always have the *power* to choose. You cannot choose what others do or don't do. You cannot control what others do *to* you. But you *can* choose to do you: your *actions*, your *response*, your *limits*. Abigail couldn't control her husband's sinful response to the king. However, she knew she had the power to choose *her* response. And she did.

Abigail didn't slip into codependency with her husband's sin. She did not try to control it or manage it. Nor did she justify, deny, or hide it. She didn't unwittingly perpetuate it by making it more acceptable or livable. She didn't become part of it at all. She remained separate from his sin and dysfunction. In no way did she partake in, promote, or accept it. She maintained her boundaries and limits—and her power to respond.

> *You always have a choice.* No matter which challenges you face, you always have the *power* to choose.

So often we see women, in an attempt to cope with the sinful behavior of their spouses, try to make something that's unacceptable . . . somehow acceptable. They make excuses and go to great lengths to justify and modify reality. Of course, that never works. Although denial is understandable as a coping mechanism, in reality it's just a form of self-delusion.

LIVING LOVED IN UNLOVELY CIRCUMSTANCES

Abigail didn't base her identity in either her husband or her circumstances. Like Esther, who also found herself in challenging circumstances, Abigail knew she was a child of God. She was first and foremost a follower of the Most High God. She committed herself to living out of her God-given identity and reality. She devoted herself to being the best she could be, doing the best she could do, in whatever circumstances she found herself. She dedicated herself to following God and His ways in all her dealings. She pledged to serving God and *His* purposes in the relationships in her life.

In spite of a dishonorable husband, Abigail courageously lived honorably and respectfully. Like Esther, she made the best of her circumstances and committed to be the best she could be within each relationship. While she couldn't control Nabal,

she could—and did—control herself. She did what was within her power, ability, and authority to do. She apparently ran her household well and treated her servants with honor and dignity. They returned her respectful leadership with deep trust, obedience, and loyalty. They followed her and they relied on her. When faced with the threat of retaliation from Nabal's drunken insults, they immediately sought her wisdom and leadership. They readied themselves to obey her thoughtful direction.

Nabal's drunken arrogance provoked a fight with the warrior king. The customs of the day and the nature of the insult are somewhat foreign to our culture. However, it's clear that everyone involved, from Nabal, Abigail, and their servants, to David and his fighting men, understood the gravity of the offense and the impending disaster it brazenly invited.

As a follower of God, Abigail's goal was to "love the LORD [her] God, to walk in obedience to him and to hold fast to him" (Deuteronomy 11:22), which is summarized in the greatest commandment, to love God and love others. Her devoted obedience was expressed in serving *God's* interests in her relationships and dealings.

Love protects. Love provides. Love pursues. It acts. Love *does*. Love is not passive. It's a noun, but it's a verb too. You cannot love without loving; without *doing* love. Love is nothing if it *does* nothing. Abigail loved deeply. Her love is showcased in her response to David's need, her husband's folly, and her household's crisis.

Abigail's response sheds some much needed light on what godly submission is in a marriage relationship. We see that Abigail "acted quickly" (1 Samuel 25:18). She prepared a generous gift of provision for David and his men. "But she did not tell her husband Nabal" (v. 19).

SUBMISSION VS. SUBJUGATION

Did Abigail act in disobedience or rebellion to her husband? Were her actions wrong? Was she guilty of being unsubmissive or disrespectful? One school of thought carries the principle of submission between a husband and wife to an extreme conclusion—not taught in scripture—that more resembles slavery than godly honor. This unbiblical extreme is often justified by a misinterpretation of the Genesis account regarding Eve and the curse, namely, that her husband would rule over her. But as we saw, this *ruling over* was *not* God's design for marriage, it was the result of and the curse of sin.

Submission is an emotionally loaded word. In the name of submission, sinful authorities have justified exploitation, abuse, and oppression. On the flip side, in the name of rejecting ungodly authority, some reject *all* authority, attempting to

justify rebellion and disrespect. Abigail's actions paint a vibrant, authentic picture of what biblical submission is—and is not.

A few definitions may be helpful to lay a foundation. Webster's definition and the original Greek meaning for the word *submit* are almost identical. Webster's defines *submit* as "to yield one's opinion to the opinion or authority of another."[29] To yield is to "give way . . . to cease opposition; to be no longer a hindrance or an obstacle . . . end resistance . . . move in order to make room for someone . . . cease opposition, [or] stop fighting."[30]

By definition, *submission* does not mean being controlled. It is not being coerced. It is not being dominated or ruled over. Submission, by definition, cannot be demanded or taken; it can only be voluntarily given.

Some confuse *submission* with *obedience*. The Greek word used in Ephesians 5:21–22 and 1 Peter 3:1, commanding husbands and wives to submit to *one another*, as well as telling wives to submit to their husbands, is this word *submit* (Strong's G5293). It is "to arrange under . . . to subject one's self . . . to yield to one's admonition or advice."[31] Submission is yielding. Yielding is choice. It is an opportunity to willingly, *voluntarily* take into consideration another's perspectives, thoughts, and feelings. Essentially, biblical submission is reminding us to consult, consider, and cooperate with our husbands.

The Greek word for *submission* between husband and wife is not the same as *to obey*, as in "Children obey your parents" (Ephesians 6:1) or to obey authorities. That word in the Greek is Strong's G5219, which means "to hear under (as a subordinate) . . . to heed or conform to a command or authority."[32] A subordinate has a lower rank or position in an authority structure. Subordinates are under the authority or control of another. This word can even mean to be treated or regarded as being less important within the authority structure.

Wives are not told to obey their husbands in this subordinate, authoritative, command-and-control way. This is not what God said, nor is it what He ever intended. Godly submission is *not* the same as *subjugation*. According to Webster's, to subjugate is "to subdue, to bring under the yoke of power or dominion, to conqueror by force, compel to submit . . . put down by force or intimidation . . . quash, repress . . . keep down, reduce."[33] Subjugation uses coercion, force, threats, fear, personal power, and intimidation in order to control. This is *never* justified or condoned by God in the name of biblical submission.

The submission God spoke of in the Bible is a beautiful commitment of cooperative consideration of one another's needs, thoughts, and feelings. In biblical

submission, there's no power struggle or dominance. *This* submission serves the well-being of the other. It's deferential and respectful, intentionally thoughtful and protective. In Abigail, we see godly submission to and consideration of her husband, without her coming under ungodly subjugation.

NEVER SUBMIT TO SIN

Abigail exemplified how to submit to and respect a sinner without submitting to the sin. She submitted to God's ways and His purposes first and foremost. In doing so, she exhibited protective love for *all* her household, including her abusive husband. Her ultimate authority was the Lord; subsequently, her purpose was to do right. She did not allow herself to be coerced or bullied into submitting to Nabal's sin. Submission to God *always* trumps submission to anyone or anything else.

> Submitting to sin or dysfunction is *always* disobedience to God.

Submitting to sin or dysfunction is *always* disobedience to God. If you submit to sin in the name of obeying God's command to submit to your husband, you are *disobeying* God. We cannot use the idea of *obeying God* as an excuse to disobey Him! Said like this, it might sound ridiculous, but it's easier to fall into this trap than you might think.

For example, if your husband is dishonest on his tax return or his expense report and you know it; but in the name of submission, you say nothing and go along with it, you have joined his sin and are also guilty of tax fraud and theft. Or if your husband wants you to watch porn with him and you join him in this sin, you are guilty of sexually exploiting others, contributing to sex trafficking, and violating the sexual purity of your marriage. Perhaps the most cruel and evil application of perverted submission is to be silent and complacent in the face of a husband who physically abuses your children. If you submit to this, you join his sin and share his guilt of abuse. In short, we are *never, ever* to submit to sin.

The servants reported Nabal's provoking insults and the subsequent imminent danger to the household. Abigail quickly and assertively assumed personal responsibility for her relationships with both the servants and David. She didn't sit by and passively resign herself to their fate at the hands of Nabal's sin. She didn't justify inaction with false submission. She did not embrace victimhood with unconditional compliance and coming under subjugation.

Rather, she boldly and courageously exercised what was within her authority and power to do. Abigail was the woman of the home. The servants reported to

her. She ran the kitchen and the domestic affairs of their household. Knowing she had no time to lose, she took stock of the food inventory they had on hand. She rapidly made preparations to deliver the provisions to David and (hopefully) intercept him before he reached their home. All of this *was* within her power and authority to do.

Sometimes women have been convinced they have no power or authority in their own homes or within their own lives. However, God has given every one of us a voice and a choice. True, some choices may be costly and require great courage and faith. But know God is with you, He is for you, and He will honor your trust and obedience. He can make a way where there seems to be no way.

You have the authority and responsibility to manage your time, passions, energy, and relationships—to use your voice and make your choice. Beware of coming under the spirit of subjugation and domination. Renounce victimhood and take personal responsibility for your life. Steward your freedom, influence, and authority wisely.

COURAGEOUS INTERVENTION

Abigail used her influence to save Nabal's life. She responded differently from him, and independently of his sin. However, she was not self-serving. Rather, she was God-serving; and she served Nabal's *best* interests, which is different from serving his sinful *self*-interest. Love protects. Abigail's courageous intervention in meeting and diverting David's army saved Nabal from his own folly.

She willingly did what was right. She was honest with Nabal. While she prudently did not tell him *before* she acted, she did not hide it or lie about it. Upon returning home to an intoxicated husband, Abigail wisely and respectfully protected him from further sin by waiting to share with him the events of the day until he was sober.

Her communication with Nabal further revealed Abigail's respect and character. She calmly, confidently, and clearly shared the entire story with Nabal. She lived out Ephesians 4:15—She spoke the truth in love. She did not yell or come emotionally unhinged. She didn't belittle or blame him. She simply told the truth. Rather than shield him from the truth, she let the full weight of it land on him.

Her intervention saved Nabal's life, along with her own and those of all their household. She separated herself from her husband's sin. She protected *both* of them, upholding the oneness of their marriage. Her righteous choices and actions *blessed* her husband. She didn't take advantage of him, exploit his weakness, or

manipulate his drunkenness for her own benefit. Rather, she detached herself from it. She refused to communicate significant things to him while he was under the influence of alcohol. What incredible wisdom and self-control! She did not need Nabal, but she still honored and blessed; she was faithful to him.

Abigail also showed incredible wisdom in how she related with the king-to-be. She met David and his men roaring down a mountain ravine, swords blazing, bent on war. Immediately she moved out in front of her servants. Surrounded by generous provision for David and bowing low, she submitted herself to David and began her wise and gracious appeal.

We can learn as much from what Abigail *didn't* do in this moment as we learn by what she did do. She didn't move into self-preservation overdrive. She didn't just gather up her favorite servants and flee the house, leaving evil Nabal and his buddies to get what they deserved. She could have viewed David's rage as an answer to her prayers for deliverance from a difficult marriage. She could have rushed out to meet David, pointed her finger toward her unsuspecting husband, and said, *Go! Get 'em! God be with you!* She could have spurred David on toward Nabal's annihilation, but no. She didn't capitalize on the opportunity to harm her husband and save herself.

WE HAVE A VOICE

Abigail didn't focus on saving herself or Nabal at all. Instead, she focused on saving David from himself. She greeted David, not with a plea, but with provision. Before she even spoke a word, the donkey food-and-wine brigade intercepted David and his men. Abigail generously met David's legitimate needs. She honored his request. She righted the wrong. Before she even spoke, her actions were speaking louder than words.

She bowed down, respectfully acknowledging David's authority as the future king and submitting herself to him. Her response was the opposite of her husband's. She showed as much honor to David as Nabal had shown dishonor. She didn't pretend that all was well—or that the gift of food would make everything better. Instead, she truthfully and tactfully acknowledged the offense. Abigail did not try to justify or gloss over Nabal's unacceptable behavior. She was not in denial. She didn't make excuses or try to explain away the offense. She called it what it was: foolish. *Fool* was Nabal's name, and it matched his insulting behavior.

Then Abigail began to speak one of the most eloquent and profound appeals ever recorded. With uncommon grace and courage, Abigail appealed to David's

own deep love and trust of his Lord, the Lord God. She reminded David that he, too, was under the authority, care, and protection of one greater than both of them. It is this Lord, *the* Lord, who had sent her to intervene and keep David from the needless bloodshed of avenging himself. Her words revealed her goals: to protect David from sin, to keep his hands clean, to protect his honor and integrity, to encourage him to trust in the Lord's protection and provision.

If we are being honest, how often are our motives selfless, noble, and pure? We communicate—and we communicate a lot! But what is the driving motive behind our communication? Is it to be right? To get our needs met? To get what we want? Are we seeking to be esteemed or respected? To prove our value or worth? To show someone else is wrong? To win?

Assessing our ultimate motives can be very revealing. How often can we truly say that our primary motive is to honor and esteem someone else? To build them up in love and truth? To encourage their faith and hope in the Lord? To protect them from sin and bless *them*?

Her strategy was beautiful. She acknowledged her husband's wrong, confessed God's intervention in protecting David from sin, and made things right with a bountiful gift of food. Then she deferentially but boldly used her voice to appeal to David's integrity.

> *Please forgive your servant's presumption. The* Lord *your God will certainly make a lasting dynasty for my lord, because you fight the* Lord's *battles, and no wrongdoing will be found in you as long as you live. Even though someone is pursuing you to take your life, the life of my lord will be bound securely in the bundle of the living by the* Lord *your God, but the lives of your enemies he will hurl away as from the pocket of a sling. When the* Lord *has fulfilled for my lord every good thing he promised concerning him and has appointed him ruler over Israel, my lord will not have on his conscience the staggering burden of needless bloodshed or of having avenged himself. And when the* Lord *your God has brought my lord success, remember your servant.* (1 Samuel 25:28–31)

Brilliantly and strategically, she reminded David of his past—he had fought the Lord's battles; remember Goliath? Then she pointed to his future—God had already anointed him to be the king of Israel. She did it to protect his present, saving him from avenging himself and carrying the guilt of needless bloodshed.

SPEAKING TRUTH IN LOVE

She lifted up the Lord as faithful and true. The God who called David, fought for him, protected him in the past, was the same God who would fight for him and protect him in the present. She exhorted David to place his trust in the faithful, powerful hands of God rather than taking matters into his own hands. She essentially encouraged him to remember God's protection, provision, and vengeance in the past. God would be faithful to him and fulfill *all* He had promised him.

Abigail appealed to God's greater purposes in David's life. *You are chosen, anointed, and destined to be king! Don't get baited into a petty squabble with a foolish drunk over a meal! You are a king and son of the Most High God. Stand on it. Rest in it. Act like it.* Her truth-filled appeal to David served *God's* purposes in his life. She dissuaded him from sin. She stirred his faith. Her redirection restored his vision and focus.

There is profound power in speaking the truth in love. When we appeal to God's best for others, when we care for their best interests to be served, when we advocate God's plans and purposes for them, that's when our words can change another's heart—or the world. When our motives are for the best for another, defenses come down; self-protection is disarmed, and our words are received as a gift.

Abigail could have resorted to a less noble appeal. She could have appealed to his pride: *You are the greatest man alive; you don't need to fight a puny guy like Nabal.* She could have appealed to his shame: *You call yourself a servant of God and yet here you are about to avenge yourself! Where is your trust in your powerful God now?* Or she could have made a legal appeal: *You have no right to do this! Go get a warrant and get off my property! Until you are king, you can't do this!*

How often do we women attempt to persuade using criticism, guilt, or shame? A woman can manipulate by playing on and provoking a man's ego. These methods of influence are rooted in *our* pride, judgment, and sin. Shaming, blaming, and belittling are *never* godly ways to communicate. Resorting to personal power or a biting tongue is not an honoring strategy to share your needs, opinions, or desires. These are passive-aggressive, or just aggressive-aggressive—and disrespectful. Moreover, they are ineffective. While we may get some half-hearted, surface compliance, it will be temporary at best. Below the surface, a deep resentment and wall to intimacy will begin to grow. No one likes to be manipulated. No one appreciates being provoked, shamed, or controlled.

Further, Abigail did not appeal to David's flesh. She was beautiful, yes, but she did not resort to using her assets to influence his decision. She didn't hike up

her skirt and pull down her shirt, seductively sauntering up to David and hoping to sexually distract him from his mission. It's important to note Abigail's purity, dignity, and sexual respect as she related to David.

Finally, Abigail did not appeal to David's anger or offense. She could have added fuel to the already raging fire and then try to direct it to serve her purposes. I've known women who know how to play their husbands' emotions. They skillfully know which buttons to push to stir them up, provoke their shame, or rile their anger. Then they manipulatively direct those emotions to action that will accomplish their own agendas. This is *not* being a helpmeet or a partner. Instead, this wife acts as a puppeteer, exploiting her husband's weakness and vulnerabilities rather than protecting them.

APPEALING TO INTEGRITY

Abigail didn't do any of these sinful or self-serving behaviors. Instead, she appealed to David's faith and integrity. She reminded him of God's goodness and faithfulness. With calm confidence, she defused and disarmed the offense. The flames cooled. Masterfully, she redirected David's passion back to the promises and purposes of the Lord.

Her dignified submission and respectful appeal radically influenced her relationship with David. Abigail first won his respect and esteem. Later, she won his heart. She served God's interests in David's life. In doing so, she served David's best interests. David was so deeply impacted by her protective love and wise counsel that he praised God for sending her to him. The future king received Abigail's advice and gracious warning as a gift from God! He was not offended. He was not threatened. David was grateful.

"David said to Abigail, 'Praise be to the LORD, the God of Israel, who has sent you today to meet me. May you be blessed for your good judgment and for keeping me from bloodshed this day and from avenging myself with my own hands'" (1 Samuel 25:32–33).

When we purify our communication with protective love and respect, we will be *heard* and our counsel will be *heeded*. Our words

> Our words are truly wisdom when they're at the service of God's purposes.

are truly wisdom when they're at the service of God's purposes. If we forsake speaking out of selfish ambition (demanding our own way or needs) or our vain conceit (filled with our criticism and judgment), then our words will bring *life*

and *blessing* to others. They will be received with *gratitude* because they serve the best interests of those who hear.

This strategy is true for communication in *all* relationships. Most people will receive input more readily when it's delivered with honor and respect. Speak the truth in love rather than in judgment, in humility rather than in pride, and as encouragement rather than critique.

Abigail's words reveal a heart full of wisdom and love. "Out of the overflow of the heart, the mouth speaks" (Luke 6:45, BSB). Wisdom flowed through her to bless and guide those around her. Psalm 37:30 says, "The mouths of the righteous utter wisdom, and their tongues speak what is just." Further, a noble woman is described in Proverbs 31:26: "She speaks with wisdom, and faithful instruction is on her tongue."

Godly wisdom was the hallmark of Abigail's life. Wisdom protected and informed her. In wisdom, she believed and obeyed God's statutes. Psalm 111:10 reveals that all wisdom begins with reverence for the Lord and obeying His ways. Abigail's wisdom saved them all from Nabal's folly and David's fury. Proverbs 2:12 played out like a chorus over her life: "Wisdom will save you from the ways of wicked men, from men whose words are perverse."

TRUST AND TRIUMPH

In wisdom, Abigail submitted to the Lord her God. She entrusted her cause to Him. She trusted God with her precarious and challenging marriage. Rather than despairing, she committed to following God above all else and being the woman God had called her to be. Unlike Sarah, she did not concoct a wild scheme to *fix* her situation. She didn't run from the challenge or the heartache. She did not seek escape by running away physically, or emotionally escaping into addiction like her husband. Even when presented with opportunity, she didn't scheme to get out of her marriage. Rather, she exerted her authority and power to choose righteousness within her sphere of influence. In the midst of another's sin, she entrusted justice for herself, as well as David, to God.

God proved to be just. When Abigail told Nabal all that happened, "his heart failed him and he became like a stone. About ten days later, the LORD struck Nabal and he died" (1 Samuel 25:37–38). God avenged David and, in mercy, God released Abigail from her painful marriage. He worked salvation and deliverance. God took care of the justice. He honored Abigail's and David's trust and obedience and rewarded their submission and surrender to *His* timing and purposes.

David rejoiced when he heard Nabal's fate at God's hand. His heart welled with gratitude that he had not avenged himself but had left room for God's justice. "When David heard that Nabal was dead, he said, 'Praise be to the LORD, who has upheld my cause against Nabal for treating me with contempt. He has kept his servant from doing wrong and has brought Nabal's wrongdoing down on his own head'" (v. 39).

David's profound gratitude for Abigail's intervention morphed from deep respect and admiration to love and desire. Abigail won his heart with her wisdom and character, her courage, and her grace. "A wife of noble character is her husband's crown" (Proverbs 12:4). David saw, in the noble fortitude of Abigail's heart, a crown more desirable than gold. He saw the heart of a woman he could trust and love. David proposed and asked her to be his queen.

Abigail readily accepted. She *quickly* left her past to step into the future God himself had opened up to her. Abigail did not stay and wallow. She didn't draw back in fear or insecurity from the open door that God offered. With the same courageous trust she had exhibited in facing her past, she responded to her opportunities for the future. She went immediately, without reservation.

Years later, David celebrated God's eternal justice and faithful goodness in a song he wrote. Perhaps he was inspired as he gazed upon his wise and beautiful wife, recalling her prophetic counsel on the mountain, to pen the following song. Then reigning as King David, basking in the joy of God's redemptive purposes fulfilled, he passionately worshipped:

> *Do not fret because of those who are evil*
> *or be envious of those who do wrong;*
> *for like the grass they will soon wither,*
> *like green plants they will soon die away.*

> *Trust in the LORD and do good;*
> *dwell in the land and enjoy safe pasture.*
> *Take delight in the LORD,*
> *and he will give you the desires of your heart.*

> *Commit your way to the LORD;*
> *trust in him and he will do this:*
> *He will make your righteous reward shine like the dawn,*
> *your vindication like the noonday sun.*

Be still before the LORD
 and wait patiently for him;
do not fret when people succeed in their ways,
 when they carry out their wicked schemes.

Refrain from anger and turn from wrath;
 do not fret—it leads only to evil.
For those who are evil will be destroyed,
 but those who hope in the LORD *will inherit the land.*

A little while, and the wicked will be no more;
 though you look for them, they will not be found.
But the meek will inherit the land
 and enjoy peace and prosperity. (Psalm 37:1–11)

Abigail's influence showcased this revelation. Her life illustrated this truth. Her faith embodied this hope. Faced with reasons to worry, doubt, and despair, Abigail chose life. She chose hope. She trusted. She did good. She delighted in the Lord. She turned from anger, placing her confidence in the goodness, mercy, and faithfulness of the Lord. And her hope was not in vain. Her character and courage rewarded her with a king and a kingdom as her inheritance. Abigail waited for the Lord, and the Lord fulfilled the desires of her heart.

Lord Jesus,

Thank you that you give me the wisdom I need to navigate any challenge I face. You are wise. You know the beginning from the end. And nothing is hidden from you. Lord, help me to serve your purposes in every situation and in every relationship. Protect me from compromise or enabling sin. I renounce all victimhood and subjugation. Help me use my voice to speak the truth in love. Give me courage to boldly face the challenges in my life and to make godly, loving, righteous choices. Enable me to respond with respectful and protective love.

In Jesus' name, Amen

DISCUSSION QUESTIONS

1. Abigail could have seen herself as a victim. Instead, she did what was in her power to do. What is a challenging situation or relationship for you? What is within your power to do? What choices do you have?

2. Abigail did not submit to sin. You can love a person and still refuse to be party to sin. Perhaps God is calling you to establish a healthy boundary, confront some sin or dysfunction, remove yourself from another's sin, or speak the truth in love. Is there a relationship that the Lord is highlighting for you to change? If so, how?

3. Abigail communicated to David by appealing to his best interests and God's purposes instead of her own. Is your current communication self-serving, critical, or demanding—or is it encouraging godliness in others? How can you improve your communication to serve God's purposes in others instead of being self-serving?

9

BATHSHEBA: SEDUCE AND REDUCE

Some time after David's marriage to Abigail, he assumed his role as King of Judah. Several years into his reign, it was spring, the time of year when the kings and all the king's men went off to war. Only this particular year, King David had stayed behind, choosing to be a spectator instead of a player in the action. Bored and restless, he wandered the castle's rooftop balcony in the cool of the evening. Down below, passing time alone without her military husband, Bathsheba bathed naked on a rooftop of her own. She was beautiful. Her raw sensuality ignited the fire of desire as David watched. Boredom, hunger, and fantasy met opportunity and roared to life in one of the most infamous and devastating affairs in history.

> *In the spring, at the time when kings go off to war, David sent Joab out with the king's men and the whole Israelite army. They destroyed the Ammonites and besieged Rabbah. But David remained in Jerusalem.*
>
> *One evening David got up from his bed and walked around on the roof of the palace. From the roof he saw a woman bathing. The woman was very beautiful, and David sent someone to find out about her. The man said, "She is Bathsheba, the daughter of Eliam and the wife of Uriah the Hittite." Then David sent messengers to get her. She came to him, and he slept with her. (Now she was purifying herself from her monthly uncleanness.) Then she went back home. The woman conceived and sent word to David, saying, "I am pregnant."*
>
> *So David sent this word to Joab: "Send me Uriah the Hittite." And Joab sent him to David. When Uriah came to him, David asked him how Joab*

was, how the soldiers were and how the war was going. Then David said
to Uriah, "Go down to your house and wash your feet." So Uriah left the
palace, and a gift from the king was sent after him. But Uriah slept at the
entrance to the palace with all his master's servants and did not go down
to his house.

David was told, "Uriah did not go home." So he asked Uriah, "Haven't
you just come from a military campaign? Why didn't you go home?"

Uriah said to David, "The ark and Israel and Judah are staying in tents,
and my commander Joab and my lord's men are camped in the open country.
How could I go to my house to eat and drink and make love to my wife? As
surely as you live, I will not do such a thing!"

Then David said to him, "Stay here one more day, and tomorrow I will
send you back." So Uriah remained in Jerusalem that day and the next. At
David's invitation, he ate and drank with him, and David made him drunk.
But in the evening Uriah went out to sleep on his mat among his master's
servants; he did not go home.

In the morning David wrote a letter to Joab and sent it with Uriah. In it
he wrote, "Put Uriah out in front where the fighting is fiercest. Then withdraw
from him so he will be struck down and die."

So while Joab had the city under siege, he put Uriah at a place where
he knew the strongest defenders were. When the men of the city came out
and fought against Joab, some of the men in David's army fell; moreover,
Uriah the Hittite died.

Joab sent David a full account of the battle. He instructed the messenger:
"When you have finished giving the king this account of the battle, the king's
anger may flare up, and he may ask you, 'Why did you get so close to the city
to fight? Didn't you know they would shoot arrows from the wall? Who killed
Abimelek son of Jerub-Besheth? Didn't a woman drop an upper millstone on
him from the wall, so that he died in Thebez? Why did you get so close to the
wall?' If he asks you this, then say to him, 'Moreover, your servant Uriah the
Hittite is dead.'"

The messenger set out, and when he arrived he told David everything Joab
had sent him to say. The messenger said to David, "The men overpowered us
and came out against us in the open, but we drove them back to the entrance of
the city gate. Then the archers shot arrows at your servants from the wall, and
some of the king's men died. Moreover, your servant Uriah the Hittite is dead."

David told the messenger, "Say this to Joab: 'Don't let this upset you; the sword devours one as well as another. Press the attack against the city and destroy it.' Say this to encourage Joab."

When Uriah's wife heard that her husband was dead, she mourned for him. After the time of mourning was over, David had her brought to his house, and she became his wife and bore him a son. But the thing David had done displeased the LORD.

The LORD sent Nathan to David. When he came to him, he said, "There were two men in a certain town, one rich and the other poor. The rich man had a very large number of sheep and cattle, but the poor man had nothing except one little ewe lamb he had bought. He raised it, and it grew up with him and his children. It shared his food, drank from his cup and even slept in his arms. It was like a daughter to him.

"Now a traveler came to the rich man, but the rich man refrained from taking one of his own sheep or cattle to prepare a meal for the traveler who had come to him. Instead, he took the ewe lamb that belonged to the poor man and prepared it for the one who had come to him."

David burned with anger against the man and said to Nathan, "As surely as the LORD lives, the man who did this must die! He must pay for that lamb four times over, because he did such a thing and had no pity."

Then Nathan said to David, "You are the man! This is what the LORD, the God of Israel, says: 'I anointed you king over Israel, and I delivered you from the hand of Saul. I gave your master's house to you, and your master's wives into your arms. I gave you all Israel and Judah. And if all this had been too little, I would have given you even more. Why did you despise the word of the LORD by doing what is evil in his eyes? You struck down Uriah the Hittite with the sword and took his wife to be your own. You killed him with the sword of the Ammonites. Now, therefore, the sword will never depart from your house, because you despised me and took the wife of Uriah the Hittite to be your own.'

"This is what the LORD says: 'Out of your own household I am going to bring calamity on you. Before your very eyes I will take your wives and give them to one who is close to you, and he will sleep with your wives in broad daylight. You did it in secret, but I will do this thing in broad daylight before all Israel.'"

Then David said to Nathan, "I have sinned against the LORD."

Nathan replied, "The LORD has taken away your sin. You are not going to die. But because by doing this you have shown utter contempt for the LORD, the son born to you will die."

After Nathan had gone home, the LORD struck the child that Uriah's wife had borne to David, and he became ill. . . .

David noticed that his attendants were whispering among themselves, and he realized the child was dead. "Is the child dead?" he asked.

"Yes," they replied, "he is dead." . . .

Then David comforted his wife Bathsheba, and he went to her and made love to her. She gave birth to a son, and they named him Solomon. The LORD loved him; and because the LORD loved him, he sent word through Nathan the prophet to name him Jedidiah.

2 SAMUEL 11:1–27; 12:1–15, 19, 24–25

David was Israel's hero; and by this time, he was also Israel's king. Bathsheba grew up in the wake of David's fame. She, along with all of Israel, revered the legendary exploits of the shepherd boy turned giant slayer. She grew up singing and celebrating David's victories in their patriotic songs. Bathsheba's father, Eliam, was one of David's mighty men—one of the 30 listed as his closest friends.

David's larger-than-life persona enveloped much of her existence, from being the most famous celebrity in Israel to being the focus of her family's sacrificial devotion and service. She grew up in close proximity to David. She likely admired David. She may have even dreamt of David in her youthful heart.

Bathsheba grew up and married Uriah, a good, honest, and respectable man. He was sincerely devoted and faithful to her. Uriah also served in David's army. *David* was a household name, her father's friend, her husband's boss, and her country's king.

LONELINESS AND LONGING

Bathsheba's motives the night of her rooftop bathing episode are not clearly stated. We do not know the intentionality of the seduction between David and Bathsheba, although the advice and warnings she gives to her son years later are revealing. In them she shares the most detailed, insightful description and warnings of the strategic ways of an enticing, seducing woman in the Bible. Regardless

of her intentions, we know the adulterous result. From this we can draw some very clear principles for stewarding our sexuality in purity, dignity, and respect.

Bathsheba was beautiful. She was married. And she was alone—a lot. The wife of a military man who was deployed every spring for another military campaign, she was potentially bored and emotionally and relationally hungry.

As days stretched into weeks, and weeks into months, the time apart created fertile soil for loneliness to grow. Loneliness can grow into a hunger, creating a vulnerability and a willingness to flirt with disaster, in search of relief. As a beautiful young woman, Bathsheba was likely accustomed to a certain diet of male attention and affirmation. With all the men, including her husband, off to war, the daily work of managing her childless household may have lacked interest or significance.

Ahh, but David was home! As a family of rank and importance, they lived close to the palace, actually within a stone's throw. Did she sit on her roof, looking up at the castle window's glow at night, wondering what David was doing? He was the nearest man around, the only man on campus. She had very limited contact with her husband—no phone, email, or text. Letters from a battlefront would have been rare.

Knowing the emotional makeup of women, our longing for connection and intimacy, it is not difficult to imagine the scenario and the step toward compromise to get attention and affection for her hungry heart. Walking the palace roof may have been David's habit when he could not sleep. Had Bathsheba observed him walking before? Regardless of intent, she acted. She bathed naked in view of the palace.

As an American, I came to understand the dynamic of living near a castle while living in a German city with a castle. The houses are close, stacked next to each other. The castle is always at the highest point of the city and the city center. As a matter of practice, extra precautions are taken to ensure modesty and privacy in these old cities. You can look out your window and see directly into the window of your neighbor a few feet away. This potential for exposure is obvious, known, and accounted for in how you conduct yourself, especially to dress and bathe.

For Bathsheba, the proximity and risk of being seen was likely very clear. Did she purposefully take advantage of her location, considering the vantage point from the king's roof? She bathed naked, out in the open, where the king could clearly see her and be drawn to her beauty. And if he could see her, then she could see him. Her nakedness enticed him, invited him. He took the bait of Satan.

SOLICITING ATTENTION

Ladies, we are stewards of our own sexuality. We can use and abuse the sexuality entrusted to us, or we can steward it with modesty, integrity, and honor. The road to adultery for David and Bathsheba began with her bathing naked and exposed on a rooftop balcony. This implies a goal: to get some male attention—regardless of where it came from or if it was hers to have.

It is wrong to solicit sexual attention that is not yours to have. It is wrong to use your assets to try to entice a man who is not yours. Striving to get sexual attention or sexual affirmation is rooted in an identity idol. Seduction and immodesty manipulate men and exploit their male sexuality.

This principle, along with women's awareness of the power of our sexuality, is universal. I've shared this concept with women in several countries. As women, we know when we're using our sexuality as a means of power or manipulation. We recognize when other women are using their sexuality to solicit attention. We know when we're honoring men's sexuality by being modest. Likewise, we fully comprehend when we exploit the sexual makeup of a man and manipulate his vulnerabilities visually—with our immodesty and with our body language. We understand the difference between giving friendly, modest hugs and pressing our bodies in to elicit his arousal. We're consciously aware when we guard modesty and when we intentionally let our shirts fall open.

With the advent of the internet, social media, and countless apps, the platforms for soliciting sexual attention are endless. Technology is the new *rooftop* where men and women are being bombarded with sexual bait. The temptation to entice and receive attention as well as to consume and devour sexual stimuli is rampant. Sexuality via technology exploits and corrupts; it diverts sexual expression to engage images instead of real people. The damage to our healthy sexual expression and sexual satisfaction is profound.

The root of seduction and lust-based sexuality begins with identity. We seek identity. We will pursue whatever we turn to for identity. A woman may place her identity in her physical beauty or her ability to attract men. Or her identity might be feeling unloved and constantly looking for male affirmation. This thirst for identity can trump the values of respect, purity, and love.

The drive for this misplaced identity can cause us to solicit attention from men who don't belong to us and those who may even belong to someone else. We've all known (and maybe have been) the woman who oversteps a marriage or a relationship, vying for validation and a man's sexual interest. Rooting our

identity in our beauty or attractiveness creates a constant need for affirmation. Then our self-esteem and value ride and fall on the validation and sexual response of others. In this we easily succumb to comparing and competing with other women.

Female sexuality is awesome and wonderful, powerful and glorious! Choosing to walk in purity and relate in protective love that respects a man's sexuality is a beautiful thing to behold. In our journey from girlhood to womanhood, we all must navigate the precarious waters of understanding, bridling, and directing the power of our sexuality. Bathsheba was no exception.

Whether Bathsheba's actions were calculated or not, she flaunted her beauty and nakedness publicly—within view of David's rooftop. Curiosity may have driven her. Daydreams of being noticed, desired, and pursued—even falling in love—may have filled her mind. We are not told this. But we do know that all Scripture is inspired by God and is meant to teach us (2 Timothy 3:16; Romans 15:4). With this in mind, let's look more closely at her story, knowing that there are life lessons for us to consider, learn, and apply to our own lives.

STEALING AFFECTION

Adultery never *just happens*. It starts in the mind and moves to the heart long before it manifests in the body with a sexual act. Adultery can also be emotional. Emotional adultery is soliciting connection, relationship, and affection that belong to someone else. It steals and diverts the loyalty meant for a spouse. It uses and exploits the other person to *get* for self.

Guard your connections and affections. Don't seek to divert a man's energy from his wife to yourself. Likewise, if you're married, watch yourself and your thoughts, that your affections remain directed toward your spouse. Take care not to entertain thoughts of connection to or attention from another.

Adultery and sexual impurity are rooted in idolatry. Idolatry is looking to someone or something other than God for our identity and value. It's seeking security, significance, and purpose from a source other than God. Adultery uses the person of interest to *get*; to fill and fulfill one's own desire. Adultery is always *self*-driven. It willingly uses another person for its own selfish gain. Adultery and sexual impurity will always desire for self, pursue for self, and then consume for self. It has little regard for the cost to the other person.

Proverbs 6:26 says, "A prostitute reduces you to a piece of bread" (WEB). When you enter an adulterous or sexual relationship outside of marriage, you are reduced to being used to feed someone's need, and you reduce them to feed yours.

The driving force can vary. Sometimes, while wrestling with legitimate emotional, relational, or sexual hunger, we choose an illegitimate way to be fed. Other times, our quest for validation and approval can lead to compromise and seeking affirmation from sources that don't belong to us. Worst-case scenario, adultery can be motivated by rivalry. Rooted in a deep brokenness that needs to *win*, this spirit measures success by possessing the object of its desire. It feeds on the *thrill of the chase*, seeking to gain identity by conquering and feeling superior to competitors—not very noble motives.

TO SEDUCE IS TO REDUCE

The definition of *adultery* is "the unfaithfulness of a married person to the marriage bed . . . voluntary sexual intercourse by a married woman with another than her husband."[34] The nature and dynamics of illicit relationships include an element of seduction. To seduce is "to lure and entice away from duty, principles, and proper conduct . . . to entice to evil, to lead astray, to tempt and lead to iniquity; to corrupt."[35] Bathing naked in full view of any healthy man is easily characterized as enticing and tempting.

> If we seduce, we solicit sexual attention that is not ours to have.

If we seduce, we solicit sexual attention that is not ours to have. We are diverting a man's attention, affection, and connection *away* from the *one* to whom he's committed and redirecting it to ourselves instead. In doing this, we are *stealing* the attention, interest, and connection that belong to someone else.

Further, the protective commands regarding adultery also apply to all sex outside of marriage relationships. The warning is clear that sexual activity outside of marriage is destructive to all involved. I know this isn't the cultural norm in our day, but stay with me for a minute, to understand the rationale, risk, and reward.

Real love requires commitment. Sex without love uses, consumes, and devalues the participants—both of them. Sex without commitment fosters insecurity. Sex is meant to be a *permanent bond*. When that bond is repeatedly broken, it damages a woman's ability to bond and be united with the one she loves and may eventually marry.

Visualize two bar graphs. One is intimacy, the other is commitment. God intended for commitment and intimacy to be equal. Intimacy is given in proportion to the level of commitment. As commitment in a relationship grows, intimacy can grow. When either emotional or sexual intimacy grows greater

than the level of commitment, the resulting gap produces insecurity, jealousy, and fear. It leaves us exposed and emotionally vulnerable. Many of us have experienced the devastation of giving more of ourselves emotionally or sexually than the commitment or the nature of the relationship warranted. As a result, we've experienced heartbreaking pain and profound loss.

Guarding and reserving your sexual intimacy for a committed marital relationship is counter cultural and sounds old-fashioned today. But the realities of how we are made and wired, along with our deep desire to be known, accepted, and loved, has not changed in *forever*. We long to be wanted, united, and cherished as "bone of my bones and flesh of my flesh" (Genesis 2:23).

The current culture of "hooking up" in noncommitted sexual experiences totally opposes the deepest longings and needs of a woman's heart. There is little to no relational investment. It's having sex completely void of any form of love. Once upon a time, actually *dating* a girl was still an expected prerequisite to any kind of relationship, and marriage was a prerequisite for intimacy. Today, for many, a *relationship* seems to be a thing of the past. First, our culture divorced sex from marriage, then divorced it from love. With the hookup culture, now we've even divorced sex from relationship. This is *tragic* for both men and women. This generation is being robbed of the beauty and healing power of *falling* in love, *being* in love, and *living secure* in committed marital love.

When we engage in sex outside of marriage, we sabotage our own fulfillment, and we devastate our own hearts. I've never talked to a married woman after the fact, who said, *You know, sleeping around before marriage was the best thing I ever did for my marriage. I am so glad I had all those other sexual experiences with other people before I got married. It's also really awesome that my husband has slept with other people—it really helped and strengthened our marriage.* Seriously, no one has *ever* said that.

STEWARDING SEXUALITY

In an era where women are being trafficked and porn has poisoned the purity and beauty of sex, reducing it to just a commodity to buy and consume, we have a choice. We can give in and come into subjugation to the spirit of pornography, accepting the lie that we are just objects to be used and abused, a thing to be consumed and discarded. Or we can rise up, stand up, and say, *No more!* We can cast off the cloak of seduction-based sexuality and false beauty. We can stand tall in the strength and dignity of a woman who knows that her value is far deeper

than simply her sex appeal. You can be a woman who guards your precious sexuality as a treasure to be shared only with one who is worthy and willing to deeply love and cherish you.

Sisters, we are not beggars! We won't desperately compete for the crumbs of corrupted sexuality and leering attention. We will not be diminished into believing or accepting that our only value comes from being sexy. Rather, we will embrace our God-given beauty and steward our glorious sexuality as women. We will honor male sexuality with our modesty and care. We will respect ourselves enough to say no and refuse to perpetuate the culture of the objectification of women. Do not beg for attention! Do not compromise for affirmation! Wait for a man who has the character to give and receive real love, one who is capable of loving you with pure and tender, faithful intimacy.

You *are* beautiful! You *are* loved! You are precious to the God who made you. He can heal you and make you whole. Living *for* external beauty, or *from* it, leads to bondage *to* it. This creates enslavement to the lie that your core value comes only from your sexual desirability. This can result in eating disorders, obsession with pursuing external perfection, and willingness to do almost anything for acknowledgment of your beauty. Don't fall into that trap.

> Living *for* external beauty, or *from* it, leads to bondage *to* it.

Instead, transfer your identity of who you are to God. This will secure your worth and your heart. In God's perfect love, you can live and love from a position of strength and wholeness.

Proverbs 31:30 says, "Charm is deceptive, and beauty is fleeting; but a woman who fears the LORD is to be praised." External beauty changes, and it is only that—external. I am not diminishing or vilifying physical beauty. I'm simply clarifying that beauty is more than merely external. Real, lasting beauty comes from within.

When we're young, we all have some element of external beauty. As we age, our faces begin to reflect our spirits. We all know the woman who is potentially physically beautiful, but whose anger and bitterness distort her features. Likewise, we recognize defeat on an otherwise attractive woman, whose face reflects despair.

Recently, I was on an airport shuttle and noticed a woman sitting across from me. She was absolutely radiant! Her eyes sparkled with joy and life. Her countenance was alive with pleasure and peace. She was older—possibly well into her seventies, or even eighties—but I didn't notice her age. I was literally *awestruck* by the glory and beauty emanating from her face. That, my sisters, is *real* beauty!

I often tell my daughters that joy is the most attractive attribute a woman can wear. It is the most beautiful makeup she can put on her face!

THE FIRE OF DESIRE

Bathsheba's strength in her early days was her noticeable physical beauty and her ability to draw a man's attention, including the king's. She succeeded. David inquired who she was. When he found out, he recalled the girl he had known. She was the daughter of his warrior friend, the stunning wife of his general, and the intoxicating bathing beauty who aroused his desire. They were alone. No one needed to know. What harm could come of it? It was a warm spring night. "Love" was in the air. He sent for her.

Now, I've heard the argument that Bathsheba did not have a choice. That she *had* to go. It was the king who had summoned her, after all. But nothing in Scripture bears this out. David *sent* a messenger to her. He did not officially summon or *command* her. She gave no question as to the nature of the call, which might imply she already knew. She expressed no surprise, dismay, or resistance to the invitation to the king's chambers. She readily—not reluctantly—headed for the palace. There was no protest.

Furthermore, and most significantly, if she were an unwilling participant, she would have been a victim of rape or coerced sex. The Bible is not shy about calling out rape. In her and David's case, the Bible records it as adultery. David confesses it as adultery. Nathan the prophet confronts it as adultery. Bathsheba herself admits it as adultery. And if there were still any doubt, God himself, who perfectly knows the motives and secrets of *all*, judged it as adultery.

Her willingness to go suggests she was anticipating this outcome. Again, as with our other women, what she doesn't do is as significant as what she does do. She could have, like Abigail, appealed to David to not sin. *David, you are the king! God has withheld nothing good from you. The whole kingdom is yours. Now do not sin by taking what is not yours. Do not sin by taking the wife of another man.* The Bible indicates no appeal or protest. There was just silent, immediate, hushed cooperation to David's invitation.

Even if she perceived the summons as an order and was threatened to comply, she could have refused the king, like Daniel who refused to pray under threat of the lion's den. Or Shadrach, Meshach, and Abednego, who refused the king's order to bow and thus were thrown into the furnace. But she didn't refuse. She didn't choose to say no.

The night may have seemed magical, like a dream come true. Here they were, basking in passion and the thrill of forbidden fruit for a moment . . . until a deep, gnawing guilt began to grow in the pit of her stomach. As described in Hebrews 11:25, they enjoyed "the pleasures of sin for a season" (KJV). But as promised in Romans 6:23, "the wages of sin is death." This principal is described in even greater detail in James 1:14–15, where we learn that sin comes with a high price. Their dream-like moments of stolen bliss quickly turned into an epic nightmare of deceit, regret, murder, and death.

Bathsheba snuck back home, their secret rendezvous known only to David, herself, and a few trusted servants. Was she satisfied with her conquest? The king wanted her. Did she wonder when they might meet again? She was his chosen mistress, his secret passion. Her beauty must be irresistible. Perhaps satisfaction gave way to regret when she entered her empty home, knowing that the woman who had earlier left for the palace no longer existed. The wife of Uriah was no longer a faithful wife. However Bathsheba processed her conflicting feelings, her sin with King David had set in motion a series of events that would leave her heartbroken and reeling.

Whether she wrestled with guilt or smug satisfaction, she soon faced a crisis. She was pregnant! Levitical law demanded, "If a man commits adultery with another man's wife—with the wife of his neighbor—both the adulterer and the adulteress are to be put to death" (Leviticus 20:10). How does a woman whose husband is off to war . . . get pregnant?! What were they going to do? If and when the pregnancy was discovered, she would be stoned.

Her mind likely raced with panic. Somehow, she sent word to the king. Then she waited. Did David give her any reassurance? Did he communicate that he could or would protect her? Did he share his plan to cover up the affair? Or did she wait and wonder alone? The Bible doesn't tell us what David communicated to her during this time.

Anxiety and fear must have fostered remorse and regret as the seriousness of their situation settled over Bathsheba. She could tell no one. She had no one to discuss this with or seek advice from, no one to comfort her. She was alone with her sin and her secret. Days passed, then weeks. Day after excruciating day, the baby growing inside her, she waited and wondered what would become of her.

David couldn't risk connecting with her. Did he even care? Or was he up in his bedchamber enjoying the pleasures of another woman now that she

was indisposed? Did the view from her home torment her as she looked at his windows, wondering if he remembered, hoping he would come to her rescue? When she lounged on her rooftop, did she recall the carefree, sensual bathing she had naively believed would bring her happiness at no cost? As she slept, did she have nightmares of a mob banging down her door to stone her in the street as an adulteress while David slept securely in his castle?

SOURED AND DEVOURED

David tried to resolve the crisis and sent for Uriah, her husband, to be brought home from the battlefield. David greeted him warmly and sent a lavish homecoming gift to Uriah's home. He hoped that Uriah would enjoy a sweet reunion with his wife, making it plausible to believe that he fathered her child that night. But Uriah did not go home. He slept in the barracks with the other soldiers on duty. David called him the next day and inquired why he had not gone home. Uriah protested that he would not do such a thing. After all, how could he go home and eat and drink and make love to his wife when he and his company were in the middle of a war? How could he rest in pleasure while his men were fighting and dying on the battlefield? No! He would not do such a thing! His loyalty and selfless devotion to his men would not let him slack off while on the job.

Desperate, David invited him to a banquet with the sole purpose of getting Uriah drunk. He strategized that a few stiff drinks would loosen up his moral reserve and that desire for a night with his wife would overcome his resolve. But plan B failed too. Uriah did not go home. With the life of Bathsheba in danger, David crossed yet another line. He crafted a note for Uriah to take to Joab, the commander of the army. "Put Uriah out in front where the fighting is fiercest. Then withdraw from him so he will be struck down and die" (2 Samuel 11:15). The honorable Uriah dutifully delivered the message containing his own death warrant. Uriah died in the next battle, struck down by the swords of the Ammonites. But the death and destruction did not end there.

Bathsheba mourned for her husband, likely aware that this was no casualty of war, no random accident. Had she loved him? Did she sit at her empty dinner table or lay alone in her bed and feel the weight that her husband was never coming home? Did she dream of him gasping for breath, an arrow in his chest, calling out to her, his love, one last time? Did she see her own face when the hood was pulled back from the archer's brow? As her belly bulged, did the guilt inside her also swell? The reality of Proverbs 14:1 loomed over her life: "The wise

woman builds her house, but with her own hands the foolish one tears hers down."

What about David? Where was the noble, God-fearing, heroic man of faith? Who was this lying, scheming murderer? When we steal love that isn't ours, when we seduce, we diminish the character and strength of the man we desired. By seducing and sinning with David, Bathsheba destroyed the character that made David so attractive to her in the first place. She destroyed what she desired. As you'll recall from chapter 4, the Hebrew word for *desire* (Strong's H8669) refers to a "beast to devour" its prey [36]. Their sin figuratively devoured David's integrity.

Adultery and sexual impurity always result in death. Not necessarily physical death, but death to innocence and purity. Honor, respect, and dignity disintegrate. Honesty and integrity perish. James 1:14–15 says, "But each person is tempted when they are dragged away by their own evil desire and enticed. Then, after desire has conceived, it gives birth to sin; and sin, when it is full-grown, gives birth to death." King David and Bathsheba were no exception.

CONFRONTATION AND CONSOLATION

After the period of mourning was complete, David sent for Bathsheba and brought her to the palace to be his wife. In time came the birth of their son, the child whose life had cost the life of Uriah. Perhaps they could move on and put the unpleasant business of Uriah's death and their scandalous beginnings behind them. They eagerly looked to their son's future and tried to forget the past. "But the thing David had done displeased the LORD" (2 Samuel 11:27).

God sent Nathan the prophet to confront David. He shared a story of a rich man who slaughtered a poor man's sole little sheep instead of taking one from his own bountiful supply. David burned with anger and condemned the rich man for showing no mercy. Nathan thundered, "You are the man!" (2 Samuel 12:7). He reminded David of how the Lord had generously established him on the throne, giving him victory on every side. Through Nathan, the Lord called out David and Bathsheba's adultery and called Uriah's death what it was—murder. Then Nathan pronounced the consequence from God. "Why did you despise the word of the LORD by doing what is evil in his eyes? . . . Now, therefore, the sword will never depart from your house, because you despised me and took the wife of Uriah the Hittite to be your own. . . . Before your very eyes I will take your wives and give them to one who is close to you." And finally, Nathan concluded, "Because by doing this you have shown utter contempt for the LORD, the son born to you will die" (2 Samuel 12:9–11, 14).

David wept. David grieved. And David repented. We see the heartrending process of David's repentance in Psalm 32 and Psalm 51. He cried out to God in soul-wrenching remorse and confession. He came clean before the Lord. He pleaded for his son's life as the boy grew weaker every day. After seven days of David's being on his face before the Lord, the boy died. David's grief was spent, but in the process of repentance, his heart was restored. David ate, washed, and worshipped, composing one of the most powerful songs of repentance and restoration in the Bible.

> *Have mercy on me, O God,*
> *according to your unfailing love;*
> *according to your great compassion*
> *blot out my transgressions.*
> *Wash away all my iniquity*
> *and cleanse me from my sin.*
>
> *For I know my transgressions,*
> *and my sin is always before me.*
> *Against you, you only, have I sinned*
> *and done what is evil in your sight;*
> *so you are right in your verdict*
> *and justified when you judge. . . .*
>
> *Cleanse me with hyssop, and I will be clean;*
> *wash me, and I will be whiter than snow.*
> *Let me hear joy and gladness;*
> *let the bones you have crushed rejoice.*
> *Hide your face from my sins*
> *and blot out all my iniquity.*
>
> *Create in me a pure heart, O God,*
> *and renew a steadfast spirit within me.*
> *Do not cast me from your presence*
> *or take your Holy Spirit from me.*
> *Restore to me the joy of your salvation*
> *and grant me a willing spirit, to sustain me.*

> *Then I will teach transgressors your ways,*
> *so that sinners will turn back to you.*
> *Deliver me from the guilt of bloodshed, O God,*
> *you who are God my Savior,*
> *and my tongue will sing of your righteousness.*
> *Open my lips, Lord,*
> *and my mouth will declare your praise.*
> *You do not delight in sacrifice, or I would bring it;*
> *you do not take pleasure in burnt offerings.*
> *My sacrifice, O God, is a broken spirit;*
> *a broken and contrite heart,*
> *you, God, will not despise. (Psalm 51:1–4, 7–17)*

God heard David's prayer and forgave him. However, the consequences of David and Bathsheba's adultery still came to pass. Uriah was dead. The son conceived in their unfaithful union died. David's kingdom would one day be divided. Years later, on the same palace rooftop, one of his sons would sleep with David's wives, flaunting his conquest of his own father's kingdom. Indeed, the cost of their sin was death and destruction. But God, whose heart yearns for redemption and restoration, responded with a resounding *yes* to David's repentance and cry for mercy!

REPENTANCE AND RESTORATION

God forgave David and Bathsheba and blessed their repentance. After suffering the consequence for their sin, God allowed David and Bathsheba to conceive again, this time as forgiven husband and redeemed wife. She gave birth to Solomon, who became the wisest and wealthiest king on earth.

Real repentance is not merely shame or regret. Repentance involves a change of *heart*. It's a turning away from and forsaking of sin. It invokes God's forgiveness. Repentance leads to freedom from nagging guilt. Receiving forgiveness allows us to walk into a new day. God indeed washed their sin away. These parents of mercy stayed true to their promise to teach their son God's ways.

Solomon grew in wisdom, and he authored the strongest, clearest warnings against adultery in the Bible. He heralded the glories of wisdom, exhorting men to guard their paths from impurity and keep their hearts from sexual seduction. He admonished holding fast to his father and mother's instruction. He credits

both his parents with teaching him to run from sexual sin, guard his heart and eyes, and avoid the seducing woman.

Solomon also authored the most beautiful celebration of marital sexual pleasure in the Bible—and arguably in historical literature—the Song of Songs, also known as the Song of Solomon. He understood the intended joy and glory of sexual intimacy between a husband and wife in faithful devotion, exclusive purity, and intimate vulnerability.

> Real repentance is not merely shame or regret. Repentance involves a change of *heart*.

David and Bathsheba's story is one of redemption. They truly learned from their mistakes. As the fruit of repentance and God's mercy wove through their story, a deep and profound respect swelled into gratitude for the corrective voice of God. They came to appreciate the life-giving rebuke from Nathan, the prophet, who bravely confronted their sin. His willingness to tell them the truth and call them to repentance reversed their downward spiral of sin and consequences. We've seen the enormous significance of names in Jewish culture. There's only one other Nathan in the Bible besides this truth-speaking, sin-confronting prophet. In honor of the restorative ministry of their prophet Nathan, David and Bathsheba named one of their four sons Nathan, meaning *gift from God*.

GLUED AND TORN APART

Sexual brokenness, depravity, and sin wreak havoc on our hearts. Indeed, the exhortation from 1 Corinthians 6:18 plays out true: "All other sins a person commits are outside the body, but whoever sins sexually, sins against their own body." When we compromise our intimacy, when we misuse our sexuality, we play with fire and we will get burned. The pain from sexual intimacy outside of being loved and cherished in a committed, faithful, marital relationship is devastating. Sexual intimacy is like gluing two pieces of paper together. It's meant to be permanent, making the two one in body, soul, and spirit. When intimacy is not permanent, the process of separating, of attempting to *unglue* people from one another, tears apart and shreds the fabric of trust in their hearts.

Many of us, like Bathsheba, have broken, shredded hearts. We've sinned and others have sinned against us. Our purity is pulverized. Our trust is obliterated. Our dreams of real love are shattered. Is there healing? Is there hope?

My dear friend, no matter how, why, or when your purity was compromised—whether by your will or another's forceful will against you, the love and grace

of God can make you whole again. God will not despise a broken and contrite heart.

Envision again the torn paper; it may have been glued and torn apart, glued and torn apart, until it was weak and frayed, barely resembling the fullness of its original self. When we repent and seek forgiveness, God forgives. And when God forgives us, He glues us to himself, filling in the torn and shredded places. He brings *His* purity and strength wherever ours is gone. He secures our hearts to His. His grace fills in the broken places in our intimate relationships, completing and healing them.

Bathsheba's story is a warning. It is a guide. It is a gift. Our sexuality is not a toy to be played with or experimented on. It's a powerful part of our identity. It is to be guarded and stewarded with dignity, wisdom, and care. We honor our own womanhood *and* men's sexuality when we relate in purity, modesty, and respect. The best and truest sexual fulfillment occurs in a committed and honoring marriage between one man and one woman. In a loving marriage, sex can be expressed and enjoyed free from guilt, shame, and regret.

Where we have fallen short, where we have hurt ourselves and stolen from others, God offers mercy. Receive God's forgiveness and healing. Confess and turn away from sin—and turn toward His grace. Glue yourself to Jesus. Let Him restore the broken and torn places of your heart. Trust Him.

True beauty is all-encompassing. True beauty radiates from the inside . . . out. Embrace your beauty. Steward your sexuality. Receive God's precious gift, the restoration of your purity and the blessing of true sexual and relational intimacy.

Lord Jesus,

You are the creator of sex and our sexuality. You ordained the perimeters and expression of sex for our enjoyment, blessing, and fulfillment. Help me to guard, protect, and steward my sexuality with purity, integrity, honor, and respect. Lord, please forgive me for the ways that I have misused my sexuality and solicited sexual attention that did not belong to me. Lord, in your mercy and grace, I ask you to restore my purity, redeem my mistakes, and heal my sexual brokenness. Thank you for the gift of sex, for the gift of physical, emotional, and spiritual intimacy. May I respect and protect this precious gift; in myself and in those around me.

In Jesus' name, Amen

DISCUSSION QUESTIONS

1. In what ways are we as women tempted to use our sexuality for personal gain? What does sexual manipulation look like?

2. When we seduce a man, we reduce the man. How does seduction-based sexuality disrespect and reduce a man?

3. Pornography is rampant: TV, social media, advertising, music, internet. How does exposure to pornography hurt and hinder healthy sexual relationships?

4. Our culture is embracing same-sex intimacy. How does opening same-sex friendships to possible sexual relationship diminish safety and security? In what ways does same-sex intimacy hurt and diminish the God-given sexuality of the participants?

5. Sexual sin comes in many shapes and forms. It always comes with a price to pay, and at great cost. What are some of the costs of sexual sin that you've witnessed or experienced?

10

RUTH: TRUE BEAUTY

Ruth is a powerful portrait of a woman who breaks free from the bondage and dysfunction of a godless upbringing, overcomes devastating loss, and triumphantly rises above as a victorious daughter of the Most High God. She sets her heart and hopes on the goodness and faithfulness of God and never looks back. She possesses a unique and powerful beauty: the intriguing allure of a woman at peace with herself. She radiates purity. She embodies hope. She exudes joy. She is a woman fully alive and full of faith; she is a showcase of a woman who *lives loved*.

> *In the days when the judges ruled, there was a famine in the land. So a man from Bethlehem in Judah, together with his wife and two sons, went to live for a while in the country of Moab. The man's name was Elimelek, his wife's name was Naomi, and the names of his two sons were Mahlon and Kilion. They were Ephrathites from Bethlehem, Judah. And they went to Moab and lived there.*
>
> *Now Elimelek, Naomi's husband, died, and she was left with her two sons. They married Moabite women, one named Orpah and the other Ruth. After they had lived there about ten years, both Mahlon and Kilion also died, and Naomi was left without her two sons and her husband.*
>
> *When Naomi heard in Moab that the Lord had come to the aid of his people by providing food for them, she and her daughters-in-law prepared to return home from there. With her two daughters-in-law she left the place where she had been living and set out on the road that would take them back to the land of Judah.*
>
> *Then Naomi said to her two daughters-in-law, "Go back, each of you, to your mother's home. May the Lord show you kindness, as you have shown*

kindness to your dead husbands and to me. May the LORD grant that each of you will find rest in the home of another husband."

Then she kissed them goodbye and they wept aloud and said to her, "We will go back with you to your people."

But Naomi said, "Return home, my daughters. Why would you come with me? Am I going to have any more sons, who could become your husbands? Return home, my daughters; I am too old to have another husband. Even if I thought there was still hope for me—even if I had a husband tonight and then gave birth to sons—would you wait until they grew up? Would you remain unmarried for them? No, my daughters. It is more bitter for me than for you, because the LORD's hand has turned against me!"

At this they wept aloud again. Then Orpah kissed her mother-in-law goodbye, but Ruth clung to her.

"Look," said Naomi, "your sister-in-law is going back to her people and her gods. Go back with her."

But Ruth replied, "Don't urge me to leave you or to turn back from you. Where you go I will go, and where you stay I will stay. Your people will be my people and your God my God. Where you die I will die, and there I will be buried. May the LORD deal with me, be it ever so severely, if even death separates you and me." When Naomi realized that Ruth was determined to go with her, she stopped urging her.

So the two women went on until they came to Bethlehem. When they arrived in Bethlehem, the whole town was stirred because of them, and the women exclaimed, "Can this be Naomi?"

"Don't call me Naomi," she told them. "Call me Mara, because the Almighty has made my life very bitter. I went away full, but the LORD has brought me back empty. Why call me Naomi? The LORD has afflicted me; the Almighty has brought misfortune upon me."

So Naomi returned from Moab accompanied by Ruth the Moabite, her daughter-in-law, arriving in Bethlehem as the barley harvest was beginning.

Now Naomi had a relative on her husband's side, a man of standing from the clan of Elimelek, whose name was Boaz.

And Ruth the Moabite said to Naomi, "Let me go to the fields and pick up the leftover grain behind anyone in whose eyes I find favor."

Naomi said to her, "Go ahead, my daughter." So she went out, entered

a field and began to glean behind the harvesters. As it turned out, she was working in a field belonging to Boaz, who was from the clan of Elimelek.

Just then Boaz arrived from Bethlehem and greeted the harvesters, "The LORD *be with you!"*

"The LORD *bless you!" they answered.*

Boaz asked the overseer of his harvesters, "Who does that young woman belong to?"

The overseer replied, "She is the Moabite who came back from Moab with Naomi. She said, 'Please let me glean and gather among the sheaves behind the harvesters.' She came into the field and has remained here from morning till now, except for a short rest in the shelter."

So Boaz said to Ruth, "My daughter, listen to me. Don't go and glean in another field and don't go away from here. Stay here with the women who work for me. Watch the field where the men are harvesting, and follow along after the women. I have told the men not to lay a hand on you. And whenever you are thirsty, go and get a drink from the water jars the men have filled."

At this, she bowed down with her face to the ground. She asked him, "Why have I found such favor in your eyes that you notice me—a foreigner?"

Boaz replied, "I've been told all about what you have done for your mother-in-law since the death of your husband—how you left your father and mother and your homeland and came to live with a people you did not know before. May the LORD *repay you for what you have done. May you be richly rewarded by the* LORD*, the God of Israel, under whose wings you have come to take refuge."*

"May I continue to find favor in your eyes, my lord," she said. "You have put me at ease by speaking kindly to your servant—though I do not have the standing of one of your servants."

At mealtime Boaz said to her, "Come over here. Have some bread and dip it in the wine vinegar."

When she sat down with the harvesters, he offered her some roasted grain. She ate all she wanted and had some left over. As she got up to glean, Boaz gave orders to his men, "Let her gather among the sheaves and don't reprimand her. Even pull out some stalks for her from the bundles and leave them for her to pick up, and don't rebuke her."

So Ruth gleaned in the field until evening. Then she threshed the barley she had gathered, and it amounted to about an ephah. She carried it back

to town, and her mother-in-law saw how much she had gathered. Ruth also brought out and gave her what she had left over after she had eaten enough.

Her mother-in-law asked her, "Where did you glean today? Where did you work? Blessed be the man who took notice of you!"

Then Ruth told her mother-in-law about the one at whose place she had been working. "The name of the man I worked with today is Boaz," she said.

"The LORD *bless him!" Naomi said to her daughter-in-law. "He has not stopped showing his kindness to the living and the dead." She added, "That man is our close relative; he is one of our guardian-redeemers."*

Then Ruth the Moabite said, "He even said to me, 'Stay with my workers until they finish harvesting all my grain.'"

Naomi said to Ruth her daughter-in-law, "It will be good for you, my daughter, to go with the women who work for him, because in someone else's field you might be harmed."

So Ruth stayed close to the women of Boaz to glean until the barley and wheat harvests were finished. And she lived with her mother-in-law.

One day Ruth's mother-in-law Naomi said to her, "My daughter, I must find a home for you, where you will be well provided for. Now Boaz, with whose women you have worked, is a relative of ours. Tonight he will be winnowing barley on the threshing floor. Wash, put on perfume, and get dressed in your best clothes. Then go down to the threshing floor, but don't let him know you are there until he has finished eating and drinking. When he lies down, note the place where he is lying. Then go and uncover his feet and lie down. He will tell you what to do."

"I will do whatever you say," Ruth answered. So she went down to the threshing floor and did everything her mother-in-law told her to do.

When Boaz had finished eating and drinking and was in good spirits, he went over to lie down at the far end of the grain pile. Ruth approached quietly, uncovered his feet and lay down. In the middle of the night something startled the man; he turned—and there was a woman lying at his feet!

"Who are you?" he asked.

"I am your servant Ruth," she said. "Spread the corner of your garment over me, since you are a guardian-redeemer of our family."

"The LORD *bless you, my daughter," he replied. "This kindness is greater than that which you showed earlier: You have not run after the younger men, whether rich or poor. And now, my daughter, don't be afraid. I will do for you*

all you ask. All the people of my town know that you are a woman of noble character. Although it is true that I am a guardian-redeemer of our family, there is another who is more closely related than I. Stay here for the night, and in the morning if he wants to do his duty as your guardian-redeemer, good; let him redeem you. But if he is not willing, as surely as the LORD lives I will do it. Lie here until morning."

So she lay at his feet until morning, but got up before anyone could be recognized; and he said, "No one must know that a woman came to the threshing floor."

He also said, "Bring me the shawl you are wearing and hold it out." When she did so, he poured into it six measures of barley and placed the bundle on her. Then he went back to town.

When Ruth came to her mother-in-law, Naomi asked, "How did it go, my daughter?"

Then she told her everything Boaz had done for her and added, "He gave me these six measures of barley, saying, 'Don't go back to your mother-in-law empty-handed.'"

Then Naomi said, "Wait, my daughter, until you find out what happens. For the man will not rest until the matter is settled today."

Meanwhile Boaz went up to the town gate and sat down there just as the guardian-redeemer he had mentioned came along.

RUTH 1:1–4:1

Boaz shrewdly negotiated with the other redeemer, who legally renounced his claim. The matter was settled in front of the elders. Boaz officially became the guardian-redeemer (kinsman-redeemer).

So Boaz took Ruth and she became his wife. When he made love to her, the LORD enabled her to conceive, and she gave birth to a son. The women said to Naomi: "Praise be to the LORD, who this day has not left you without a guardian-redeemer. May he become famous throughout Israel! He will renew your life and sustain you in your old age. For your daughter-in-law, who loves you and who is better to you than seven sons, has given him birth."

Then Naomi took the child in her arms and cared for him.

RUTH 4:13–16

Ruth grew up in Moab, surrounded by the oppressive culture of superstitious traditions and the twisted religion of Chemosh worship (also known as Molech, Baal, and Asherah). The Moabite god demanded child sacrifice as well as perverse and sexually abusive customs of worship. As a Moabite, she likely witnessed some horrific practices: watching beautiful babies placed in the stone arms of the god, only to see them roll down and be burned alive in the fire of the idol's belly.

Naomi, a Jew, along with her husband and two sons, had fled to Moab during a famine in Israel. In the providence of God, Ruth met and married one of Naomi's sons. She left the home of her father and mother as well as the culture of the Moabites. By marrying a Jew, she would participate in their culture and practice the radically different faith of Jehovah God. The God of the Jews was all-powerful, yes. However, He was also a God of extreme love, undying faithfulness, and profound goodness. The contrast between the religion of her upbringing, with its torturous and vile practices, compared to the glories of a loving and faithful God, was extreme. In response to this abundant love and lavish goodness, Ruth converted, placing her faith in the holy God of Israel.

Young Ruth was received and enfolded into this joyous Jewish family. She deeply bonded to her new family until her ten years of marriage was unexpectedly ended by the deaths of her husband and his brother. Suddenly widowed, Ruth and her sister-in-law joined Naomi, their already widowed mother-in-law, in grieving the death of her two sons. The three widows were left alone—without care, protection, or provision. Distressed and dismayed, feeling forsaken and abandoned, Naomi prepared to return to her homeland. Ruth and her sister-in-law, Orpah, determined to go with her.

STANDING AT THE CROSSROADS

On the road, Naomi appealed to them both to return to their mothers' homes and find new husbands. They were not obligated to her. This was her great loss. They did not need to suffer more on her account. In her grief, Naomi told them, "Go back, each of you, to your mother's home. May the LORD show you kindness, as you have shown kindness to your dead husbands and to me" (Ruth 1:8). Orpah cried and left, leaving Ruth clinging to Naomi. "'Look,' said Naomi, 'your sister-in-law is going back to her people and her gods. Go back with her'" (v. 15). But Ruth would not go.

Ruth stood at a literal crossroads; the road that led to Israel and the road that led back to Moab. She could not sit on the fence. There was no having one

foot in each world. This was decision time. Ruth chose God. She chose to leave her culture, her country, and her family's gods in exchange for the culture and kingdom of the one true, living God. Ruth left Moab. For her, there would be no turning back.

"Ruth replied, 'Don't urge me to leave you or to turn back from you. Where you go I will go, and where you stay I will stay. Your people will be my people and your God my God'" (v. 16). While Ruth deeply loved Naomi, her declaration of loyalty was not merely personal. She was declaring her decision to follow God and her fierce determination to be part of the people of God. Ruth went all in. Her commitment to God was not an add-on to an already full life. It was her entire life. And she was willing to forsake all other things to gain a place with the people of God.

I love the passionate, wholehearted nature of Ruth. I love that she was all in. She did not waiver between two kingdoms. She knew who she was and whose she was. I love that when she committed to follow the Lord God, she did it with all her heart. She determined to live, walk, and stand in her identity as a child of God, willing to leave everything else behind. She courageously grabbed hold of her identity and jumped ship. Fully confident in the God of Israel, she entrusted her entire life and future into His faithful hands.

DRAWN BY DIGNITY

Ruth and Naomi returned to Israel. Naomi was bitter. However, Ruth was hopeful, and she committed to carving out a life for them in Bethlehem. It was late summer, the time of the harvest. Ruth asked Naomi if she could go out into the harvest fields and glean behind the harvesters. It was the custom in Israel to harvest your fields only once and to leave what was missed for the poor to glean. Unbeknownst to Ruth, she ended up in the field of Naomi's relative Boaz.

Ruth worked hard all day, gleaning what she could from behind the harvesters. Toward the end of the day, Boaz went to the field to check the progress of the harvest. An unknown woman, working diligently, caught his eye and aroused his curiosity. "Who does that young woman belong to?" (Ruth 2:5) he inquired.

"The overseer replied, 'She is the Moabite who came back from Moab with Naomi. She said, "Please let me glean and gather among the sheaves behind the harvesters." She came into the field and has remained here from morning till now, except for a short rest in the shelter'" (vv. 6–7). Upon learning that the young

woman was the much-talked-about daughter-in-law of Naomi, Boaz called her over. "My daughter, listen to me. Don't go and glean in another field and don't go away from here. Stay here with the women who work for me. Watch the field where the men are harvesting, and follow along after the women. I have told the men not to lay a hand on you. And whenever you are thirsty, go and get a drink from the water jars the men have filled" (vv. 8–9).

Humbled and genuinely surprised by the favor, provision, and protection of the landowner, Ruth sought to discern his motives. Who was this man? Why was he being so generous? Were there strings attached to his offer? Why would a Jewish landowner pay attention to her, a foreigner? Were his intentions pure, or should she beware? She was not about to accept a "gift" wrapped in some questionable "obligations" from a strange man! Ruth shrewdly bowed down with her face to the ground, perhaps guarding her eyes lest they reveal the questions in her heart. She asked him, half hoping and half dreading his answer, "Why have I found such favor in your eyes that you notice me—a foreigner?" (v. 10).

Boaz's response revealed his deep respect for Ruth, her stellar reputation among the people, and his own integrity as a man. He replied, "I've been told all about what you have done for your mother-in-law since the death of your husband—how you left your father and mother and your homeland and came to live with a people you did not know before. May the LORD repay you for what you have done. May you be richly rewarded by the LORD, the God of Israel, under whose wings you have come to take refuge" (vv. 11–12).

Boaz didn't know Ruth, but he already knew *of* her. Her story of faith, courage, and sacrifice had already spread through the town of Bethlehem. Naomi's "return in ruin" was the talk of the town, tragic except for the surprising loyalty of the mysterious and foreign widowed daughter-in-law, Ruth. Reportedly, Ruth's persevering faith kept hope alive as she admirably provided for herself and the aging Naomi. Ruth seemed truly remarkable; who would do such a courageous thing, leaving her land and her people without a husband? The rumors about town mirrored the truth that Ruth stayed with Naomi because of her faith in and devotion to the Lord God of Israel.

And here this remarkable woman of rumor was standing humbly before him, expressing her gratitude for his help. She replied, "May I continue to find favor in your eyes, my lord" (v. 13). Relief flooded her soul at his answer! He was sincerely a kindhearted man doing a charitable act. There was no hint of impropriety or of exploiting Ruth's vulnerable position. "You have put me at ease by speaking kindly

to your servant—though I do not have the standing of one of your servants" (v. 13).

Boaz continued to watch her throughout the day. She did not demand or presume upon his generosity. She worked hard. She was friendly and respectful but kept to herself. Wisely, she was cautious and modest in her interactions with the harvesters. While young working men abounded, Ruth stayed focused on her task. She neither sought out their attention nor flirted with the men. Boaz's interest and intrigue grew as he observed her purity. He had seen relief and gratitude flood her eyes in response to his noble intentions. She worked with a peaceful joy. She was soft-hearted yet strong, hope-filled, and diligent. She was absolutely intriguing! This was no common woman.

Boaz wanted to learn more. His initial curiosity morphed into a deep respect, compelling him to pursue, provide, and protect. At mealtime Boaz invited her, "'Come over here. Have some bread and dip it in the wine vinegar.' When she sat down with the harvesters, he offered her some roasted grain. She ate all she wanted and had some left over. As she got up to glean, Boaz gave orders to his men, 'Let her gather among the sheaves and don't reprimand her. Even pull out some stalks for her from the bundles and leave them for her to pick up, and don't rebuke her'" (vv. 14–16).

Her respectability drew out the nobility in him. Her strength of character roused his strength of character. He was fascinated by her purity, transfixed by her hope-filled joy, enthralled by the beauty of her peace and contentment. As a rich single man, he certainly had experienced other women trying to attract his attention. Such women likely seemed petty and unsubstantial to him. Ruth was different. She carried herself with a dignified strength and modesty. Ruth let her character—and the content of who she was and what she was about—do the attracting rather than resorting to letting her body do the seducing.

NOBLE DESIRE

As we saw with Bathsheba, seduction reduces a man. It awakens and draws out a man's weakness and vulnerabilities rather than his strength. Seducing disrespects a man's sexuality. Contentment, commitment, and confidence are different. They attract a man. They call up the best of a man. This true beauty inspires a man to pursue, provide, and protect. Ruth's confident, committed, and contented beauty elicited from Boaz one of the most stunning displays of manhood in the Bible.

Boaz respectfully pursued her. He generously provided for her. He valiantly

protected her. He didn't use or abuse her. He didn't take advantage of the situation or leverage his position of power to exploit her. Rather, he ensured her safety, guaranteed her provision, and fostered her contentment.

It was an amazing day of divine encounter. When Ruth woke up that morning to glean in a nearby field, she could not in her wildest dreams have imagined this orchestration of God. She left home empty-handed that morning, hopeful but cautious. She returned that evening with all the grain she could carry, along with the leftovers from lunch. As she recounted the story to Naomi, awareness of the providential mercy of God dawned in Naomi's heart. God had *not* abandoned them! He was still with them, working on their behalf! Could it be that they were not destitute and forsaken after all?

"That man is our close relative; he is one of our guardian-redeemers" (Ruth 2:20). In the tradition and law of Israel, if a man died without an heir, the brother was to take the widow as his wife, provide for her, and conceive a son to carry on the family name. In the case of Ruth, there was no brother left. Therefore, the right—the duty—transferred to the next closest male relative. These relatives were known as guardian-redeemers or *kinsman-redeemers*, for they could claim or "redeem," the widow and her property for themselves. Boaz was in line as a kinsman to redeem Ruth.

Ruth continued gleaning daily in Boaz's field until the time of the harvest ended. It was the eve of the celebration for the completion of the work. There would be feasting and drinking, a time of thanksgiving for the bounty God had provided. While Ruth had gleaned faithfully in Boaz's field for weeks, enjoying his care and provision, Boaz had made no mention of redeeming Ruth as a kinsman-redeemer. Naomi knew men and she understood human nature. But she also knew Boaz.

PERSUADED BY PURITY

The man was clearly captivated by Ruth. He sought her out, made sure she was taken care of, and favored her over all the other harvesters. What was his hesitation? Boaz was older than Ruth. He may have supposed he was too old for her. Indeed, while she readily accepted his provision and protection, he would never assume she desired his affection. He was a man of honor. He would not presume upon the rights of a kinsman-redeemer or make a relational demand of Ruth. He already cared too much about her to claim her like a piece of property. He clearly wanted her happiness, and he planned to ensure she was taken care of. He was

glad to do his duty as provider and protector. But to claim her womanhood—no, he would not demand such a thing. Love and marriage were not an advantage to take, but a privilege that could only be given. Because of his restraint, Naomi was convinced that he indeed already truly loved Ruth.

Ruth needed to somehow communicate her willingness to be redeemed by Boaz and her desire to be his wife—before the season of harvesting was over and the opportunity passed. As the man and redeemer, Boaz was in the position of power in their relationship. But he would never leverage that power to push Ruth to be his wife.

Naomi devised a plan. After the feasting, Boaz would go to sleep in the fields surrounding the bonfire. Borrowing from a marriage custom of the day, she instructed Ruth to go to where he was lying, uncover his feet, and lie there at his feet until he awoke. Naomi trusted Boaz's noble character—he had treated Ruth with the utmost respect all these weeks. She was confident he would be honorable again.

Ruth bathed, dressed, and perfumed herself. Then she waited. She may have watched the winnowing of the barley from a ridge above the threshing floor. The men worked hard. They ate merrily and finally settled into a content slumber. Ruth watched Boaz and noted where he lay down. She likely circled around the outer perimeter and stealthily made her way to where he was sleeping, taking great care not to be seen or awaken others. As instructed, she uncovered his feet, lay down, and waited. Finally, he stirred. Imagine her heart pounding as she readied herself for what she would say when Boaz discovered a woman at his feet!

Alarm jolted Boaz awake with the realization that a woman was lying at his feet! "'Who are you? he asked" (Ruth 3:9).

CHOSEN . . .

"'I am your servant Ruth,' she said. 'Spread the corner of your garment over me, since you are a guardian-redeemer of our family'" (v. 9). It was an invitation. It was a proposal. It was Ruth! Ruth was inviting him to cover her with his garment, to redeem her as his wife! Warren W. Wiersbe, in his Bible commentary, confirms this act as a marriage proposal and a request for Boaz to do his duty as kinsman-redeemer and take Ruth to be his wife. Western cultures are less familiar with both the tradition and interpretation of "spread the corner of your garment over me."[37] However, it was a common practice in the marriage ceremonies of several Asian cultures. Ruth was in no way compromising her integrity or purity; rather, she was asking Boaz to take her under his protection in marriage in an

honorable and understood way.

Was it possible she actually wanted to marry him?! This was no half-hearted suggestion, no flippant toying with his emotions. She had come to him intentionally and at great risk. She was sincere. She was serious!

The affection and love he felt but had suppressed burst forth in a rush of emotion and transparency. "'The Lord bless you, my daughter,' he replied. 'This kindness is greater than that which you showed earlier: You have not run after the younger men, whether rich or poor'" (Ruth 3:10). Ruth could have pursued younger men, but she had not. She had waited and watched until the Lord directed and opened the door. She didn't have a string of past relationships. She had no regrets. She had chosen. She had chosen *him*.

. . . AND CHERISHED

"And now, my daughter, don't be afraid. I will do for you all you ask" (v. 11). While the custom of the time is not familiar to us, her request and the manner it was communicated was clear to Boaz. Ruth had asked. She had requested, and his answer was a resounding, enthusiastic, *Yes!*

"All the people of my town know that you are a woman of noble character" (v. 11). He reassured her that he understood her motives in the moment. There was no assumption of impropriety or seduction. He correctly interpreted that her offer was not for a one-night roll in the hay, but for a lifetime as husband and wife.

"Although it is true that I am a guardian-redeemer of our family, there is another who is more closely related than I" (v. 12). Apparently, Boaz had already done his homework. He knew he was not next in line, but he knew exactly who was. "Stay here for the night, and in the morning if he wants to do his duty as your guardian-redeemer, good; let him redeem you. But if he is not willing, as surely as the Lord lives I will do it" (v. 13). He vowed that he would marry her if the other man would forfeit his rightful claim. He promised to take care of the matter that very day!

"Lie here until morning" (v. 13). Ruth remained at his feet until morning. She did not crawl up next to him, take off her clothes, or offer sex to him. He confirmed her purity and guarded it throughout the night. His advice to stay there until morning was for her protection. In essence, saying, *Stay here, near me, where I can guard and protect you until morning when it is safe to walk about. I don't want you to be molested or hurt, suspected or wrongly accused.* Ruth stayed.

At the crack of dawn, unrecognizable in the dim light, she rose to return

home. Boaz protectively warned, "No one must know that a woman came to the threshing floor" (v. 14). In a gesture of reassurance, he asked her to hold out the shawl she was wearing. He filled it with barley and wrapped the bundle on her back. Determined, with a strategy unfolding in his mind, he headed to town to settle the claim with the other potential kinsman-redeemer.

Boaz knew the intricacies of the law. He also knew human nature. He understood the subtleties of coveting something of perceived value. He had clearly thought about this possibility and devised a plan to navigate it. When the rival kinsman-redeemer approached, Boaz gathered together a council of elders and witnesses according to the law and custom of the day. He offered the *land* of the deceased son of Naomi to the other man as the first in line to redeem it. The response was predictable. Sure, he'd like to claim the land, why not? As an addendum to the land negotiation, Boaz off-handedly added that with the land also came the dead man's widow, as well as the duty to produce an heir to the estate. Ugh. A widow? Another possible heir? That could endanger the inheritance of his own sons. He didn't want to share his estate on behalf of another, and he had no interest in an unknown, additional wife. He promptly bowed out. Boaz nonchalantly sealed the deal, legally, with the town's elders as witnesses.

FAITH, HOPE, AND LOVE

Elated and victorious, Boaz headed to Naomi's house to take Ruth as his wife. The elders and townspeople held a celebration to bless the marriage union of Boaz and Ruth. Boaz married Ruth as a wanted and willing wife. She was not an inherited duty, but the woman who captured his heart. Ruth gave birth to a son. The community rejoiced in this fairytale-like ending to what had began as a story of tragedy. Naomi received an heir to carry on her family line. The courageous and faithful-hearted Ruth won the affection and devotion of one of the noblest and greatest men of Bethlehem.

Boaz was convinced he was the blessed one. He was the one who won the prize of the most incredible, strong, and noble woman he had ever known. He valued and esteemed the love of Ruth. Her love was not a cheap gift, easily gotten and quickly forsaken. No, her love was received as a precious gift, a cherished treasure that he committed to guard and nurture. She was his beauty. She was his bride. She was his beloved. She was blessed.

Ruth's faithfulness, her hope and trust, not only won the heart of a noble man,

but also restored Naomi's faith that God is good. Naomi, whose name means *pleasantness*, lost her faith in God when devastated by the deaths of her husband and sons in Moab. Upon return to Bethlehem, she told people to call her Mara, meaning *bitter*. But as she bounced her grandson on her lap and observed the gaze of affection pass between Boaz and Ruth, Naomi's bitterness melted away. It was replaced with renewed hope, faith, and belief in the awesome mercies of the Lord.

Ruth's impact on Naomi was not lost on others. As women of the community watched the redemption of this family—the restoration of hope and joy—they pronounced bountiful blessings upon Naomi, along with Ruth, Boaz, and their son. But the hero of the story was Ruth, this incredible woman of faith and courage, of sacrifice and surrender, whose love and loyalty were used by God to redeem a family and change history. She was crowned in their praises. The women of Bethlehem said to Naomi, "Your daughter-in-law, who loves you and who is better to you than seven sons, has given him [your grandson] birth" (Ruth 4:15).

CONFIDENT IDENTITY

True beauty is this: being *confident* in your identity as a daughter of the Most High God. According to Webster's, confidence is "trusting, or putting faith in; trust, reliance, belief . . . such assurance as leads to a feeling of security."[38] It is to firmly trust. Confidence is being fully convinced and standing on who God says you are to Him. It is believing at your core that you are loved.

Confidence is not the same as arrogance or pride. It's not cocky or haughty. Confidence is stunningly beautiful when accompanied by humility. Ruth's confidence was not in herself and her own abilities, wisdom, or strength. Rather, her confidence was in the Lord's unfailing, unwavering love for her, His precious daughter. Godward confidence produces a deep security that radiates peace and joy. It has no fear of rejection, abandonment, or failure. Essentially, Ruth trusted God's love with *all* her heart. She *lived loved*.

> Godward confidence produces a deep security that radiates peace and joy.

COMMITTED INFLUENCE

Ruth's confidence generated commitment. To the extent that we trust, we will follow and obey. Her identity was firmly set as a child of God. Her life goal naturally followed: to be part of God's people, no matter the cost. She was completely

devoted and passionately determined to obey the Lord in every aspect of life. She committed to following His ways and trusting His plans and purposes. She fully submitted and surrendered to His Lordship. Hers was not a heart divided. She was not double-minded. Ruth took God at His word. She trusted His character and believed His promises—so much so, that she willingly staked her very life and future upon them!

True beauty is being confident in our identity and *committed* to our influence as children of God.

Ruth committed to the roles, responsibilities, and relationships God gave her. She willingly laid down all other competing interests and goals. She didn't try to be everything to everyone. She didn't try to do it all. She surrendered her own will and entrusted herself to the will of God. She did not devise her own plans and self-directed goals. Rather, she submitted them to the purposes of God. She didn't go chasing rabbit trails or dream of escaping her reality. Instead, Ruth followed the path God laid before her. She wholeheartedly engaged in fulfilling her responsibilities and honoring her relationships in the present.

As women, we can find ourselves so easily divided and conflicted, especially if we try to please everyone. We can't win. I struggled for many years with the tension and pressure of

> To live all-in, we must let go of all the other things we cling to for our value and identity.

trying to balance the approval of all those around me. No matter what I chose to do, someone, somewhere disapproved: *You're single, you should be married . . . You're getting married, you're too young . . . You're a stay-at-home mom, you should be working . . . You're working, you should be staying home.* And so it went.

Part of living out our identity as redeemed women is listening to *one* voice, having *one* leader—and that's the Lord God. We need to remember the message from Mark 3:25, that a house divided cannot stand. When our hearts are divided, listening to multiple voices, we'll doubt God's wisdom and direction. "The one who doubts is like a wave of the sea, blown and tossed by the wind . . . double-minded and unstable in all they do" (James 1:6, 8). We cannot try to please and win the approval of both people and God.

Ruth stabilized and focused her life by choosing whom she would trust and obey. She went all in. To live all in, we must let go of all the other things we cling to for our value and identity. We must reach out and take the hand of Jesus. Only then will we be secure and stable, living purposefully without fear. Then we can *live loved.*

We see the beautiful, alluring glory of Ruth's devotion to live right and do well. She devoted herself to be faithful, to live and love as the Lord led. She was not self-seeking. She did not look to glean life from others. Rather, she committed to serving God's purposes in others' lives. She plugged in to the strength of God. Ruth became a source of hope, faith, and love *for* others rather than seeking to gain life *from* others. Simply stated, she was a giver—not a taker. She gave generously of herself, loved wholeheartedly, and spent her strength serving others.

RELATIONAL CONTENTMENT

Ruth's confident trust in God and her commitment to serve His purposes resulted in a deep contentment. Because she entrusted her entire life to the Lord, trusting His ways and wisdom, she approached life from a place of wholeness, security, and satisfaction. She was able to wait and remain patient, even with the longings, dreams, and desires of her heart.

Being content does not mean we are without desire. Rather, it is the fruit of a patient, hopeful, believing trust. It rests in gratitude and waits in expectancy. Being content is being able to appreciate and receive the gifts of today. It is taking pleasure in the moment. It is empowered to be satisfied with the present because the future is already secure in the sovereignty of a good and faithful God.

> Being content does not mean we are without desire. Rather, it is the fruit of a patient, hopeful, believing trust. It rests in gratitude and waits in expectancy.

True beauty is being *content*. It's content in living out our identity and entrusting our present and future to God. In Ruth's life, it was this depth of strength and this generous character that attracted the interest and ignited the affections of Boaz in one of the most epic love stories of all time.

Ruth embodied true beauty—beauty that was *confident* in her identity as a child of God, *committed* to serving the plans and purposes of God, and *content* in her relationships. She entrusted her heart, needs, dreams, and desires to God. Hers was a beauty marked by purity and clothed in humility. Gratitude and grace were her hallmark. Courage and conviction were her foundations. Joy and peace were her reward. Her beauty was far more than skin deep! She radiated the inner beauty of a woman fully alive and full of hope. She *lived loved*.

Embrace your identity as a perfectly loved child of God. Commit to living out God's plans and purposes for your life. Rest content, entrusting your desires and

dreams to His faithful provision. Forsake your bitterness and disappointment. Renounce your *Mara* spirit and embrace His hope-filled beauty for you. Watch as the Lord redeems your life, fills your heart, and blesses your beauty.

Lord Jesus,

You are the Alpha and Omega; you know the beginning and the end and every day in between! Help me to trust you with my present and forsake my own attempts to orchestrate the future. I trust your sovereign plans for me. Lord, I renounce all other "kingdoms" where I am tempted to turn for life, value, and security. Help me to walk confidently in my identity as your child. Help me to live faithfully committed to serving your purposes in my relationships. I choose to stand tall, secure as I rest in your perfect, unfailing love. I will walk in integrity, serve diligently, and love unselfishly. I will *live loved*.

In Jesus' name, Amen

DISCUSSION QUESTIONS

1. Ruth released competing "kingdoms" and cultures for God's kingdom. What cultural idols is God calling you to release in order to place your identity solely in Him?

2. Ruth was committed to God's purposes and the roles, responsibilities, and relationships in her life. Are there any competing goals, interests, or relationships you need to alter to be fully committed to serving God's purposes in your life? How can you express your commitment more wholeheartedly?

3. Ruth rested in God's provision for her relationally. She fostered contentment. How can you pursue contentment relationally, whether single or married? What does living and relating from contentment look like?

Notes

Redeemed Eve

11

LIVE LOVED

If only . . . two little words sum up the cry of a woman's heart. At the core, what are we really longing for? *If only I could be loved with a love that never failed, disappointed, or lacked. If only I could be completely secure and stable without fear or anxiety. If only I could be confident and comfortable with who I am. If only I could be significant and have a purpose in life. If only I could be filled with joy, live in peace, and enjoy life. If only* . . .

REVERSE THE CURSE

Ultimately, *Redeeming Eve* is the journey to restore our hearts to our Creator, to secure our identities in the One who loves us unfailingly and eternally . . . to turn away from our broken cisterns that cannot hold water and turn instead to Jesus. He is the Living Water, the source to quench and fill our thirsty, hungry hearts.

We've traveled through the lives of nine beautiful women who sought to find the life and love their hearts so desperately craved. We watched as they struggled and surrendered, wavering between hope and despair, victory and defeat. We saw them thirst for love and meaning—and seek life from whatever source they could find, good or bad. This inner thirst either led them to broken cisterns and empty wells or drove them to the well of God's unfailing love to fill their hearts. We saw firsthand how the foundations of identity determined their goals, directed their influence, and defined their intimate relationships.

Jesus came to redeem Eve, to restore her strength and dignity, and love her back to wholeness. Jesus' love can reverse the curse.

EMBRACE LOVE

My friend, if you've never opened your heart to Jesus, may I invite you to do so now? You don't have to "clean up your act" to go to God. He invites you to come as you are, with your hurts, dysfunctions, brokenness, and needs. He promises to receive you. He will never reject you! Jesus said, "Whoever comes to me I will *never* drive away" (John 6:37, emphasis added).

> He invites you to come as you are, with your hurts, dysfunctions, brokenness, and needs. He promises to receive you. He will never reject you!

When we open our hearts to Jesus as Lord and Savior, when we confess our sins and believe in our hearts that He is God, He *will* forgive, heal, and save us. I love the picture of forgiveness God paints in Isaiah 1:18: "Though your sins are like scarlet, they shall be as white as snow." Think of it: forgiven, washed clean, and made as pure as freshly fallen snow!

Jesus, the Living Water, also promises to fill us up. "I am the bread of life. Whoever comes to me will never go hungry, and whoever believes in me will never be thirsty" (John 6:35). When we turn to Jesus, our hearts are watered with perfect love and filled with joy. Our lives are refreshed. Acts 3:19 invites us, "Repent, then, and turn to God, so that your sins may be wiped out, that times of *refreshing* may come from the Lord" (emphasis added).

This coming to Jesus is not about behavior. It is not about performance. It is not about trying to measure up to some impossible standard set by God or man. It's simply the laying down of your pride and self-direction, forsaking your broken cisterns. Confessing your sin. Repenting. It's opening your heart and welcoming the love and forgiveness of Jesus to heal and transform you.

Jesus invites you into a deep, authentic, open, and honest relationship with Him. In this relationship, we receive His love and grace and are filled with His acceptance. We open our hearts up to Him. We seek to know Him and be known by Him. We begin to *live loved*. As we live from this place of love, intimacy, and security, we are transformed from the inside out.

SECURELY LOVED

This love relationship with Jesus changes everything. At our core, it secures the knowledge in our hearts that we are unconditionally and eternally loved. We are completely accepted and adopted by the God who created us. We are fully

known and securely embraced. Because we are forgiven, we don't have to fear punishment from God; we don't have to hide anymore! "There is no fear in love. But perfect love drives out fear" (1 John 4:18).

I have two favorite verses about this relationship with Christ. First, Hebrews 4:16 says, "Let us then approach God's throne of grace with confidence, so that we may receive mercy and find grace to help us in our time of need." And Ephesians 3:12 reads, "In him [Jesus] and through faith in him we may approach God with freedom and confidence."

Notice that we can approach God's throne of *grace*. It is not a throne of judgment! It's not a throne of evaluation. It's not a throne of critique. It is His throne of grace where we will *always* find mercy and help. Not disapproval or dismissiveness—but mercy and help. When? In our time of need, in our time of weakness and failure. In our time of grief and loss. In our time of *if only*.

Because we're forgiven and clothed in God's grace, we can approach God with freedom. We can be free from fear of rejection, free from fear of disapproval or judgment, free from pressure or anxiety. And with confidence—we can be confident that He wants us, confident that He accepts and receives us, confident that He loves us!

This grace and love radically transform our identity. We need to stand on the truth of who we are *in Christ*—not who someone else says we are, not our culture, not our community, not our family, not our jobs, not our net worth, not our performance or achievements, not the mirror or our external beauty. We are who God says we are!

God says you are loved. (Jeremiah 31:3)
You are wanted. (Isaiah 30:18, Jeremiah 31:20)
You are chosen. (1 Peter 2:9, John 15:16)
The God who created you has pursued you. (Psalm 23:6, Luke 19:10)
You are eternally forgiven. (Psalm 103:12, 1 John 2:12, Ephesians 1:7)
And you are deeply cherished. (Isaiah 43:4, 1 Peter 2:4)
Jesus is the unfailing lover of your soul. (Psalm 13:5, Exodus 15:13, Psalm 33:22)
In Christ, you are washed clean (Isaiah 1:18, 1 John 1:9) and robed in
 righteousness. (Isaiah 61:10, Galatians 3:27)
In His love, you are anointed with joy (Isaiah 61:1–3), appointed with purpose
 (Ephesians 2:10), and endowed with strength. (Philippians 4:13)

LIVING FROM WHOLENESS INSTEAD OF NEED

When our identity is securely rooted in Christ's love and acceptance, we can *live loved*. Our needs are met first and foremost in His lavish provision. We are secure. We are filled up. Our hearts are whole. We have purpose and significance in Him. We no longer enter relationships desperate and needy. Nor do we go through life hungry and thirsty. Because we are filled and loved, we are free to live and love from wholeness instead of need, to serve and nurture life in others instead of seeking life from others. We can freely love others instead of using them to meet our needs.

This was the great exchange that Jesus shared with the woman at the well. Previously, she went through life perpetually thirsty and never satisfied. Jesus told her if she would drink from His love and truth, she would never thirst again. "Indeed, the water I give them will become in them a spring of water welling up to eternal life" (John 4:14). When Jesus met her need and quenched her thirst for love, she was full for the first time in her life.

She immediately switched from being a taker to being a giver. She stopped consuming love and instead began to pour it out. Rather than seeking life from others, she let the life of God flow through her to others. When she was transformed and filled up by Jesus, the well of living water within her was unlocked and came gushing out. She left her old water jar at the well. She no longer needed it.

"Then, leaving her water jar, the woman went back to the town and said to the people, 'Come, see a man who told me everything I ever did. Could this be the Messiah?' They came out of the town and made their way toward him. . . . Many of the Samaritans from that town believed in him because of the woman's testimony, 'He told me everything I ever did'" (John 4:28–30, 39).

She had living water flowing in her and through her. She went back to town, to those she had once sought life *from* and took life *to them*. Her testimony spilled out of her like a river. She was alive in a way she had never known. It showed and she glowed. It intrigued and it inspired. She invited them to come meet Jesus, the One who totally knew her, who finally quenched her thirst and loved her to fullness.

REDEEMED DESIRE

When a woman's need for love is met, her desire and influence are redeemed. No longer will she live from the curse of "your desire will be for your husband, and he will rule over you" (Genesis 3:16). She will be freed from this unquenchable desire for a man's love. She will no longer constantly seek his attention, approval,

and affection. Her need is fulfilled in being the apple of God's eye (Psalm 17:8) and the object of God's unfailing love (Psalm 31:16).

Instead of desperately seeking love, she can focus on fulfilling the Lord's plans and purposes for her life. She literally switches her source, purpose, and goals—from seeking the love of a man to receiving and dispensing the never-ending supply of Jesus' love.

Instead of desiring to drink from the waters of human approval, which will leave us thirsty again, we turn to the living water of God's love to fill us. Indeed, God promises, "Take delight in the LORD, and he will give you the desires of your heart" (Psalm 37:4). Jesus said in Matthew 6:33, "But seek first his [God's] kingdom and his righteousness, and all these things will be given to you as well."

Redeemed desire commits to knowing, loving, and being with Jesus as your top priority. Receive your life from Him. Make pursuing His person and presence the desire of your heart. Drink deeply of His love, approval, and acceptance. *Then*, the other things in life fall into their rightful places.

NURTURE LIFE

Redeemed influence will *give* life to others rather than seek life *from* others. Redeemed influence will serve *God's* purposes in others instead of using others for your *own* fulfillment. Influence that is redeemed is alive and full. It is a conduit of life flowing freely and powerfully. It forsakes self-seeking and self-directing. It's committed to purposely letting the love of God flow *through* you *to* others.

Think about your relationships with family and friends. Are you looking to them to *get*—to receive what you want and desire from them? So often we value and judge people and relationships based on what we get out of them. This is the influence that God wants to redeem in us.

> Redeemed influence will *give* life to others rather than seek life *from* others.

Redeemed influence is submitted and surrendered to fulfilling and serving God's purposes. Redeemed influence goes through life and approaches relationships with questions like these: *Lord, how can you use me to encourage and build up this person? How can I show your love to this person? How can I reflect your character and respond as you would in this situation? How can I lovingly speak truth and invite this person into relationship with you?*

When we understand and embrace this reality, we will receive people and situations as assignments for godly influence rather than viewing them as burdens to

bear. Your difficult family member, your political job, your irresponsible child—it's things like these that make you pray, *God, please send someone to do something!* If you're there, God has sent *you*. These challenging situations and relationships are not just problems to be rejected and avoided, but rather they are opportunities to reflect Christ, share love and truth, and influence others toward godliness.

God will use you tremendously—if you let Him. Having His power and love flow through you will fill you up and energize you like nothing else can! Lives will be restored, and relationships will flourish as God's mercy and grace are poured out through you onto others.

RELATIONAL CONTENTMENT

When a woman stands confident in her identity as a beloved child of God and walks committed and submitted to God in her influence, contentment in her intimate relationships is the result. No longer will her relationships be plagued with fear, need, and control.

When we *live loved*, living from wholeness instead of need, we relate from confident security and committed generosity. We let go of controlling, trying to *make* people, things, and circumstances fill us up. Grace and freedom become the hallmarks of our relationships. When we are relating from wholeness instead of need, we will stop accusing love and life of not being enough. We free others from the demand to fill us. In doing so, we are finally free to *receive* love without *devouring* it, to let someone love us, without measuring, critiquing, or rejecting.

Contentment is found in graciously *receiving* the relationships, love, and friendships the Lord has given us. Will we receive our husbands with honorable acceptance and esteem, releasing them from our constant critique and insatiable desire? Will we receive our children and their unique personalities, releasing them from our attempts to mold and hold them? Can we receive our in-laws as family and release them from our evaluation, comparison, and expectations? Can we find the trust and courage to embrace our circumstances in each season of life? Can we stop complaining, and willingly release our control and critique?

Friend, you can only do you. You have your own race to run. Focus on drinking deeply of God's life-giving love, letting it flow through you. Let go of others. Let them live and make their own choices. Steward your influence in cultivating love and goodness. Forsake controlling others. There is great freedom in releasing others and just doing you. Love well. Receive and release. *Live loved.*

REVERSE THE CURSE IN MARRIAGE

Jesus came to abolish the curse. He re-established and redeemed the pre-sin order of creation for men's and women's roles, responsibilities, and relationships. When a husband and wife embrace the forgiveness, acceptance, and grace of Jesus, they can enter their marriage in wholeness. Women will no longer enter relationships need-first. Men will no longer enter relationships greed-first. Wives will be free to love their husbands from wholeness, and husbands will be free to love their wives from selfless strength and vulnerable transparency.

In Christ, redeemed wives are free to submit to and respect their husbands. As we read in Colossians 3:18–19 and Ephesians 5:21–33, redeemed husbands are to submit to and love their wives. In fact, Ephesians 5:21 prefaces both commands to the husband and the wife with the command to "submit to one another." Submission, from the start, was to be a two-way, mutual practice.

A couple's submitting one to another keeps God in His rightful place. As we see in Exodus 20:3 and in Abigail's story, a woman is to have *no* other gods before the Lord God—not even her husband. We are *not* to *worship* our husbands nor give them ultimate, unconditional authority in our lives. According to 1 Peter 3:15, we are to revere Jesus as Lord. 1 Peter 3:7 exhorts husbands to be considerate, to respect their wives as partners and co-heirs with Christ. Romans 8:17 reminds us *again* that, as believers, we are co-heirs with Christ. When both men and women submit first to God and then to one another, there is no battle, no power struggle, no dominance. Christ becomes the true head of the home. Christ is Lord of both.

DON'T JUMP!

When faced with the temptation of the Serpent and the choice to obey or disobey God, Eve *jumped* over Adam. She did not consult him or include him. She took charge, made the decision, broke the unity of partnership, and assumed the position of leadership in marriage. As we've seen in the lives of the women we've studied, there are fundamental tendencies of our fallen Eve nature: abandoning God's authority, taking matters into our own hands, leaning on our own understanding, and trying to control others.

The command for a wife to submit to and respect her husband counters that fallen nature. In its most simplistic sense, the command is *Don't jump!* Remember your husband! You are in partnership. Remember. Consult. Consider. Take into account the perceptions, perspectives, and preferences of another—namely, your husband! Don't jump ahead, over, or above him. Stay *with* him.

To the extent that wives grab authority and exert control in relationship with their husbands, they lose intimacy. Why? Because being dominated feels deeply disrespectful to a man. In fact, dominating or controlling another is sinful, and it diminishes the one subjugated. When a wife jumps over and ahead of her husband, she forfeits the trust and safety needed to foster true intimacy.

Likewise, responsibility and authority go hand in hand. When a husband is given authority to choose for himself, he must also take the corresponding responsibility. When a wife submits to her husband, she is essentially taking care not to assume authority over or responsibility for him. Instead, he becomes responsible for himself and his choices. When a husband is given authority to choose, he can no longer hide behind his wife or play victim of her leadership or decisions. He can no longer blame the woman, "the woman you gave me . . ." (Genesis 3:12, NLT). Rather, he is called upon to take personal responsibility before God as a man, husband, and father.

The most important aspect of the command *Don't jump* is that it keeps a wife *next to* her husband—and God *above* him. When a wife jumps into authority over and above her husband, she replaces God as his authority. This is what happened in the garden of Eden. In Genesis 3:17, God confronted Adam for listening to and obeying Eve over Him. "You listened to your wife and ate from the tree about which I commanded you, 'You must not eat from it.'" Adam had listened to Eve as his authority. He obeyed her instead of God. Submitting to your husband, that is, *not* jumping ahead, keeps you from assuming God's place in your husband's life.

Looking deeper, when Eve jumped, she exalted herself as a god in Adam's life. She became his idol, assigning to herself worship, loyalty, and allegiance that belongs to God alone. When a husband worships his wife, he lives for *her* approval instead of God's. At first glance, that might not sound so bad to us ladies. However, a man cannot both *need* your approval and *love* you at the same time. If he needs your approval, he will *give* and *do love* for *his* need for approval and success rather than to love you and care for your needs for your sake.

For example, consider a husband who buys flowers for his wife and then posts it on social media. The flowers may be to bless her, or they might be to bless *him* with the approval and admiration from others.

> Any form of demanding love results in something less than authentic love.

Love is best when it's freely given. A husband is called upon to love his wife as he loves himself, to care for her needs as he cares for his own. When a wife stops taking or demanding love and acting as her

husband's authority, she moves into a position of partner so she can be given love and receive it instead.

The same principle holds true in other relationships. Any form of demanding love results in something less than authentic love. What is given in response to demand, need, and shame is reluctant and even resentful relationship. Again, love is best when it is freely given and freely received. Let go. Let love flow. *Live loved.*

EMBRACE THE CALL OF OUR MOTHER NATURE

"Adam named his wife Eve, because she would become the mother of all the living" (Genesis 3:20).

Every woman, regardless of her life situation, can embrace the call of her mother nature. We can seek God and His plans for how to let this life-giving encouragement and nurture flow through us. We'll see His kingdom grow and His purposes flourish around us. Natural mothering is, of course, one beautiful expression, but *spiritual* birthing and mothering is a call for all of us. Every woman can let her nurture nature flow to build up and strengthen people around her.

God has used my mother nature in unique and nontraditional ways to foster life. Experiencing my parent's divorce as a teen forged in my heart a deep compassion for children who are hurting. This compassion led me to invest the past several decades of my life into ministry to orphans and children at risk around the world. Additionally, God has used my mother nature to spiritually lead and disciple children, youth, and adults in several countries and contexts. I've poured my heart and soul into building teams, ministries, and movements to take the hope and healing love of Jesus to the brokenhearted.

All this to say, you do not need to be a literal mother to nurture the plans and purposes of God for your life. There are lives all around you that need the God-bearing image of a redeemed Eve pouring life into them instead of extracting life *from* them. Ask the Lord to reveal in whom, in what, and where you should be investing your mother nature. It may be a family or a friend, a ministry or a business, a charity or a cause. Invest yourself. Be faith-filled. Express love.

If you are the mother of children, please know that you have been blessed! Your precious children are a gift from God. "Children are a heritage from the LORD, offspring a reward from him" (Psalm 127:3). We are all natural-born sinners. Every child will be at times selfish, unruly, and disruptive. Too often, however, I see parents internalize their children's sin, weakness, or lack of perfection as

their own failure. This is lie and a trick of Satan to foster resentment in parents to despise their own children.

Parenting is work, true, but it is to be a labor of love. Children are a blessed gift from God for you to treasure, train, and cherish. You are called to bring life, love, and truth to them, to support them toward maturity, to encourage their character and foster their development. You have God's divine help and empowerment in this task. To be clear, you are not responsible for them. You cannot *make* a child into someone. However, you are responsible *to* your children—to *be* the mother God intends you to be. You can only do you. Love well and leave the results to God.

LIVING LOVED

Ultimately, the point of *Redeeming Eve* (and *Redeeming Adam*) is redeeming both of them to an intimate relationship with their Creator. The key to *Redeeming Eve* is restoring our heart-to-heart connection with the Lord God.

God is calling to your heart today: "I have loved you with an everlasting love; I have drawn you with unfailing kindness" (Jeremiah 31:3). Listen to His heart: "I have swept away your offenses like a cloud, your sins like the morning mist. Return to me, for I have redeemed you" (Isaiah 44:22). Can you hear His desire for you? "I will give them a heart to know me, that I am the LORD. They will be my people, and I will be their God, for they will return to me with all their heart" (Jeremiah 24:7).

The Father is calling, *Return to me! I love you and I want you! I have redeemed you—return to me! I will give you a new heart so you can know me. I chose you. I want you. You will be mine, and I will be yours. Return to me . . . I love you!*

Lord Jesus,

Thank you for loving me. Thank you for wanting me! I come to you right now with all my pains and failures, hopes and dreams, fears and faith. I am tired of trying to control my circumstances and extract life from other people and things. Lord Jesus, thank you for dying to pay for my sin, forgiving me and setting me free. Wash me clean. Renew my heart. Revive my hope. Restore my joy. I commit to living and loving from wholeness instead of need. I release those in my life from my demands and expectations to fill my needs. Redeem my mother nature so I can nurture life, hope, and joy to those around me. May I *live loved*.

In Jesus' name, Amen

DISCUSSION QUESTIONS

1. Perfect love drives out fear. How can *living loved* challenge and change your identity? How does *living loved* foster security? Which fears are nullified and replaced when you *live loved*?

2. When we *live loved*, we live from a place of wholeness instead of need. We seek to bring life to others instead of taking life from them. What would change in your closest relationships if you related from wholeness instead of need?

3. When a woman *lives loved*, she is free to partner with her husband instead of dominating him. Submission and respect mean "don't jump" over, ahead, or above. If you are married, how can you apply these principles to your marriage? How might your marriage improve as a result?

12

ARISE AND SHINE

Arise, shine, for your light has come, and the glory of the LORD rises upon you. (Isaiah 60:1)

It is time for us, as the women of God, to embrace the love and purposes of God. It's time to get up and stand up, to arise as women created in the image of our glorious, Almighty God. It's time to stand confident in our identity as co-heirs with Christ—to arise and shine! It's time to radiate and emulate the glory of God revealed through us. We are to showcase the life-giving, nurturing, mothering nature of a redeemed Eve.

A redeemed Eve is confident in her identity, committed to use her godly mother nature and influence to serve God's purposes, and content in her intimacy. She knows that "charm is deceptive, and beauty is fleeting; but a woman who fears the LORD is to be praised" (Proverbs 31:30). Charisma, glamour, and sensuality—while they may dazzle and beguile—in the end are shallow and vain; they are faulty foundations for identity. Youthful beauty is fleeting. Real and lasting beauty comes from the inside, from a spirit at peace with God and life, from a heart that *lives loved* and loves others. In 1 Peter 3:3–4, it is affirmed that "your beauty should not come from outward adornment, such as elaborate hairstyles and the wearing of gold jewelry or fine clothes. Rather, it should be that of your inner self, the unfading beauty of a gentle [humble] and quiet [peaceable] spirit, which is of great worth in God's sight" (amplified by the author).

A woman who puts her hope and trust in the Lord will be radiant. She will literally shine! She will "become light . . . be illuminated . . . give light . . . become bright."[39] She will be a glorious celebration of the splendor of godly womanhood. She will exude joy. She will reflect glory. She will flash forth light! She will reveal the majesty of redeemed femininity.

She is clothed with strength and dignity; she can laugh at the days to come. (Proverbs 31:25)

Fully alive. Standing tall. Washed clean. A redeemed Eve is "clothed with strength and dignity" (v. 25). She is endowed with power and might. She is a firm, secure, and fortified tower. Her heart offers refuge to others.

A redeemed Eve *lives loved*. She embraces her stature as an image bearer of God. Her identity is firmly established as a daughter of the Most High God. Her life is surrendered to His plans and purposes. Secure in the faithful hands of her trustworthy Savior, she has no worry about tomorrow. She looks expectantly to the future. Hope-filled joy bursts forth in renewed wonder and confident delight. She can laugh. She can smile, make merry, and celebrate the days to come.

> She firmly believes that His favor, grace, and kindness will constantly pursue her, that He will zealously and passionately fight for and defend her all the days of her life.

She is fully convinced of Psalm 23:6: "Surely your goodness and love will follow me all the days of my life, and I will dwell in the house of the LORD forever."

Her heart is secure. She is confident that God's goodness will follow her. She firmly believes that His favor, grace, and kindness will constantly pursue her, that He will zealously and passionately fight for and defend her all the days of her life. A redeemed Eve, rescued and restored by Jesus, will *live loved* in the faithful and true presence of Jesus—forever.

She speaks with wisdom, and faithful instruction is on her tongue. (Proverbs 31:26)

She is arrayed in glorious purity, and righteous strength restores her voice. Her identity secure, her influence purified, her healed heart will overflow with words of wisdom, faith, and hope. She will water her world with her grace-filled, truth-saturated, loved-soaked, God-exalting proclamation: "The tongue has the power of life and death" (Proverbs 18:21). A redeemed Eve speaks forth life!

The Spirit and the bride say, "Come!" And let the one who hears say, "Come!"
Let the one who is thirsty come; and let the one who wishes take the free gift
of the water of life. (Revelation 22:17)

Hear God's invitation to you! Come and drink of the living water, the rich love of Jesus flowing from the throne of God. No longer will we be plagued by perpetual thirst and unmet needs. We come to Jesus. Saturated in His grace. Washed clean by His forgiveness. Refreshed by His joy. Quenched by His love.

We come to Jesus. Saturated in His grace. Washed clean by His forgiveness. Refreshed by His joy. Quenched by His love.

Who is this coming up from the wilderness leaning on her beloved?
(Song of Songs 8:5)

My hope and prayer in walking through this *Redeeming Eve* journey with you is for you to fall completely and eternally in love with Jesus, that you will find in these portraits the beauty and power of God's redeeming love for you, His beloved daughter! I pray this perfect, thirst-quenching love will heal, fill, and restore your precious heart. I pray that you can live from wholeness instead of need, confident in your identity, committed to your influence, and content in your relationships—that you can be secure, joyful, and free.

Indeed, at journey's end, may you be found coming up out of your wilderness, your desert, your wandering—and leaning on Jesus, the Lover of Your Soul. He has rescued and redeemed you. He has called you by name. Jesus has found you! Take His hand and walk into life and love with Him—perfectly loved.

For the Lamb [Jesus] at the center of the throne
** will be their shepherd;**
'he will lead them to springs of living water.'
** 'And God will wipe away every tear from their eyes.'" (Revelation 7:17)**

One day God's redemptive plan will culminate with the return of Christ. And on that glorious day, the curse of sin and its effect will be completely nullified, rectified, and reversed!

No longer will there be any curse. (Revelation 22:3)

Embrace love. Drink deeply. *Live loved.*

A Moment for Personal Reflection

In Luke 18:39–41, a blind man called out to Jesus, "Son of David, have mercy on me!" Jesus responded and brought the man near. Then Jesus asked him a profoundly personal, soul-piercing question: "What do you want me to do for you?"

Just as Jesus heard the blind man, He hears the cry of your heart, your inner needs and longings. He is asking you today, *Daughter, what do you want me to do for you?* As we conclude our journey through *Redeeming Eve*, take a moment to sit with Jesus. Hear His offer of healing and wholeness. Let yourself be honest, and ask Him for what you need.

Daughter, what do you want me to do for you?

There was a season when God took me on my own restoration tour, when I physically went back to some places and spaces where my heart had been broken. In facing my demons, so to speak—the lies and weapons that were forged against my value and my destiny—I wrote a poem as my declaration of freedom from the past. I pray that it brings encouragement to your soul. May your heart be strengthened and your spirit set free!

I'm Taking Back What You Stole from Me

I'm taking back what you stole from me,

My peace, my joy, my identity.

You attacked, you lied, you accused and abused,

Telling me I was to be consumed and used.

You mocked my faith and rejoiced in my pain,

Telling me my hope and trust was in vain.

You forged a weapon against my heart,

One uniquely crafted to tear it apart.

You set the stage and secured the rope

To sabotage my heart and strip it of hope.

Where love was to flow and bless my soul,

You twisted and diverted it, swallowing it whole.

Your plan was to leave me dry and famished,

Forsaken, alone, destitute, and ravished.

You installed distorted mirrors to warp reality,

Attacking my confidence and cursing my beauty.

A lethal combination of rejection and neglect,

Your destructive plan was all ready and set.

You searched my surroundings, looking for hosts

To operate through, wound, curse, and boast.

You hid behind people, inciting rejection and pain,

But I see who you are; the truth is now plain.

You're a monster, my enemy, the Father of Lies,

Trying to rewrite my story, where everything dies.

But I have a Savior who's stronger than you,

Who's the Most High God, who is faithful and true.

He sees me as precious; I'm the apple of His eye.

His face lights up when He sees me, like a sunlit sky.

I'm His beloved, the one He uniquely fashioned.

With no spirit of indifference, He loves me with passion.

So attentive, committed, so present and aware,

Wholeheartedly sharing every joy and care,

He sees me as His beauty and knows my whole heart.

He delights in me and is enthralled with every part.

He's calling me to believe and listen only to Him.

Your voice is losing power; your influence grows dim.

For my Jesus is powerful, His love is rescuing me.

The look in His eyes is redeeming my beauty.

His love is so perfect; I have nothing to fear.

I'll never be forsaken, so I can draw near.

To the spirit of abandonment, rejection, and neglect,

By the King of Kings you are defeated; and to Him subject.

I renounce and I rebuke you; be gone in Jesus' name.

I am a new creation; I will never be the same.

I reach out now and take His mighty hand;

I step onto the Rock, and here I take my stand.

I'm a child of the King, His beloved bride.

My shame is gone; I have nothing to hide.

For the sin and failure of man is not the end of my story.

In His resurrection love, I stand tall in unfading glory.

I give myself to Him, the Lover of My Soul.

I am free, redeemed, forgiven—I am whole.

Yes . . . I'm taking back what you stole from me.

You are defeated. I am loved. I am free.

In Jesus' name.

~ JULIE WRIGHT

Author Bio

Julie Wright is an author, speaker, Bible teacher, and missions leader. Her passion is helping people embrace the healing love of God and cultivate an authentic relationship with Jesus.

She has served in a variety of roles including Minister to Children and OneLess Ministry Director, with a focus on the fatherless and children at risk—locally and abroad. Julie and her husband Jon founded an international orphan care ministry and led it for over 20 years. She has also consulted on projects with Awana, Compassion International, David C Cook, and the 4/14 Movement.

Jon and Julie have an international family of three beautiful adopted daughters from the Ukraine, the U.S., and Liberia, along with a son-in-law from Ethiopia and three grandsons. They also have a son who lives in heaven with Jesus. The Wrights are currently ministering from their retreat center, The Refuge at Lost Creek, in Bailey, Colorado.

For more information about Julie, or to see more of her Bible studies, please visit www.juliewright.org.

Acknowledgments

People often ask me, "How long did it take you to write *Redeeming Eve?*" The answer lies somewhere between a couple months and three decades! I've been learning, processing, and writing *Redeeming Eve* most of my adult life. Likewise, when I think about *who* has been instrumental in the development of this work, those influences and contributions span months, years, and even decades. Some have contributed indirectly, yet others have been directly involved with my process and this work.

First, my parents instilled a deep and profound love for the Word of God, and for words in general. My mom's deep respect for the Word and her imaginative passion to understand the real people with real thoughts and emotions in the Bible brought the characters in Scripture alive for me. My dad's gift for storytelling and his deep understanding of the human heart, coupled with his relational nature, helped me "find my voice" and develop it from a young age. For these core influences, I am eternally grateful.

For *Redeeming Eve* in particular, I am so grateful for the many women who've attended my retreats and explored my Bible studies, providing invaluable feedback, affirmation, and encouragement to get this resource completed. They've shared their stories, opened their hearts, and let God love them to wholeness. Each one has enriched and blessed my life in her unique and beautiful way.

When God sovereignly connected me to Brett and Sheila Waldman and the team at TRISTAN Publishing, this dream of *Redeeming Eve* becoming a book found a home. I am grateful for Renee Garrick and Brett, whose editorial integrity and thoroughness forced the book's principles to be sharpened, clarified, and defended Biblically. Thank you! It was Sheila who personally championed *Redeeming Eve*, serving as my "midwife" in the birth of this book. I may have "conceived and carried" this baby; but she's been the friend, cheerleader, and prayer warrior who has believed in this project and carried me through. She's been there though the

anticipation, the complications, the effort, and the heavy labor of birthing this book. And now, together, we have the joy of sharing in the celebration!

Additionally, I want to thank the dozens of friends and family who've prayed for me, encouraged me, and cheered me on with reading chapters, sharing stories, and affirming the power and value of the truths in *Redeeming Eve*. I could not have done this without you.

My profound gratitude goes to my husband, Jonathan Wright. When I say I've been living and writing *Redeeming Eve* my entire adult life, Jon is the one who has walked this redemption journey with me. Through my brokenness and my becoming, he has stood with me and grown with me, showering me with God's grace and mercy, and faithfully believing in God's overcoming victory—with me and for me. Thank you, Jon Wright. You have truly been God's gracious gift in my life!

Finally, my highest gratitude goes to my precious Savior, Redeemer, and the Lover of My Soul, Jesus Christ, who began His good work in me and is faithful to complete it, until the day of Christ Jesus. On that day we will all be made whole. I love you, Lord Jesus. Thank you with all of my heart.

Endnotes

1 "H5828 - ʿēzer - Strong's Hebrew Lexicon (NIV)." Blue Letter Bible. Accessed 13 May, 2021. https://www.blueletterbible.org//lang/lexicon/lexicon.cfm?Strongs=H5828&t=NIV

2 Webster Dictionary Online, s.v. "Help," accessed May 13, 2021, https://www.webster-dictionary.org/definition/Help

3 "H5048 - neḡeḏ - Strong's Hebrew Lexicon (NIV)." Blue Letter Bible. Accessed 13 May, 2021. https://www.blueletterbible.org//lang/lexicon/lexicon.cfm?Strongs=H5048&t=NIV

4 "H5048 - neḡeḏ - Strong's Hebrew Lexicon (NIV)."

5 "H905 - baḏ - Strong's Hebrew Lexicon (NIV)." Blue Letter Bible. Accessed 13 May, 2021. https://www.blueletterbible.org//lang/lexicon/lexicon.cfm?Strongs=H905&t=NIV

6 Webster Dictionary Online, s.v. "Alone," accessed May 13, 2021, https://www.webster-dictionary.org/definition/alone

7 Webster Dictionary Online, s.v. "Good," accessed May 13, 2021, https://www.webster-dictionary.org/definition/good

8 "H1692 - dāḇaq - Strong's Hebrew Lexicon (KJV)." Blue Letter Bible. Accessed 17 May, 2021. https://www.blueletterbible.org//lang/lexicon/lexicon.cfm?Strongs=H1692&t=KJV

9 "H8669 - tᵉšûqâ - Strong's Hebrew Lexicon (NIV)." Blue Letter Bible. Accessed 16 Mar, 2021. https://www.blueletterbible.org//lang/lexicon/lexicon.cfm?Strongs=H8669&t=NIV

[10] "H4910 - māšal - Strong's Hebrew Lexicon (NIV)." Blue Letter Bible. Accessed 26 May, 2021. https://www.blueletterbible.org//lang/lexicon/lexicon.cfm?Strongs=H4910&t=NIV

[11] "H3205 - yālaḏ - Strong's Hebrew Lexicon (NIV)." Blue Letter Bible. Accessed 14 Apr, 2021. https://www.blueletterbible.org//lang/lexicon/lexicon.cfm?Strongs=H3205&t=NIV

[12] "H342 - 'êḇâ - Strong's Hebrew Lexicon (NIV)." Blue Letter Bible. Accessed 26 May, 2021. https://www.blueletterbible.org//lang/lexicon/lexicon.cfm?Strongs=H342&t=NIV

[13] Webster Dictionary Online, s.v. "Enmity," accessed May 27, 2021, https://www.webster-dictionary.org/definition/enmity

[14] Webster Dictionary Online, s.v. "Hatred," accessed May 27, 2021, https://www.webster-dictionary.org/definition/hatred

[15] "H2416 - ḥay - Strong's Hebrew Lexicon (NIV)." Blue Letter Bible. Accessed 13 May, 2021. https://www.blueletterbible.org//lang/lexicon/lexicon.cfm?Strongs=H2416&t=NIV

[16] Webster Dictionary Online, s.v. "Respect," accessed May 13, 2021, https://www.webster-dictionary.org/definition/respect

[17] Webster Dictionary Online, s.v. "Trust," accessed May 13, 2021, https://www.webster-dictionary.org/definition/trust

[18] Webster Dictionary Online, s.v. "Submit," accessed May 13, 2021, https://www.webster-dictionary.org/definition/submit

[19] Webster Dictionary Online, s.v. "Accommodate," accessed May 13, 2021, https://www.webster-dictionary.org/definition/Accommodate

[20] Webster Dictionary Online, s.v. "Serve," accessed May 13, 2021, https://www.webster-dictionary.org/definition/serve

[21] Webster Dictionary Online, s.v. "Benefit," accessed May 13, 2021, https://www.webster-dictionary.org/definition/benefit

[22] Webster Dictionary Online, s.v. "Prosper," accessed May 13, 2021, https://www.webster-dictionary.org/definition/prosper

[23] Webster Dictionary Online, s.v. "Grow," accessed May 13, 2021, https://www.webster-dictionary.org/definition/grow

[24] "H6031 - ʿānâ - Strong's Hebrew Lexicon (NIV)." Blue Letter Bible. Accessed 26 May, 2021. https://www.blueletterbible.org//lang/lexicon/lexicon.cfm?Strongs=H6031&t=NIV

[25] Larry Crabb, *The Marriage Builder* (Grand Rapids, MI: Zondervan, 2013), 99–100.

[26] H6711 - ṣāḥaq - Strong's Hebrew Lexicon (NIV)." Blue Letter Bible. Accessed 3 March, 2022. https://www.blueletterbible.org/lexicon/h6711/niv/wlc/0-1

[27] "H7186 - qāšê - Strong's Hebrew Lexicon (NIV)." Blue Letter Bible. Accessed 13 May, 2021. https://www.blueletterbible.org//lang/lexicon/lexicon.cfm?Strongs=H7186&t=NIV

[28] "H7451 - raʿ - Strong's Hebrew Lexicon (NIV)." Blue Letter Bible. Accessed 16 Mar, 2021. https://www.blueletterbible.org//lang/lexicon/lexicon.cfm?Strongs=H7451&t=NIV

[29] Webster Dictionary Online, s.v. "Submit," accessed May 13, 2021, https://www.webster-dictionary.org/definition/submit

[30] Webster Dictionary Online, s.v. "Yield," accessed May 13, 2021, https://www.webster-dictionary.org/definition/yield

[31] "G5293 - hypotassō - Strong's Greek Lexicon (KJV)." Blue Letter Bible. Accessed 17 May, 2021. https://www.blueletterbible.org//lang/lexicon/lexicon.cfm?Strongs=G5293&t=KJV

[32] "G5219 - hypakouō - Strong's Greek Lexicon (NIV)." Blue Letter Bible. Accessed 16 Mar, 2021. https://www.blueletterbible.org//lang/lexicon/lexicon .cfm?Strongs=G5219&t=NIV

[33] Webster Dictionary Online, s.v. "Subjugate," accessed May 13, 2021, https://www.webster-dictionary.org/definition/Subjugate

[34] Webster Dictionary Online, s.v. "Adultery," accessed May 13, 2021, https://www.webster-dictionary.org/definition/adultery

[35] Webster Dictionary Online, s.v. "Seduce," accessed May 13, 2021, https://www.webster-dictionary.org/definition/seduce

[36] "H8669 - tᵉšûqâ - Strong's Hebrew Lexicon (NIV)." Blue Letter Bible. Accessed 16 Mar, 2021. https://www.blueletterbible.org//lang/lexicon/lexicon .cfm?Strongs=H8669&t=NIV

[37] Warren W. Wiersbe, *The Wiersbe Bible Commentary: Old Testament* (Colorado Springs: David C Cook, 2007), 488.

[38] Webster Dictionary Online, s.v. "Confidence," accessed May 27, 2021, https://www.webster-dictionary.org/definition/confidence

[39] "H215 - 'ôr - Strong's Hebrew Lexicon (NIV)." Blue Letter Bible. Accessed 14 May, 2021. https://www.blueletterbible.org//lang/lexicon/lexicon .cfm?Strongs=H215&t=NIV